AMERICAN WATERCOLORS
from The Metropolitan Museum of Art

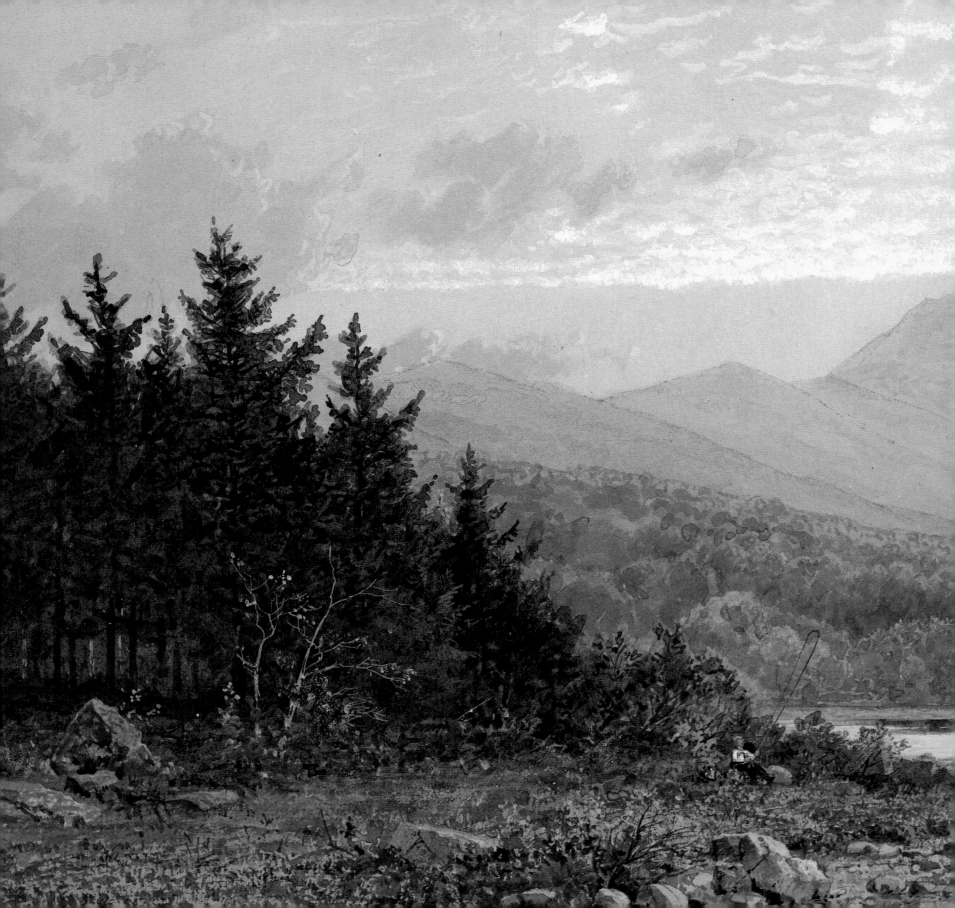

AMERICAN WATERCOLORS
from The Metropolitan Museum of Art

Foreword by John K. Howat
Introduction by Victor Koshkin-Youritzin
Commentaries on the plates by Stephen Rubin

The American Federation of Arts in association with
Harry N. Abrams, Inc., Publishers, New York

Publication Coordinators: Michaelyn Mitchell and Dorothy R. Caeser
Project Director: Margaret L. Kaplan
Editor: Ellyn Childs Allison
Designer: Darilyn Lowe

This book has been published in conjunction with "American Watercolors
from The Metropolitan Museum of Art," an exhibition organized by The
Metropolitan Museum of Art and The American Federation of Arts. This
exhibition and publication have been sponsored by Mercedes-Benz of
North America.

Founded in 1909, The American Federation of Arts is a nonprofit educational
organization that serves the visual arts community. Its primary activity
is the organization of exhibitions and film programs that travel throughout
the United States and abroad. Other services range from management
training to reduced-rate programs in fine-arts insurance and transportation.

Photographs were made by Geoffrey Clements, except those of catalogue
numbers 8, 17, 37, 43, 64, 74, 76, 83, 88, 93, 112, 116, 122, 125, 126,
144, and 150, which were made by the Photograph Studio, The Metropolitan
Museum of Art.

Library of Congress Cataloging-in-Publication Data
American watercolors from the Metropolitan Museum of Art /
 introduction by Victor Koshkin-Youritzin ; commentaries on the
 plates by Stephen Rubin ; with a foreword by John Howat.
 p. cm.
 Includes bibliographical references and index.
 ISBN 0-8109-1906-0. — ISBN 0-917418-92-1 (pbk.)
 1. Watercolor painting, American—Exhibitions. 2. Watercolor
painting—19th century—United States— Exhibitions. 3. Watercolor
painting—20th century—United States— Exhibitions. 4. Metropolitan
Museum of Art (New York, N.Y.)—Exhibitions. I. Rubin, Stephen.
II. Metropolitan Museum of Art (New York, N.Y.) III. American
Federation of Arts. IV. Harry N. Abrams, Inc.
 ND1807.A43 1991
 759.13'074'73—dc20 90-43753
 CIP

Printed and bound in Japan

Pages 2–3: WILLIAM TROST RICHARDS
Sunset on Mount Chocorua, New Hampshire
(see plate 46)

BOMC offers recordings and compact discs, cassettes
and records. For information and catalog write to
BOMR, Camp Hill, PA 17012.

ACKNOWLEDGMENTS

The Metropolitan Museum of Art's superb collection of American watercolors includes masterworks by such artists of worldwide reputation as Winslow Homer, Thomas Eakins, John Marin, John Singer Sargent, and James McNeill Whistler. "American Watercolors from The Metropolitan Museum of Art" is the fourth exhibition in the ongoing collaborative program of the Metropolitan and the American Federation of Arts (AFA) designed to share the museum's vast resources with other institutions around the country. We are delighted that the 150 works represented in this publication are being made accessible to the public nationwide.

We wish to acknowledge the efforts of a number of staff members at the Metropolitan: John K. Howat, the Lawrence A. Fleischman Chairman of the Departments of American Art; Kevin Avery, assistant curator, American paintings and sculpture; Stephen Rubin, research associate, American paintings and sculpture; Peter Kenny, assistant curator, American decorative arts, and assistant for administration; Amelia Peck, assistant curator, American decorative arts; Doreen Bolger, formerly curator of American paintings and sculpture and currently curator of paintings and sculpture at the Amon Carter Museum, Fort Worth; and Lewis I. Sharp, formerly curator and administrator of the American Wing and currently director of the Denver Art Museum. In twentieth-century art, we want to thank William S. Lieberman, chairman; Lowery S. Sims, associate curator; and Ida Balboul, research associate. Marjorie N. Shelley, conservator, paper conservation, also deserves special recognition.

On the AFA staff, those who have made important contributions to the realization of this project include J. David Farmer, director of exhibitions; P. Andrew Spahr, senior exhibition coordinator; Michaelyn Mitchell, head of publications; and Dorothy R. Caeser, interim publications coordinator. We also wish to thank Susan J. Brady, director of development and public affairs, and Jillian W. Slonim, director of public information.

Victor Koshkin-Youritzin, associate professor of art history at the University of Oklahoma, has contributed handsomely to the publication, and we are grateful to him.

Lastly, we want to thank Mercedes-Benz of North America for their generous support of the exhibition and this publication.

Philippe de Montebello
Director
The Metropolitan Museum of Art

Myrna Smoot
Director
The American Federation of Arts

Mercedes-Benz of North America is proud to provide sole corporate funding for the national exhibition "American Watercolors from The Metropolitan Museum of Art." This underwriting represents yet another extension of our long-term commitment to the arts across this great country.

"American Watercolors from The Metropolitan Museum of Art" features a wide range of works—including landscapes, topographical views, architectural studies, and still lifes—painted over a period of nearly 150 years by some of this nation's most renowned artists. We believe that this selection from the Metropolitan Museum's outstanding collection serves as an elegant testament to the aesthetic value and historical significance of American artists' work in this demanding and evocative medium.

As this exhibition makes clear, there is good reason to be proud of American art.

Erich Krampe
President and Chief Executive Officer
Mercedes-Benz of North America, Inc.

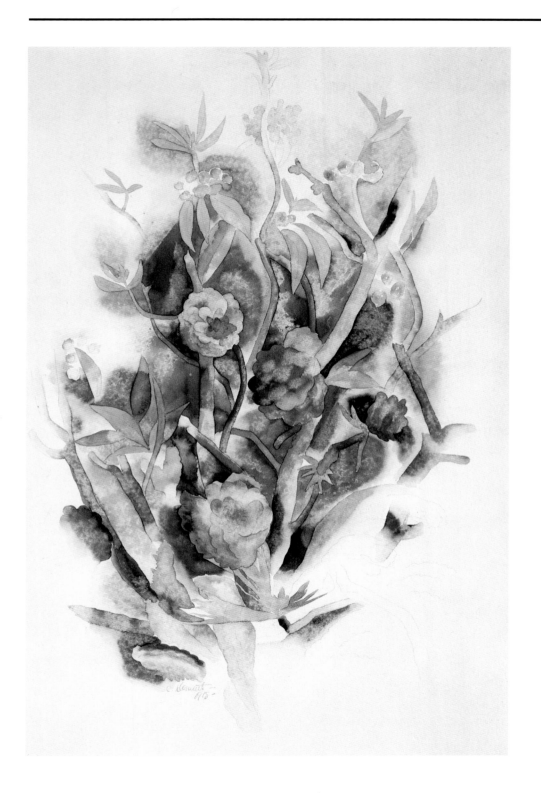

CONTENTS

CHARLES DEMUTH
Flowers (see plate 147)

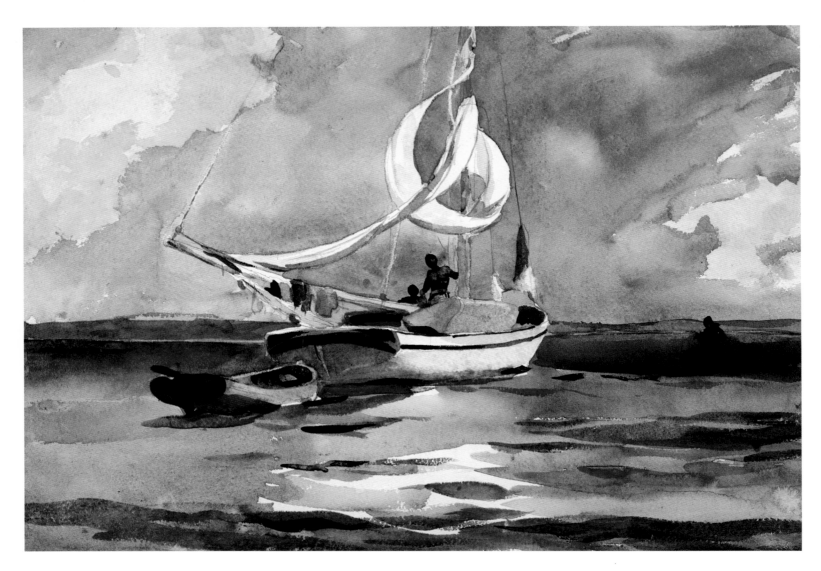

WINSLOW HOMER
Sloop, Nassau (see plate 71)

FOREWORD

The Metropolitan Museum of Art is the very fortunate possessor of one of the largest and finest collections of American watercolors in the world. The Metropolitan's good luck and responsibility in this regard are the result of both the generosity of individual benefactors and perceptive acquisitions on the part of museum curators, directors, and trustees; however, like all important collections in the museums of this country, the Metropolitan's considerable holdings of eighteenth- and nineteenth-century and early-twentieth-century American watercolors and drawings—from which the 150 examples in this volume and exhibition were selected—are dominated by the donations of individual patrons. These cornerstone gifts have been augmented by purchases recommended by the museum staff and funded by the contributions of public-spirited art lovers. The Metropolitan's collection thus reflects the same public benevolence that created the museum in 1870 and that continues to support its life today.

Ardent enthusiasm for art—for beautiful objects and their meaning—has inspired donors and staff for more than a century as they built this extraordinary body of splendid works of art. The collection was inaugurated in 1880 with the magnificent donation by the Reverend Elias L. Magoon of approximately eighty superb watercolors by William Trost Richards. A clergyman of deep faith who saw the hand of God in everything natural, Magoon embraced the work of Richards, bought it extensively, and prevailed upon the first director of the Metropolitan, General Luigi Palma di Cesnola, to accept the gift and install it in a handsome gallery. The museum archive preserves a number of Magoon's letters to Cesnola. In all of them his enthusiasm shines forth but in none so strongly as a communication urging a "Richards Gallery" upon the museum: "My dear General di Cesnola: The great Father made me earnest in every undertaking, so that what was said to you recently touching Art was wholly meant. William T. Richards is a mighty master of graphic excellence in general, and of water color delineation in particular, the completest representation of which I possess." Leaving it up to Cesnola to frame and install the collection as "his own fine taste shall appoint," Magoon went on to explain why he wished to make such a splendid gift: "To be at the foundation of things, opening a salubrious fountain for susceptible generations long after terrestrial toils and accumulations are superseded by the eternal life, is the supreme purpose of, my dear co-operative director, yours evergrowing, ELM." Writing about the bequest two years later, Magoon again sang the praises of Richards: "Amid the varied treasures of our Museum already secured, not the least in graphic excellence are the first drawings ever commissioned of William T. Richards. Admirable as a man, the time will come when his works will be in demand as much in America as those of Turner in England. He who wins one now from the greatest of living masters brings to his own soul the best of culture, and leaves to posterity a legacy more beneficent than any amount of gold." Magoon's zeal thus expressed is

touching, and although today we do not hold Richards in the same esteem as we do Turner, the quality of Richards's very best work, as represented here, still calls forth enthusiastic praise and admiration. The museum's collection of American watercolors could hardly have had a more auspicious beginning.

As this publication emphasizes, the greatest strengths of the collection are to be found in remarkable groups of works by William Guy Wall, Pavel Petrovitch Svinin, John William Hill, William Trost Richards, William Stanley Haseltine, Thomas Eakins, Winslow Homer, John La Farge, John Singer Sargent, Maurice Prendergast, Charles Demuth, and John Marin. The museum's dazzling concentration of works on paper by Winslow Homer was initiated by the swift and keen action of Bryson Burroughs, the Curator of Paintings, who also curated drawings; in 1910, within a few months of Homer's death, Burroughs prevailed upon the director and trustees to purchase twelve of Homer's finest watercolors from the artist's brother, Charles, for the modest sum of $200 each.

Two years later, Museum Director Edward Robinson began a cordial negotiation by letter with his friend John Singer Sargent that resulted in the purchase of ten brilliant watercolors by the artist. The correspondence between the two men is conspicuous for its warm collegiality. Robinson's first letter to Sargent opened: "My dear John—The Trustees of our Museum have asked me to communicate to you their desire to purchase some of your watercolors, which I gladly do as I also am anxious that we should have them. They do not ask for many—perhaps eight or ten at most, as our space for watercolors is limited at present, but the number can be determined better when we know what—if anything—you have to offer, and the prices. Have you, by chance, any now on hand by which you would like to be represented in our collection? And if not will you keep us in mind when you do some more? We should naturally be guided largely by your own selection and if you say you have some which you would recommend, you will hear from me very promptly." Sargent replied by return mail from London saying that he was flattered by the inquiry; had but one watercolor available then (*Spanish Fountain*, plate 96), which could be had for £75; and "should be glad to reserve the best of the water colours that I shall do next year for the Museum, to make up eight or ten as you say. I hope £75 does not seem an unreasonable price." Three weeks later, Robinson wrote on behalf of the Purchasing Committee to take "the fountain in Granada" at that price and to "thank you for your very generous offer to set aside for us eight or ten of what you consider the best watercolors that you may do in the near future . . . the price named being entirely satisfactory. Please understand, however, that the acquisition of these watercolors does not in any way affect our desire to have the large painting, of which I have written to you before, whenever the inspiration may seize you." The results were magnificent for the Metropolitan: in 1915 ten masterpieces of watercolor specially done for the museum entered the collection, and the following year the artist's most famous portrait, *Madame X* ("the large painting" mentioned by Robinson), was purchased by the museum. In 1950 a massive gift to the museum by Sargent's sister Mrs. Francis Ormond further enriched an already notable collection of Sargent's work.

Under the perceptive urging of Bryson Burroughs, the Metropolitan set out in 1924 to acquire a representative selection of Thomas Eakins's watercolors. Burroughs, a painter himself and an ardent admirer of Eakins's work, had arranged the first Eakins retrospective

exhibition, held at the Metropolitan in 1916 as a memorial to the artist. He was also responsible for acquiring six great Eakins oils, beginning with *Pushing for Rail* in 1916 and ending with *Max Schmitt in a Single Scull* in 1934—a remarkable example of curatorial wisdom and tenacity, matched in 1924 by his arrangements to purchase several of Eakins's best watercolors from the artist's widow. Burroughs wrote in May 1924, on a museum purchase blank, that "we own but one drawing by Eakins and that is not in color [*The Gross Clinic*, acquired in 1923]. We should make a great effort to secure at this time a group of his watercolors to match the groups by Homer and Sargent." The same year, on Burroughs's recommendation, the museum trustees bought *John Biglen in a Single Scull*, and in 1925 they purchased five more watercolors: *Negro Boy Dancing*, *Girl Looking at Plant (Young Girl Meditating;* plate 84), *Spinning (Home-spun;* plate 86), *Taking Up the Net* (plate 87), and *Cowboy Singing* (plate 88). Burroughs noted, "Mrs. Eakins selected these drawings as the available ones among those which her husband considered successful and offers them to us at a nominal price [$400 each, or $1,500 as a group]. It is an exceptional opportunity." Indeed, such opportunities are rare, and the museum is the beneficiary of Burroughs's penetrating eye and mind.

The Metropolitan's collection of American watercolors and drawings, curated both by the Department of American Paintings and Sculpture and by the Department of Twentieth Century Art, today numbers in the thousands—there are more than 1,800 in the Department of American Paintings and Sculpture alone. Every period and style beginning with eighteenth-century examples are covered, and some artists, such as Sargent and Marin, are represented voluminously. The collections continue to grow, and purchases, gifts, and bequests still swell the museum's holdings—though at a much reduced rate because of the adverse impact of high prices and extremely unfavorable current tax laws. Let us hope that one hundred years hence the Metropolitan and the public who visit the museum will look as proudly and gratefully on the acquisitions made during the twenty-first century as we now do on the collections formed by our predecessors.

John K. Howat
The Lawrence A. Fleischman Chairman of the
Departments of American Art
The Metropolitan Museum of Art, New York

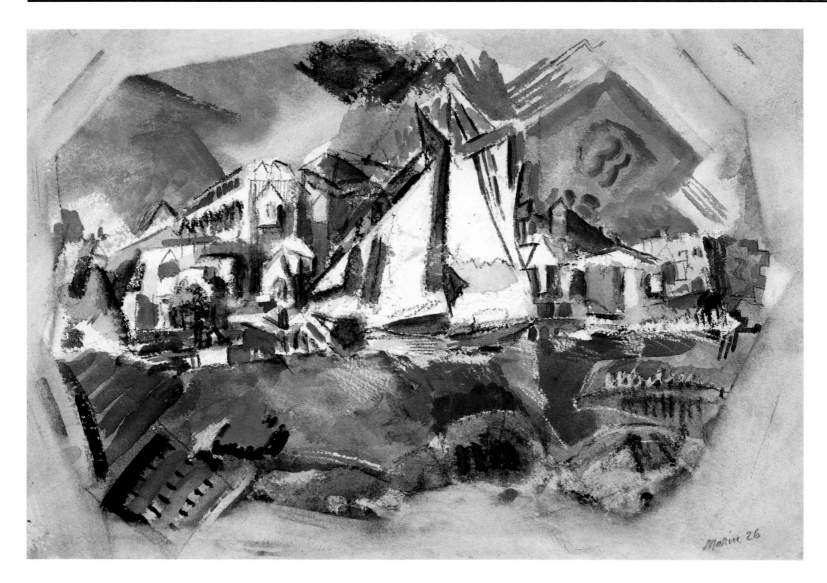

JOHN MARIN
***Pertaining to Stonington Harbor, Maine,
No. 4*** (see plate 133)

INTRODUCTION

Victor Koshkin-Youritzin

"You will see," Winslow Homer once proclaimed, "in the future I will live by my watercolors."[1] These prophetic words could just as well have been uttered by a number of other artists featured in this publication, including Maurice Prendergast, John Marin, and Charles Demuth.

The eminent nineteenth-century art critic John Ruskin, who profoundly influenced mid-nineteenth-century American artistic taste, offered this tribute to watercolor: "There is nothing that obeys the artist's hand so exquisitely, nothing that records the subtlest pleasures of sight so perfectly."[2] By definition a medium in which pigments or dyes are mixed in a water-soluble substance—with gum arabic the traditional binding agent—watercolor is usually applied with brushes, primarily in washes, over surfaces that through the centuries have included not only paper, ideally of the durable rag linen variety, but also ivory, silk, and even velvet (a popular choice among nineteenth-century American folk artists).[3] Unlike gouache, or body color—a closely related medium whose pigments contain an admixture of white—transparent watercolor is distinguished by the freshness and luminosity of its effects. As colors are applied in transparent washes over white or light-toned paper, light penetrates these layers and is reflected back to the viewer. In areas of a painting where white is desired, the paper is left blank. Whereas in oil painting the artist frequently works from dark to light, the reverse is true of transparent watercolor (though not of gouache). While oil paint, moreover, lends itself to the slow, rich, three-dimensional modeling often essential to history painting and other monumental subject matter, watercolor, especially in its pure, transparent manner, tends to be more suited to modest, intimate themes and to those that require intensely poetic handling. In fact, as the many landscapes in this volume testify, watercolor—with its evocative, mobile washes—is a particularly appropriate medium for the expression of nature's ever-changing moods.[4] Compared with oils, watercolors have the advantage of being relatively inexpensive, neat, and easily portable. Oil painting, however, permits the extensive and repeated correction of errors; watercolor, by contrast, does not, although in certain cases, if one works deftly enough, one can either scrape pigment off, erase it, or, by repeatedly rewetting the paper and applying absorbent materials, sometimes entirely blot off unwanted tints. Ideally, then, the watercolorist will carefully plan his attack in advance and know where he wants to put his washes. Other decisions also confront him. How roughly textured or absorbent a paper should he choose and how extensively can or should he wet it? How much should the pigment be diluted and how much lighter will it be when it dries? What areas to paint and which to leave blank—and how much is enough, in a medium that is unkind to those who overwork it? To what degree should any preliminary underdrawing—in pencil, ink, or other substance—be permitted to appear through the superimposed washes? (The enlivening tension achieved by overlapping a pencil grid with

transparent washes can be exquisite.) Finally, of course, there is the basic challenge of brush handling, wherein the artist's sense of touch, timing, and rhythm are tested. Watercolor, clearly, requires the utmost skill, patience, control, and agility of both mind and hand.

Although only in the latter part of the nineteenth century did the American public come to accept watercolor as deserving of serious respect, its history is a long and distinguished one. In China it was the reigning medium of painting since as early as the second century B.C. The Japanese have for centuries employed watercolor, and it found important use in Persian miniatures and the early art of India. In the West, water-based pigments adorn the prehistoric caves of Altamira and Lascaux, enjoy eternal life on Egyptian tomb and papyrus surfaces, and decorate the walls of the Minoans, Etruscans, and Romans. Watercolor graces medieval illuminated manuscripts; later, in the form of fresco painting, it became the medium for some of Western art's greatest achievements (in a broad sense, Michelangelo was a watercolorist). Albrecht Dürer (1471–1528) is considered the first major modern practitioner, with his bold, free, lyrical washes upon paper.

What is sometimes thought to be the earliest school of European watercolor painting[5] arose in the late-sixteenth-century and seventeenth-century Netherlands, but it was in England, during the eighteenth and nineteenth centuries, that the first great national watercolor school appeared. In many cases, the English watercolorists created what were actually tinted drawings, overlapped by often pale, generally transparent, washes; in other instances, however—most spectacularly in J. M. W. Turner's art—British practitioners produced watercolors of extraordinary looseness and rich luminosity. Either directly, through English artists who came to America, or indirectly, through the wide-ranging, available precedent of British watercolor, the English school was the principal source of inspiration for America's emerging watercolor tradition.

In the United States, as in England, topographical views enjoyed great popularity in the late eighteenth century and early nineteenth century. Among the principal artists who introduced the British topographical watercolor tradition into American art was the Scottish-born, London-trained Archibald Robertson (1765–1835), whose style suggests such English watercolorists as Michael "Angelo" Rooker and John "Warwick" Smith.[6] Robertson's delicately washed *Collect Pond, New York City* (plate 13) offers one engaging passage after another.[7] In the foreground is a particularly felicitous touch whereby the hats that the two men are doffing seem to be given a further visual lift by the pair of church steeples directly above them.

Charming, too, is Charles Burton's *View of the Capitol* (plate 28), which shows the seat of the American government as it looked in 1824, before Thomas U. Walter gave the edifice its modern appearance by adding a more imposing dome and enlarging the wings. A British artist, Burton was active in America from approximately 1819 to 1842. Engravings after his topographical drawings were regularly published in the *New York Mirror*, and a series of twenty sepia views of Philadelphia and New York received considerable acclaim.[8] *View of the Capitol* shows not only Burton's mastery of architectural detail and skill at capturing keenly observed human activity but also his compositional ingenuity. Tree trunks, fence posts, and human verticals affirm the rhythm of the Capitol's colonnade, while the curved top of a covered wagon finds a major echo in the dome and a minor one in a blind arch near the

building's right corner. Effective also, at lower right, is the spirited kick of a young fellow, which redirects the viewer's attention up to the Capitol.

William James Bennett (c. 1784–1844), another British topographical artist, arrived in the United States by 1826. Trained at London's Royal Academy, Bennett had a distinguished career in America as a painter and specialist in aquatint, a complex intaglio process that allows artists to achieve effects close to watercolor. In a manner notable for its exceptional control, balance, harmony, and restraint, Bennett executed cityscapes, harbor scenes, and views of the Hudson River Valley and Niagara Falls; later in his career, he illustrated a book treating the atmosphere's changing effects in "the primitive forest of America."[9] Perhaps the finest of his watercolors, *View of South Street, from Maiden Lane, New York City* (plate 17) was published as part of a set in *Megarey's Street Views in The City of New-York* soon after Bennett's arrival in America. Like Burton's *View of the Capitol*, this subtly colored painting possesses a complex structure full of intriguing eddies of activity. Wheels, sails, barrels, round-topped posts, and building arches intensify each other's rhythmic curves; bowsprits and jibbooms shoot upward to counterbalance the gentler downward movement of yardarms and roof lines. Even the X-shaped suspenders on several figures echo the bold crisscross pattern of the painting's major perspective axes.

Reaching New York in 1818, the Irishman William Guy Wall (1792–after 1863) was a superb watercolorist, highly regarded in his own day by, among others, Thomas Jefferson, who once offered the artist a teaching position at the University of Virginia. Possessing a full mastery of the British watercolor technique and working in a style reminiscent of Paul Sandby's, Wall painted to a large degree from nature. A founder of the National Academy of Design, he is most famous for his twenty watercolor views of the Hudson River region, which were published as the *Hudson River Portfolio* in several editions between 1820 and 1828. His influential paintings were widely copied and he was an early exponent of the Hudson River School.[10] In its poetic stillness, horizontal emphasis, and reflective surfaces, *View on the Hudson River* (plate 25), painted about 1820–25, presages mid-century Luminism and the marine pictures of Martin J. Heade and Fitz Hugh Lane.

In contrast to Wall's loosely washed watercolors, which contain little opaque color, Nicolino Calyo's sweeping, often dramatically lit, urban views may be said, in their heavy gouache treatment, to look back to such eighteenth-century Italian masters of body color as Francesco Zuccarelli.[11] On the other hand, the openness of Calyo's vistas is prophetic of much late-nineteenth-century landscape painting. A painter of miniatures as well as of portraits and panoramas, Calyo (1799–1884) emigrated to America in the early 1830s and traveled in 1835 from Baltimore to New York, where he depicted the spectacular fire in the commercial district that year. He remained in the city until at least 1850 and produced strongly composed pieces—powerful in their balance of masses—such as *View of the Tunnel of the Harlem Railroad* (plate 27).

Also helping boost the popularity of topographical views was the work of two other early-nineteenth-century English immigrants, John Hill (1770–1850) and his son John William Hill (1812–1879). Only William James Bennett rivaled John Hill in the engraving of aquatints. His first important commission in the United States was to engrave the plates for Joshua Shaw's watercolor series *Picturesque Views of American Scenery* (1819–21). Later, after

WILLIAM GUY WALL
View on the Hudson River (detail of plate 25)

JOHN RUBENS SMITH
Allan Melville (detail of plate 16)

moving from Philadelphia to New York City, Hill completed his most celebrated project, the aquatint engravings for William Guy Wall's *Hudson River Portfolio* (1820–28). Offering abruptly cropped buildings and laundry waving casually in the breeze, Hill's pen and wash drawing *View from My Work Room Window in Hammond Street, New York City* (plate 14) anticipates such early-twentieth-century glimpses into the behind-the-scenes reality of everyday life as John Sloan's *Backyards, Greenwich Village* (1914).

Startling not only for its realism but also for its dynamic juxtaposition of geometric shapes is John William Hill's *Circular Mill, King Street, New York City* (plate 29). Rectangular, cylindrical, trapezoidal, and triangular forms are held in precarious tension by thin, linear members. Hill's delicately tinted, highly detailed watercolor typifies his city views (many published by Smith Brothers of New York) and suggests the verisimilitude of his later, Ruskin-inspired still lifes of the 1870s (see plates 32–34).

From the beginning of the colonial period, portraiture was a subject of overriding importance for artists. Charles Balthazar Julien Févret de Saint-Mémin (1770–1852) fled France to escape the Revolution and in 1793 reached America; in 1814 he returned to his native city of Dijon, where he spent the rest of his life, serving as curator of the municipal museum. The first artist in America to adopt the physiognotrace,[12] Saint-Mémin employed this instrument (invented in 1786) to make life-size tracings on tinted paper of a sitter's profile, after which he typically completed the likeness in crayon or in black and white chalk. He then used a pantograph to reduce the portrait to miniature size. Working in a refined but vigorous neoclassical manner, with a machine-assisted standard of precision not challenged until photography became publicly available in 1839,[13] Saint-Mémin produced more than eight hundred portraits. His watercolors, however, are extremely rare. *Osage Warrior* (plate 15) is riveting in its realism as well as in its exquisite shape relations and perfect placement of the image on the sheet.

No less vital is John Rubens Smith's three-quarters-length portrayal of Allan Melville (plate 16), which possesses not only a realism but a fluid, arcing movement that recall the portraits of Smith's famous, slightly younger contemporary Thomas Sully. A topographical painter as well as a miniaturist and portraitist, Smith (1775–1849) exhibited often at the Royal Academy in his native London before coming to the United States by 1809. Settling first in Boston, where this portrait was probably done, Smith then moved to New York and Philadelphia. In both cities he established art schools and became known as an accomplished watercolorist and a fine drawing instructor.[14] In *Pierre; or, the Ambiguities* (1852), the American novelist Herman Melville included the following description of this watercolor likeness of his father: "An impromptu portrait of a fine-looking, gay-hearted, youthful gentleman. . . . The free-templed head is sideways turned, with a peculiarly bright, and care-free morning expression. He seems as if just dropped in for a visit upon some familiar acquaintance. Altogether, the painting is exceedingly clever and cheerful; with a fine, off-handed expression about it."[15]

At the turn of the nineteenth century, the Russian painter and diplomat Pavel Petrovitch Svinin (1787/88–1839) came to the United States as secretary to his country's consul general and journeyed widely along the East Coast for twenty months. Enthusiastic about America and dedicated to fostering a better understanding between the new nation and his

own, Svinin predicted, among other things, the abolition of slavery and found, in general, pronounced similarities between Russia and the United States.[16] Back in Russia, he in 1815 published *A Picturesque Voyage in North America;* this was reissued in a 1930 English edition[17] that contained reproductions of a set of fifty-two unpublished watercolors (all now in the Metropolitan Museum), which he had done in America. With his artistic interests ranging over nearly every subject he could observe—from stagecoaches and steamboats to Anabaptists, Shakers and blacks—he by decades anticipated the chronicling of everyday American life by Currier and Ives. Of all Svinin's watercolors, R.T.H. Halsey has said the Philadelphia scenes (see plates 19–21) are "the most noteworthy. . . . No other such illuminating pictures of the life of our ancestors at so early a period are known to us."[18] Thus, to use Frank Weitenkampf's words, "it was a Russian who was setting down interesting observations of American life long before Darley and Winslow Homer."[19]

JOHANN HENRICH OTTO
Fraktur Motifs (detail of plate 1)

The century between the signing of the Declaration of Independence and the Centennial witnessed the principal flourishing of folk painting. This enchanting, individualistic, and increasingly treasured branch of American art was produced by largely self-taught practitioners not working in the fine-arts tradition. Most nineteenth-century folk paintings were executed in watercolor, and they come down to us from three basic artistic groups: Pennsylvania German fraktur artists; full-time, often itinerant portraitists; and nonprofessionals, a group that included men and women from the Northeastern leisure classes as well as schoolgirls in seminaries, where accomplishment in watercolor grew increasingly fashionable. Particularly from 1800 to 1850, as William P. Campbell has recently observed, "there was more painting per capita done . . . than at any other period in the history of the country"—most of it being by folk artists and in watercolor.[20]

Originally describing a German Gothic typeface developed in the sixteenth century, the term "fraktur" was later applied to a style of writing and finally to documents and handwriting examples *(Vorschriften)*, which the Pennsylvania German artists created with pen and ink and brightly colored washes. Frequently accompanying some form of text, distinctive motifs, often of a biblical nature, adorn these paintings, which have the striking flavor of medieval illuminations. Although generally frakturs served some clearly intended practical, moral, or educational purpose, it appears that some were occasioned by a purely artistic impulse. This may have been the case with *Fraktur Motifs* (plate 1) by Johann Henrich Otto (active 1772–1797), about whom little is known. Flat, symmetrical, and meticulously crafted—as is typical of frakturs—Otto's design contains images that are scattered across the sheet with a sophisticated informality.

Before the advent of photography, professional folk portraitists responded to a widespread public demand for likenesses by executing pictures that, while often awkward by academic standards, were nevertheless imaginative, distinctive, and highly expressive. Two identifiable nineteenth-century portraitists whose work is highly regarded today are Joseph H. Davis and Henry Walton. Davis (1811–1865), who described himself as a "Left Hand Painter,"[21] traveled from 1832 to about 1837 through the back country of Maine and New Hampshire producing inexpensive portraits that put his talents within the reach of rural clients. Approximately one hundred fifty of his portraits survive (only five are signed), and the subjects include single figures, married couples, and larger family groups—all typically

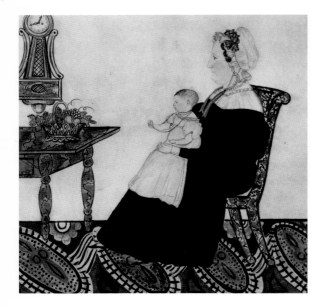

JOSEPH H. DAVIS
Mr. and Mrs. Daniel Otis and Child
(detail of plate 6)

painted in the flat, vigorously patterned, silhouetted style of *Mr. and Mrs. Daniel Otis and Child* (plate 6).[22] Few folk paintings better support Jean Lipman's proposition that "abstract design is the heart and soul of the American Primitive."[23] The rug's slanting ovals direct attention to the head of the household, whose newspaper adjusts to the table's receding edges in a visual pull toward the mother and child. The drawer knobs, the clock face, and the small ornament in the child's hand are echoed in the floral motif of the carpet. Even the swirling script that identifies the family members plays a key visual role, subtly balancing the circular and elliptical shapes of the picture.

Possessed of an almost hypnotic psychological intensity, *Frances and Charles Cowdrey* (plate 7) typifies Henry Walton's precisely delineated and sometimes unnervingly confrontational portraits, which were often done in watercolor. An artist who resided in the Ithaca, New York, area for many years and who began his career working as a lithographer and topographical painter, Walton (1804–1865) has heightened the psychological and formal tension of the Cowdrey portrait by brilliant compositional strategies. For example, a ball and wheels accent not only the siblings' heads but their staring eyes. The upward reach of the wagon handle answers the downward stretch of the children's arms, while two imaginary lines rising through the girl's right foot and the boy's left foot converge at—and help affirm—the clasp of their hands.

The early-nineteenth-century preoccupation with death is reflected in the prevalence of mourning pictures, often painted by young women. *The Orphans* (plate 10), by an anonymous artist, is a typical and poignant example, with its characteristic tomb, bereaved figures gathered under a willow tree, and church and stream in the distance.

Along with Sarah Fairchild's inviting *Union Park, New York* (plate 11), the Metropolitan's collection of nineteenth-century folk watercolors includes, by anonymous artists, the staunchly enigmatic *Stylized Bird* (plate 8), a cleverly laid-out *Picnic* (plate 9)—in which, ironically, an inanimate chair animates the rest of the composition—and *The Abraham Pixler Family* (plate 5), which offers an almost musical interplay of diagonal, curved, and rectangular motifs. Lastly, *Hudson River Railroad Station, with a View of Manhattan College* (plate 12) is astonishing for the clarity of its abundant detail, tightness of design, and provocative content. Despite all the streets and windows, with their potential for depicting human activity, there are but three visible figures in a painting that is strangely surreal and also prophetic of such twentieth-century folk masters as John Kane and Joseph Pickett.

Before considering artistic developments in the latter half of the nineteenth century, we should make some observations regarding watercolor as a medium. In the late eighteenth century in England, where papermaking was a fast-growing industry, a company named Whatman commenced making paper that was specifically prepared for watercolor application. Popular throughout the nineteenth century and into the twentieth century, Whatman paper—which was tough and sized (coated), both to prevent the excessive absorption of washes and to permit wiping, scraping, and brush corrections—came in several textures ranging from rough to smooth and was soon exported to America.[24] Providing artists with a welcome alternative to grinding their own colors, about 1780 William and Thomas Reeves of London began the commercial manufacture of cakes or pans of pigment. These high-quality painting materials were expensive to import, and by 1824 G.W. Osborne of Philadelphia had

begun to market watercolor paints similarly prepared and packaged. As Albert Ten Eyck Gardner has indicated, "the commercial manufacture of artists' colors, papers, and brushes which developed in the United States in the 1820's placed the materials of water color painting within the reach of many aspiring artists."[25] Between 1846 and 1849, an advance of still greater significance was made when the English firm of Winsor & Newton began producing moist watercolors in collapsible metal tubes. Since these were easily portable, Winsor & Newton's new product had far-reaching implications for the development of plein-air landscape painting. From the standpoint of necessary equipment, the American watercolorist was now fully armed.[26]

Helping spur the use of watercolor was the proliferation of art instruction and the publication of manuals not only on drawing but also—and sometimes exclusively—on watercolor. Archibald Robertson's *Elements of Graphic Art* (1802) and Fielding Lucas, Jr.'s *The Art of Colouring and Painting Landscapes in Water Colours* (1815) were followed at mid-century by Henry Warren's *Painting in Water Color* (1856). Influential, too, was a set of lengthy, detailed articles entitled "The Art of Landscape Painting in Water Colors"; this covered watercolor materials and techniques and was issued in the widely distributed *Bulletin of the American Art-Union* in 1851. Of great importance was John Ruskin's *Elements of Drawing* (1857) and also the American publication of his *Modern Painters* (1847), which promoted the brilliantly luminous art of Turner. (A selection of Turner's work—which would have an enormous impact on American artists—had already, about 1840, been introduced to the United States in an influential Boston show of British watercolors.)

Watercolor painting gained momentum—as well as public acceptance—in the two decades after 1850 as watercolor societies were formed and watercolor exhibitions mounted. Founded in 1850, the short-lived New York Water Color Society staged America's first major group watercolor show in 1853.[27] From 1857 to 1858, a large exhibition of British paintings in oil and watercolor was on view in New York, Philadelphia, and Boston. It included 188 watercolors by such artists in the Pre-Raphaelite circle as Ruskin, John Brett, and Ford Madox Brown and by such earlier nineteenth-century masters as David Cox, Samuel Prout, and Turner himself. This show, which gave an accurate view of contemporary English painting, "provided the teaching survey needed by the American public. . . . Watercolor painting received a new level of attention and respect in America as a result."[28] An organization of principal importance in fostering a public and professional following for watercolor was the American Society of Painters in Water Colors, formed in 1866 and eleven years later renamed the American Water Color Society, which has maintained its existence to the present day. In 1873 the society sponsored the largest and most popular exhibition of watercolors by foreign and native artists that had ever been held in America. As Helen A. Cooper has observed, "By establishing beyond question watercolor as a serious medium, it gave a tremendous impetus to the cause of watercolor painting in America."[29] By the late 1870s, realistic watercolor painting had reached its period of greatest vigor, and almost every American artist in this period worked in the medium at some point.[30]

Late in the nineteenth century, artistic currents from France and other European nations and even the Far East would reach American shores, but until about 1880 the British mode of watercolor painting prevailed in the United States. Turner's influence was para-

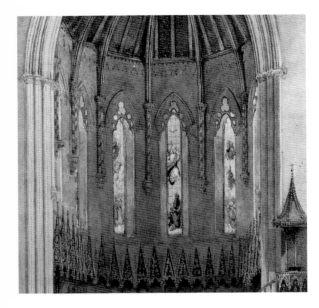

JOHN WILLIAM HILL
Interior of Trinity Chapel, New York City
(detail of plate 30)

mount, but the English Pre-Raphaelites, so evangelically promoted by Ruskin, were also widely admired and imitated. Unlike Dante Gabriel Rossetti and John Everett Millais, however, the American Pre-Raphaelites typically avoided figure painting and essentially concentrated on landscapes and still lifes. They also worked primarily in watercolor—unlike most of the English Pre-Raphaelites[31]—and took their cue from Ruskin, who believed in the moral value of a keenly observed, highly detailed, accurate rendering of nature. John William Hill was the first important American artist to propound Ruskinism, in America a term virtually synonymous with Pre-Raphaelitism.[32] His conversion to Ruskin's principles dates from about 1855, and *Interior of Trinity Chapel, New York City* (1856; plate 30) may reflect Ruskin's championship of the Gothic style. Hill's painting of peach blossoms (1874; plate 33), reaching almost ecstatically into a blank blue sky, bears a startling similarity to some of Ruskin's own work.[33] Hill's *Landscape: View on Catskill Creek* (plate 31) is typical of the high-keyed, luminous, naturalistically rendered treatment of the American Pre-Raphaelites, as is a dazzling set of landscapes by another of the group's most important members, William Trost Richards (1833–1905).

Belonging, like Hill, to the Ruskin-devoted Association for the Advancement of Truth in Art, Richards was one of America's most esteemed painters of landscapes and coastal views. Tending to paint directly from nature, Richards had a passion for depicting closely observed botany and geology. Recalling Ruskin's comment that "a stone, when it is examined, will be found a mountain in miniature,"[34] Richards's work has an exquisitely organized "hyperclarity" of vision that is sometimes "not just real, but surreal."[35] Entering his most concentrated period of watercolor production in the 1870s, Richards imbued a splendid series of landscapes with a magical luminosity, palpitating atmosphere, and piercing intensity of feeling. *Sunset on Mount Chocorua, New Hampshire* (plate 46) communicates, as do so many of Richards's watercolors, a commitment to penetrating the spiritual essence of things. As he himself once wrote, "Every day I feel more deeply the strong influence of inanimate nature over heart and brain; I go to Wordsworth with a fresher sense of all he meant, and find in him that which is 'as true as the Bible.'"[36]

The years between approximately 1840 and 1860 saw the peak of the Hudson River School, a group of artists who painted highly detailed, pantheistic views of an unspoiled wilderness. Related to this movement was William Rickarby Miller (1818–1893), who worked in and around New York State. Adept in oils as well as watercolors, Miller painted numerous landscapes and also produced many illustrations for periodicals and books. His admirably composed *Catskill Clove* (plate 36) has a clear relationship not only to the work of the Hudson River School master Asher B. Durand but also to Richards's contemporaneous pencil drawings.[37]

William Stanley Haseltine (1835–1900), some of whose early, crisply detailed Luminist coastal scenes also suggest parallels with Richards's work, was an internationally renowned American landscapist. After 1869 he spent most of his life as a distinguished member of the art colony in Rome, eventually helping to establish the American Academy there. Having worked early in the Barbizon region outside Paris, Haseltine developed a fascination for plein-air painting, atmosphere, and reflected light and came to be considered a "pre-impressionist."[38] In the 1880s, he evolved into a remarkable watercolorist. His *Mill Dam in*

Traunstein of 1894 (plate 61) poetically envelops the viewer with its radiant outward flows of color, while the undated *Vahrn in Tyrol near Brixen* (plate 58) is considered a fine example of a pastel-like effect that Haseltine's late watercolors sometimes possessed.[39] Interestingly, toward 1880 in America the fashionableness of gouache as a medium had decreased; its popularity, however, was revived as a result of the "pastel movement," led during the early 1880s by Robert Blum and William Merritt Chase. By mid-decade a change in taste had occurred, and, as Theodore Stebbins has pointed out, now "there were two quite different methods of watercolor being practiced: one, led by Homer, made maximum use of transparent washes; the other—equally significant at the time—made denser watercolors which imitated many of the effects of pastel."[40]

The most highly respected late-nineteenth-century American landscapist was George Inness (1825–1894), who traveled extensively in France and Italy during the 1850s and early 1870s. After executing early work in the Hudson River School manner of romantic realism, he turned to a freer, more tonal handling, as can be seen in one of his rare watercolors, *Across the Campagna* (plate 42). This work, dating from his 1870s European sojourn, evinces admiration for the French Barbizon painters, especially Camille Corot and Théodore Rousseau.

Among gifted later nineteenth-century landscapists is Bruce Crane (1857–1937), who began his career under Barbizon influence but moved on to a Tonalist or "decorative impressionist" manner.[41] His *Snow Scene* (plate 112) has an almost Oriental simplicity. Elliott Daingerfield (1859–1932) was not only an artist (whose career Inness promoted) but also a noted art critic; his imaginative, mystical *Moon Rising over Fog Clouds* (plate 118) evokes the romantic, dreamlike landscapes of the American artists R. A. Blakelock and Albert P. Ryder. Henry Fenn (1838–1911)—represented here by the exotic *Everglades* and by *Caesarea Philippi (Banias)* (plates 78, 79)—was a distinguished illustrator, a founder of the American Watercolor Society, and one of the chief contributors to the monumental two-volume *Picturesque America* (1872–74), edited by William Cullen Bryant. Fenn toured Europe as well as the Middle East and produced illustrations for two other publications, *Picturesque Europe* and *Picturesque Palestine, Sinai and Egypt.*

As Lloyd Goodrich has written, "The man who more than any other raised watercolor to the artistic level of oil was Winslow Homer."[42] Widely regarded today, along with Thomas Eakins, as one of the two greatest American painters of the late nineteenth century, Homer (1836–1910) was recognized in his own time as the foremost living practitioner of his craft. Born in Boston, Homer was apprenticed at nineteen to the lithographer J. H. Bufford and became a skilled draftsman, producing illustrations on the Civil War and other themes for *Harper's Weekly.* During these early years as an illustrator, Homer made wash drawings for translation into wood-block engravings, but his serious, sustained career as a watercolorist dates from 1873. During the rest of his life, he produced a body of watercolors that, while not tending to compete in human profundity with his paintings in the more substantial oil medium, nevertheless have the same extraordinary clarity and directness of approach.

It was Homer's supreme ability to simplify and to give virtually unshakable artistic structure to his observations that lifts even his seemingly incidental subject matter to the level of enduring art. Even in such an early and typically tender, gracefully washed picture as *Two Ladies* (plate 68), Homer has so adroitly constructed his seemingly informal design that the

WILLIAM STANLEY HASELTINE
Vahrn in Tyrol near Brixen (detail of plate 58)

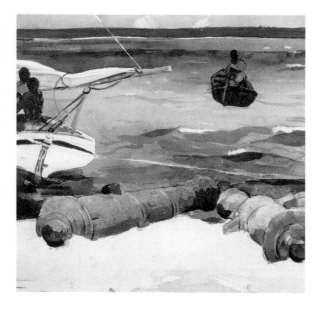

two figures would almost interlock, were they moved gently together. A crisscross of bonnet ribbons not only evokes the women's joined conversation but also constitutes a raised focal point that gives this little painting an exquisite sense of timeless suspension.

By 1881, when he departed for a two-year stay at Cullercoats, England, Homer had already developed a keen instinct for when to use transparent wash or gouache. While abroad, and up until 1884, he systematically employed the full battery of English academic methods, while producing watercolors whose scale was larger and whose detail was more finished than at any stage in his career. Then, apparently having abruptly decided "to develop a style of his own . . . which owes little or nothing to precedent,"[43] Homer embarked on the last and most glorious period of his watercolor activity. He now often started out with a loose preparatory sketch and then applied broad bands of transparent washes that frequently glow with the radiance of sapphires and emeralds (a master of color theory, Homer had carefully studied Michel Eugène Chevreul's *The Laws of Contrast of Color* [1859]).[44] His brushwork assumed a controlled calligraphic freedom, and he exploited any accidental effects with consummate artistic skill. This book features nine works from this late period. With the exception of *Channel Bass* (plate 77)—a handsome example of the many fish he painted, often with a "snapshot" vitality[45]—all are pieces "he considered his best work."[46]

During his three decades of watercolor production, Homer traveled widely, painting on vacation in the Adirondacks, New England, and Quebec; late in life, while settled in Maine, he also visited the Bahamas (1884–85, 1898–99), Bermuda (1899–1901), and Florida (1903–5). "I think Bahamas the best place I have ever found," remarked Homer,[47] and his watercolors of the islands are paeans to the beauty of the locale and its brilliance of light. Constantly in Homer one feels an empathy with natural forces, their energy and their movement. *Hurricane, Bahamas* (plate 69) seethes with nature's rage; houses cringe and huddle protectively as a dark, descending canopy of clouds creates an ever-mounting, almost excruciating sense of atmospheric pressure and, with it, the kind of pictorial and psychological tension that can give Homer's work a special urgency.

Throughout his career, Homer portrayed black people with dignity, and in the Bahamas watercolors he seems to view them as in harmony with nature.[48] In *Nassau* (plate 70) two cannons—relics of the Europeans' self-aggrandizing tendencies—lie impotent, in contrast to the serenity of the natives in their modest vessels and simple life pursuits. Boldly constructed in horizontal sections—a format Homer favored—this painting gives a stunning display of his luminous washes and deft use of untouched white paper to create reflected light, as is seen in such other Bahamian works as *Shore and Surf, Nassau* (plate 73) and *Sloop, Nassau* (plate 71).

Homer felt his Nassau and Bermuda watercolors were "as good work . . . as I ever did,"[49] yet some of his later Florida pieces are every bit as magnificent. About *Fishing Boats, Key West* (plate 75) Donelson Hoopes has written, "Homer's placement and balance of contrasting masses seems at the point of perfection."[50] *Taking On Wet Provisions* (plate 76)—a view of a vessel in Key West loading a cargo of rum—testifies to the fact that, at age sixty-seven, Homer was at the height of his artistic strength. This watercolor not only affirms Emerson's dictum that "all great actions have been simple, and all great pictures are," but also communicates another quality that often accompanies supreme artistic achievement: the feeling that the work actually created itself.

Unlike Homer, Thomas Eakins (1844–1916) achieved recognition only at the end of a career that suffered at first from public hostility and then from indifference. While Homer produced at least 685 watercolors, Eakins's total watercolor output consisted of about 30 pictures, most of them executed when he was a relatively young man, in the 1870s and early 1880s, with two dating about 1890.[51] Although these rare works—of which five are illustrated here—do not have the weighty impressiveness of his oils, they are just as splendidly composed and indeed have, as Lloyd Goodrich has said, a "greater refinement and subtlety,"[52] as well as added luminosity. Eakins's own opinion was apparently that his watercolors were as fine as his oils,[53] and, unlike many artists, including Homer, who produced watercolors as preludes to their work in oils, Eakins frequently executed oil studies in preparation for his watercolors.

Undoubtedly the most powerful, sensitive portraitist in the history of American art, Eakins possessed a logical turn of mind, having from youth been adept at mathematics, science, and perspective studies. He became America's first major painter-photographer, often using photographs as source material for his paintings. Born in Philadelphia, where he spent almost his entire life, Eakins early acquired a physician's knowledge of anatomy at the Jefferson Medical College. He also studied at the Pennsylvania Academy of the Fine Arts, for a time with Christian Schuessele (1824/26–1879) who, under the supervision of James Sommerville (d. 1899), created the extraordinary watercolor titled *Ocean Life* (plate 41). In 1866 Eakins went to Paris, where his teacher was Jean Léon Gérôme; during the almost four years he spent abroad, Eakins was also particularly impressed by Rembrandt, Diego Velázquez, and José Ribera. Eakins never returned to Europe and concentrated instead on the everyday subjects around him at home. He produced genre scenes, some of America's finest sporting pictures, and—particularly after 1885—a series of deeply probing, uncompromisingly realistic portraits, often of family and friends.

Preferring, as a watercolorist, transparent to opaque paint—and characteristically applying it not in broad sweeps of color but in carefully connected patches[54]—he could produce such luminous outdoor scenes as *Taking Up the Net* (plate 87), which was based on a photograph. *Young Girl Meditating* (plate 84) has an absorbing psychological flavor, augmented by the artist's treatment of the hands, an expressive feature crucial to many of his portraits (Eakins even once learned sign language).[55] *Home-spun* (plate 86), a remarkable 1881 watercolor that preceded a bas-relief of about 1883, also possesses an introspective quality that is characteristic of Eakins's work. A year before her death, Eakins's favorite sister, Margaret, posed for this piece, which is part of a series—perhaps inspired by the Centennial of 1876—in which women dressed in styles fashionable during earlier periods of American history are shown spinning, sewing, or knitting.[56]

One subject of special interest to Eakins was music. In his *Cowboy Singing* (page 88), the subject's hat suggests the shape of the banjo he plays, and, like a repeated musical motif, the instrument is half light, half dark in tone, as is the background, where, in the top right quadrant, brushstrokes flutter upward and outward almost as if to evoke the warbling of his song.

Two genre painters popular in their own time were Thomas Waterman Wood (1823–1903) and Enoch Wood Perry (1831–1915). Such was Wood's prestige that he served as

CHRISTIAN SCHUESSELE and
JAMES SOMMERVILLE
Ocean Life (detail of plate 41)

THOMAS EAKINS
Young Girl Meditating (detail of plate 84)

THOMAS WATERMAN WOOD
Reading the Scriptures (detail of plate 40)

president of the American Watercolor Society (1878–87) and the National Academy of Design (1891–99). Vermont-born and largely self-taught, Wood worked in New York as a portraitist, traveled to Canada, and later in Baltimore commenced painting genre scenes. After an 1858–59 European tour, he settled in the war-torn South and then in the late 1860s returned to New York. Wood did portraits but was most noted for his genre scenes. Strongly composed, *Reading the Scriptures* (plate 40) shows him at his unsentimental artistic best. A slanting broom handle and a rising diagonal line within the fireplace effectively frame the reader's intensely modeled head and repeat in reverse the converging temple lines of his glasses, whose lenses are gently echoed by the small hole at the top of the andiron.

"Mr. Perry at the present time occupies a position very nearly at the head of our *genre* painters," stated the New York *Art Journal* in July 1875.[57] Like Wood, Perry was an able portraitist, but his fame still rests on his genre work, which has been related to earlier English and Dutch traditions as well as to such nineteenth-century American masters as Francis Edmonds and William Sidney Mount. Boston-born, Perry went to Düsseldorf, Germany, in the early 1850s, studied in Paris with Edouard Manet's teacher Thomas Couture, and even briefly served as United States consul in Venice. He eventually established himself in New York, where the National Academy elected him an academician in 1869. Similar to Eakins's *Home-spun* (plate 86) in its portrayal of a domestic scene, Perry's admirably detailed *A Month's Darning* (plate 44) offers such subtle delights as the reappearance of the window sill's flowers across the pattern of the young woman's dress and the repetition of the chair back's parallel lines in the striped socks and rug below.

"I *hate* to paint portraits!"[58] once exclaimed the most spectacularly successful, eagerly sought-after portraitist of the late nineteenth century, John Singer Sargent (1856–1925). His internationalism provoked this thumbnail description: "an American born in Italy, educated in France, who looks like a German, speaks like an Englishman, and paints like a Spaniard."[59] Born in Florence of American parents, Sargent grew up in a cosmopolitan atmosphere and did not even visit America until 1876. Educated first in Rome and Florence, he later studied in Paris with C. E. A. Carolus-Duran and was influenced by Velázquez, Frans Hals, and such Impressionists as Manet and Claude Monet, whom Sargent visited at Giverny. Sargent's contacts with the Impressionists were later reflected in his vibrant, sun-filled, plein-air watercolors. Masterful oil portraits of the 1880s and 1890s, such as *Daughters of Edward Darley Boit, Asher Wertheimer,* and the *succés de scandale* of 1884, *Madame X,* are high-water marks of a portrait career in which psychological substance and sustained artistic resolution too often took second place to superficial dash. But what dash! As Christopher Finch has noted, "Sargent was too good a portraitist to falsify a [homely] likeness deliberately, but so deft was his brushwork that . . . [he] learned to create an illusion in which the beauty of the paint came to represent the beauty of the flesh."[60] His brilliant, virtuoso touch is perhaps nowhere better seen than in his watercolors. Though he painted some early in his life, most date from after 1900, when, increasingly dissatisfied with portraiture, he turned to watercolor as a favored medium. By this time he was enormously famous and wealthy, and produced watercolors for his own pleasure. Few of them are dated, but they often parallel his oils in their subject matter.

Sargent traveled extensively—from Europe, to North Africa, the Middle East, and

America—and he concentrated on, among other subjects, mountain streams, rock quarries, architectural views, bedouins, and Venetian lagoons. Sargent executed his watercolors quickly, usually in one session, and often under intense sunlight. He apparently treated his themes largely as "vehicles for statements about colour and light, and even paint itself."[61] Whereas in oil he could put marks of spontaneity on top of a more carefully built-up base, in watercolor his initial, underlying strokes had to be as sparkling and free as his last.[62] Working on dry as well as wet paper and sometimes relying on preliminary pencil indications, Sargent applied his bold, loose washes with sponges as well as broad brushes. Although he often allowed the white of the paper to create light, he would at times also use gouache to fortify his forms and establish highlights.[63] The magic of his art was transmitted by a hand whose calligraphy was almost musical (in fact, Sargent was also an accomplished pianist, good enough to play duets with Artur Rubinstein).[64]

The Metropolitan Museum possesses one of the largest, most important Sargent watercolor collections, culminating chronologically with work he did while visiting the battlefields during World War I (see plate 108) and incorporating ten paintings the artist himself selected for the museum. Twenty Sargent pieces are illustrated in this book, including a wide range of his favorite subjects and the full panoply of his technical wizardry. During his preparation of murals for the Boston Public Library, Sargent visited Italy and studied G. B. Tiepolo's ceiling decoration for the Palazzo Clerici, Milan, *The Course of the Sun's Chariot*. In its exhilarating lightness, sweep, and radiance of color, Sargent's *Tiepolo Ceiling—Milan* (plate 93) could pass for a nineteenth-century reincarnation of the great Rococo master's spirit. Sargent had an artistic love affair with Venice. *Giudecca* (plate 103) and *Venetian Canal* (plate 104) capture the city's shimmering poetry. The muted *Venetian Doorway* (plate 91) suggests not only Whistler's influence but the fact that—as opposed to the distant Venetian views of Turner and Canaletto—Sargent often moved close up,[65] putting the spectator in this case virtually on the entrance steps.

Travels in Spain inspired three of Sargent's most remarkable watercolors. A masterpiece of reflected light, *Spanish Fountain* (plate 96) is a chromatic tone poem. *Escutcheon of Charles V of Spain* (plate 97), showing an elaborately carved coat of arms on a garden wall of Granada's Generalife Palace, is almost blinding in the dazzle of light giving life to an architectural surface. *In the Generalife* (plate 98), which shows Sargent's sister Emily painting a watercolor, displays his psychological and formal powers. Here he perhaps ironically and a bit disquietingly dissolves the face of his presumably most important central figure—his sister, no less—and deflects attention instead upon the two flanking individuals. At the easel's back, a white spot provides a vital compositional accent.

Camp at Lake O'Hara (plate 105), dating from a camping trip to British Columbia in 1916, exemplifies Sargent's tendency, unusual among nineteenth-century American watercolorists, to create areas of sharp versus indistinct focus within a single painting—this in accordance with not only photography but also the dictates of retinal perception. By contrast, the impressionistically glittering *Mountain Stream* (plate 101), done at one of Sargent's choice sketching sites, Italy's Val d'Aosta, features what Christopher Finch—who describes this watercolor as Sargent's "masterpiece in the wilderness genre"—has termed an allover composition of equally important parts.[66]

JOHN SINGER SARGENT
Venetian Canal (detail of plate 104)

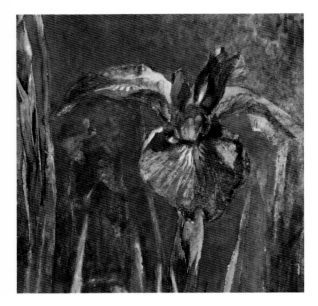

JOHN LA FARGE
Wild Roses and Irises (detail of plate 64)

The dynamically cropped *Tyrolese Crucifix* (plate 102) dates from the beginning of World War I and may reflect Sargent's foreboding mood at the time.[67] The picture is constructed on a series of V shapes, open against closed areas, and brushstrokes integrated to the degree that Christ's trickles of blood subtly reappear as hatchmarks across the left tree trunk. Sargent loved white, and the fluttering, triply bunched loincloth (repeating the tripartite structure of Christ's halo) permanently energizes His figure, whose bent knees are given further life by the complementary sharp angle of the lowermost twig suspended out in space at the painting's bottom right. *Tyrolese Crucifix* proclaims that not only was Sargent a master of the improvisatory sketch but that, at his best, he could be as powerfully architectonic as Winslow Homer.

"He was quite the most interesting person we knew,"[68] wrote Henry James of John La Farge (1835–1910), whose obituary in the *New York Tribune* carried the headline, "Was One of the Greatest Geniuses This Country Ever Produced—Revived Lost Arts."[69] Although today critical opinion is more guarded about La Farge and his uneven artistic accomplishments, in his own time he was regarded as even more imaginative and influential than Homer.[70] Born and raised in New York City by prosperous French emigré parents, the highly educated La Farge traveled widely and in France associated with such literary luminaries as Victor Hugo and Charles Baudelaire as well as with numerous leading painters. Not only did he become an acclaimed master of landscape, still-life, and figure painting but Sadakichi Hartmann regarded him as, along with Howard Pyle, one of the two principal creators of America's first "serious" school of illustration.[71] In 1876 La Farge began producing murals for H. H. Richardson's Trinity Church in Boston and became a pioneer in the Arts and Crafts revival of mural decoration and stained glass. He was also a celebrated author and lecturer and one of the founders of the Metropolitan Museum. In the late 1870s, La Farge began preferring watercolor to oil, and, as Theodore Stebbins has perceptively noted, "Perhaps most satisfying of all his work are his watercolors . . . in this medium he expressed himself more fluently and freely than in his more ambitious, larger works, which often appear labored."[72] Still lifes such as *Wild Roses and Irises* (plate 64) are among his freshest, most vibrant achievements; moreover, as William Gerdts and Russell Burke have asserted, "the variety of La Farge's still-life was unequaled by any other nineteenth-century flower painter."[73] Accompanied by his close friend the writer Henry Adams, La Farge visited Japan (1886), becoming one of America's first artists to do so, and the South Seas (1890–91), slightly preceding Paul Gauguin on his own celebrated journey there. On these trips, watercolor was La Farge's main vehicle of expression (see plates 65, 66).

As famous and riveting a watercolor as La Farge may ever have done—and one that recalls his often frightening, bizarre late-1860s illustrations—is *The Strange Thing Little Kiosai Saw in the River* (1897; plate 67), whose haunting quality is heightened by the juxtaposition of a fragile pink flower and the severed head. In La Farge's own words: "Kiosai, the famous Japanese painter, when a child, saw floating in the river, swollen by spring tides, something he took for the fairy tortoise, with long hair, of his nursery stories. He caught it and found it to be a head freshly cut off—some political murder. He brought it home to draw from, then wrapping it in the written prayers for the dead, gave it 'honorable water burial.' "[74]

The most famous of American expatriate artists was the flamboyant, eccentric, origi-

nal, and highly influential James McNeill Whistler (1834–1903), who in 1855 permanently left the United States and went first to Paris. There he became a member of the cultural avant-garde and established personal acquaintanceships with such writers as Théophile Gautier, Baudelaire, and Stéphane Mallarmé, as well as with the painters Gustave Courbet, Manet, Monet, and Edgar Degas (the only one of the artist's circle whose devastating wit could surpass Whistler's own). After his 1859 move to England, where he became embroiled in repeated controversy (including a financially ruinous lawsuit with Ruskin), Whistler was a leader in the late-nineteenth-century Aesthetic movement and a major advocate of art for art's sake. In his focus on the nonrepresentational properties of art and his choice of musical titles for his pictures (for example, *Symphony, Nocturne*), he even anticipated Wassily Kandinsky. A master of the subjective and suggestive, Whistler had a delicate touch and an economical style that found apt expression in his watercolors, most of which date from about 1880. *Scene on the Mersey* (plate 57) is characteristic of his gently brushed, minimalist work, which has parallels with the muted Tonalist paintings of the late-nineteenth-century American artists Thomas Dewing and John Twachtman. While at times Whistler's art could devolve into a too-formless, tasteful mode that lacked decisiveness and bite, one of the finest portraits he ever produced in any medium, *Lady in Gray* (plate 56), strikes us with the force of a Goya.

Two of Whistler's many American admirers, J. Alden Weir and Childe Hassam, were principal founding members of a primarily Impressionist group of New York and Boston artists known as The Ten, which flourished from 1898 to 1919. Weir (1852–1919), who belonged to an artistic family, studied at the Ecole des Beaux-Arts with Jean Léon Gérôme. Done about 1890, just before his full conversion to Impressionism—and recalling, in style and subject, his 1888 oil in the Metropolitan Museum, *Idle Hours*—the unfinished *Anna Dwight Weir Reading a Letter* (plate 89) tenderly depicts Weir's favorite sitter, his wife, who died some two years later. His admiration for Velázquez, watercolors, and still lifes is reflected in the objects forming a geometric grid against which Anna Weir's head is sensitively set (this picture-within-a-picture device also appears in works by Whistler, Degas, and Manet: for example, Manet's portrait of Emile Zola in the Musée d'Orsay, Paris).[75] In its precision of handling, Anna's head suggests yet another artist important to her husband: Hans Holbein.

Albert E. Gallatin, whose *American Water-Colourists* (1922) was the first book on watercolor published in this country, commented earlier in the century that "Childe Hassam is beyond any doubt the greatest exponent of Impressionism in America."[76] Born into a cultivated family of Dorchester, Massachusetts, Hassam (1859–1935) had already produced such masterful early Tonalist paintings as *Rainy Day, Boston* (1885) when, during a three-year sojourn in Paris, he became an ardent devotee of Impressionism. Hassam explored the watercolor medium during his entire career, producing in the early 1890s magnificent watercolor illustrations for his friend Celia Thaxter's book *An Island Garden* (1894). Although his strongest artistic period is often considered the 1890s, the Metropolitan Museum's two watercolors illustrated here (plates 119, 120), which both date from about 1916,[77] have the characteristic sparkle and underlying interest in structure that distinguish Hassam, at his best, from some other American Impressionists. In *Street in Portsmouth* (plate 120), for example, the blocklike masses, triangular motifs, and adjustment of tree limbs into parallel alignment with roof lines recall the structural assertiveness of Camille Pissarro and Paul Cézanne.

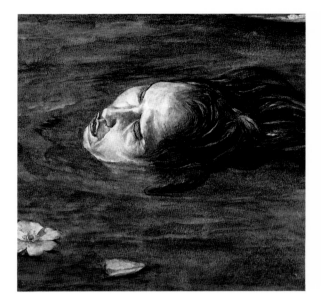

JOHN LA FARGE
The Strange Thing Little Kiosai Saw in the River (detail of plate 67)

JANE PETERSON
Parade (detail of plate 139)

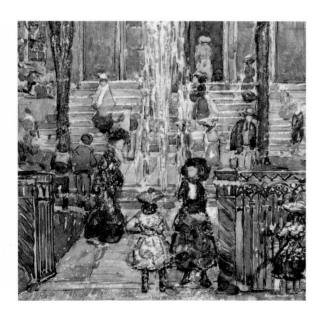

MAURICE PRENDERGAST
Court Yard, West End Library, Boston
(detail of plate 114)

Like Hassam, Gifford Beal (1879–1956) developed into an Impressionist after Tonalist beginnings. A Princeton graduate who studied at Shinnecock, Long Island, with William Merritt Chase and at New York's Art Students League (whose president he would become, serving from 1914 to 1929), Beal worked primarily in pastel, gouache, and watercolor. He often produced vibrant pictures of such subjects as parks, circuses, landscapes (see plate 140), and scenes of pleasant, everyday life beside the Hudson River.

The watercolorist Jane Peterson (1876–1965), a fellow of the National Academy of Design and instructor at the Art Students League from 1914 to 1919, also carried an Impressionist style into the twentieth century. Peterson was considered one of New York City's leading women artists during her life, and her career peaked in the 1920s. Her *Parade* (plate 139) suggests stylistic affinities with Maurice Prendergast and Hassam's famous Flag series, dating from the years around World War I.[78]

Probably the first significant American modernist group of the early twentieth century was The Eight, composed of eight artists who exhibited together in 1908 at New York's Macbeth Gallery. This show was a landmark revolt against the turn-of-the-century conservative art establishment, as exemplified by the National Academy of Design. Spearheaded by Robert Henri, who advocated a vigorous art-for-life's-sake, realistic approach, the group included three important painters illustrated in this volume: Maurice Prendergast, Arthur B. Davies, and George Luks. Prendergast and Davies actually had stylistically little in common with the boldly brushed realism that characterized the art of five other group members (Luks, Henri, John Sloan, William Glackens, and Everett Shinn) who were later dubbed the Ashcan School.

One of the finest watercolorists in the history of American art, Maurice Prendergast (1858–1924) was born in Newfoundland, moved to Boston as a child, and resided there with his brother Charles until they in 1914 settled in New York—by which point Maurice had made six trips abroad that exerted a strong formative impact on his art. Having learned much from European artists ranging from the Renaissance painter Vittore Carpaccio, to the nineteenth-century muralist Pierre Puvis de Chavannes, the Impressionists, Paul Signac, Cézanne, and the Nabis, Prendergast became perhaps the earliest American artist whose work continually manifested a sophisticated assimilation of Post-Impressionist concerns with color, visual rhythms, and the compression of space. His early training as a show-card letterer undoubtedly contributed to the accomplished calligraphic brushwork that informs and helps unify his paintings. Although he began using oils to a considerable degree after 1904, he remained primarily a watercolorist. His style generally incorporated delicately applied patches of subtly interconnected color that often create an exquisite mosaic or tapestry-like decorative effect, suggesting in part a Pointillist influence. One of Prendergast's most acclaimed watercolors, *Piazza di San Marco* (plate 113), not only reflects his love for the movement and color of crowds but also features a Post-Impressionist upward-receding format[79] and a vibrant tension between illusionistic depth and the assertion of the picture plane. The horizontal bands as well as increased flattening of figures and space that characterize Prendergast's later work are seen in *Court Yard, West End Library, Boston* (plate 114), with its typically refined adjustments of pictorial emphases.

A paradoxical artist, Arthur B. Davies (1862–1928) may be best known today as a

principal organizer of New York's 1913 Armory Show, for which he helped select the avant-garde European entries. In much of his own art, however, he withdrew into an idyllic, mythic world tinged with late-nineteenth-century symbolism. After the Armory Show, he briefly experimented with Cubism but then reverted to a more romantic mode. Davies produced numerous watercolors, and toward the end of his life French and Italian landscapes became favorite subjects. *Mountains* (plate 121) recalls Cézanne's Mont Sainte-Victoire series.

Of all these members of The Eight who worked in a realist style, George Luks (1866–1933), originally a newspaper illustrator, painted with the greatest gusto. He has been called "the most interesting watercolorist belonging to the 'Ashcan' wing."[80] Regarding works like *David Parrish: Interior of a Tavern* (plate 124), which may have been painted in the Pennsylvania coal-mining region of Luks's youth,[81] Stebbins has noted that the artist employed watercolor to produce blunt, "energetic, almost frightening pictures of working-class Americans. This use of watercolor . . . was highly innovative in America."[82] Luks also created a series of remarkably controlled, expressionist landscape watercolors, such as *The Brook* (plate 122), which, with its dynamic swirls and bold color, bears comparison with the paintings of Vincent van Gogh and the Fauves.[83]

Illustration has long been an important, though perhaps a too little respected, component of American art, and many of this nation's most celebrated artists were illustrators at some point. Among the late-nineteenth-century and early-twentieth-century painters represented in this book who worked seriously as illustrators are Fenn, Homer, La Farge, Hassam, Prendergast, Robert Blum, F. Luis Mora, Joseph Christian Leyendecker, Maxfield Parrish, Arthur G. Dove, and Edward Hopper.

A successful figure painter, etcher, and illustrator, Robert Blum (1857–1903), together with his friend William Merritt Chase, was probably one of the two most highly regarded American pastelists of his time. Blum was just as accomplished as a watercolorist. Sometimes called "Blumtuny" because of his close adherence to the style of the Spanish artist Mariano Fortuny, Blum began his career as an illustrator.[84] He is considered to have been, in the 1870s, one of a "select group" of artists—including Edwin Austin Abbey, Arthur Burdett Frost, Howard Pyle, and Charles S. Reinhart—who launched the "Golden Age of American Illustration."[85] In 1890 *Scribner's* magazine sent Blum to Japan to illustrate a set of articles. *Street Scene in Ikao, Japan* (plate 111), one product of that two-and-a-half-year trip, shows his deft, lively brushwork, superb skill at integrating a diversity of elements, and possible use of photography to freeze human action.[86]

Another prominent illustrator, figure painter, and etcher was the Uruguayan-born, American-trained F. Luis Mora (1874–1940), who illustrated numerous books and periodicals, served as vice-president of the Art Students League, and painted many notable portraits, including one of President Warren G. Harding, which hangs in the White House.[87] Reproduced here are two skillful watercolors, painted when the artist was only in his twenties, featuring his father in his studio (plate 136) and Mrs. F. Luis Mora and her sister (plate 137).

Though not technically an illustrator, George Overbury "Pop" Hart (1868–1933) produced many pictures of an illustrative nature, on subjects ranging in theme from social realism to anecdote. After spending some years in the New York City region painting signs

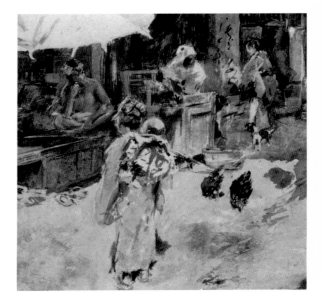

ROBERT BLUM
Street Scene in Ikao, Japan (detail of plate 111)

and stage sets, Hart became an artist who wandered the world—from Europe, to Mexico, to the South Seas—as he recorded his observations in his favorite mediums of print, pastel, and watercolor. One of his most powerful works is *125 Street Ferry* (plate 128), which superbly captures Manhattan's gritty intensity.

A commercial illustrator who stood at the pinnacle of his profession, Joseph Christian Leyendecker (1874–1951) came as a child from Germany to America, where he created the Arrow Shirt Collar Man, images of elegance for the men's clothier Hart, Schaffner & Marx, and more than three hundred magazine covers for such major publications as *Collier's* and the *Saturday Evening Post*. His stylish, turn-of-the-century *At Tea* (plate 138) crackles with a crisp virtuosity.

In 1989 the *Christian Science Monitor's* review of Maxfield Parrish's first New York show in more than twenty years called him "probably the best-known and best-loved American painter/illustrator of the early 20th century." In 1936 *Time* had asserted that "as far as the sale of expensive color reproductions is concerned, the three most popular artists in the world are van Gogh, Cézanne, and Maxfield Parrish."[88] In countless storybook illustrations, in romantic paintings of women that resurrected the languid academic style of such late-nineteenth-century painters as Sir Lawrence Alma-Tadema and Albert Moore,[89] and particularly in the stunning, luminous landscapes upon which he almost exclusively concentrated after 1935, Parrish (1870–1966) created often exotic, always enchanted worlds, frequently glowing with his distinctive "Maxfield Parrish blue."[90] Parrish developed a superb, detailed technique coupled with a sure sense of design, as can be seen in his early *Figure* (plate 135), where, from arc of hand to arch of foot he echoes the curving sweep of drapery and choreographs a sustained pattern of movement.

Of John Marin (1870–1953), critic Albert E. Gallatin said, "As a water-colourist he stands supreme."[91] Before becoming a painter, Marin in the early 1890s was a practicing architect; he then turned seriously to the study of art and lived abroad, primarily in Paris, from 1905 to 1910. Although he tended to downplay the role of influences, his dynamic fragmented style—while distinctively his own—would also come in various ways to reflect Cézanne, Cubism, Futurism, and the Orphism of Robert Delaunay (for example, Delaunay's Eiffel Tower series). By 1910 Marin was permanently settled in America and had gained the enthusiastic support of that legendary promoter of European and American modernist talent, Alfred Stieglitz; his famous New York gallery 291 gave the artist a one-man show that year, effectively launching Marin's career. An anti-intellectual painter who drew greatly on his emotions and intuitions, Marin was fascinated by the dynamism of New York and the potent forces of nature. "Taut, taut/loose and taut/electric/staccato"—this Marin poem conveys the pulsing, abstract, shorthand flavor of much of his art, crucial to which is a feeling of tension in a vibrant state of resolution.[92] As he wrote, "I see great forces at work: great movements; the large buildings and the small buildings; the warring of the great and small; influences of one mass on another greater or smaller mass. . . . While these powers are at work pushing, pulling, sideways, downwards, upwards, I can hear the sound of their strife and there is great music being played. And so I try to express graphically what a great city is doing. Within the frames there must be a balance, a controlling of these warring, pushing, pulling forces."[93] When Marin painted a landscape, mountain, or ocean, the same preoccupation with control

prevailed. Working rapidly, sometimes with both hands,[94] and virtually attacking his surfaces, Marin typically eschewed body color and painted broadly on dry, heavy, textured paper. He struck his colors down side by side with, at times, an almost brutal intensity that anticipated the methods of Abstract Expressionism. Marin's watercolors from about 1910 to the mid-1920s have been termed his finest,[95] and his paintings illustrated here not only belong to that period but exemplify some of his principal subjects: New York City (plates 131, 134), boats seen close up (plate 132), and the landscape of Maine (plates 129, 130, 133), where he regularly summered after 1914. Perhaps most impressive of all of these works is *Pertaining to Stonington Harbor, Maine, No. 4* (plate 133), with its magnificent orchestration of revolving, interpenetrating planes and effective use of a frame-within-a-frame, a characteristic Marin device that in some paintings can suggest the shaped canvases of later twentieth-century art.

"John Marin and I drew our inspiration from the same source, French modernism. He brought his up in buckets and spilt much along the way. I dipped mine out with a teaspoon but I never spilled a drop."[96] This famous comment attributed to Charles Demuth (1883–1935) "has the stamp of [his] art: crisp, elegant, cool."[97] Aristocratic, sophisticated, witty, and gentle, this financially independent esthete spent some time abroad as a young man, mostly in Paris. After returning to New York in 1914, he was taken under Stieglitz's wing and also joined collector Walter Arensberg's New York salon, which included Marcel Duchamp. Demuth, whose art, like Duchamp's, often contained ambiguous connotations and sexual allusions, considered the latter's *The Bride Stripped Bare by Her Bachelors, Even (The Large Glass)* "the greatest picture of our time."[98] Demuth also admired Japanese prints and sipped from the well of Whistler, Auguste Rodin, Cézanne, and Cubism. Although he is widely recognized for his pre–Pop Art "poster portrait" of the poet William Carlos Williams, *I Saw the Figure 5 in Gold* (1928), and did some industrial-architectural scenes in tempera and oil (*My Egypt*, 1927), Demuth is critically most noted for his many watercolors. In 1922 Gallatin stated something that holds just as true today, "In the rendering of flowers no other American has equalled him."[99] With a combination of fragile pencil lines and often delicately blotted washes, Demuth created exquisitely hued flowers and fruit that breathe in dialogue with the white sheets into which their hard-edged or muted forms sensitively fade (plate 148).

In 1916–17 (as Homer had done earlier), Demuth made a trip to Bermuda, and the pieces he produced there largely mark the beginning of his personal adaptation of Cubism. Containing the Futurist-related beams of light that would cut across so many of his later architectural motifs, *Bermuda No. 2 (The Schooner)* (plate 146) has a typical, pale-tinted, crystalline refinement. Suspended, aloof in its icicles of light, Demuth's vessel presents a stylistic contrast to Marin's two-master with its raw expressionist rigging (see plate 132) and resembles, instead, Lyonel Feininger's *Side-Wheeler* (1913). Possessing Demuth's characteristic combination of fragility and strength, *Bermuda No. 1, Tree and House* (plate 145) is beautifully designed. It also raises the provocative question to what extent sexual imagery of not only an overt but a covert nature informs his work. Commenting on a highly similar picture, *Trees and Barns, Bermuda* (1917; Williams College Museum of Art), Emily Farnham discovered in a foreground tree's branches a similarity to "the limbs of a male figure."[100] One wonders, therefore, if in *Bermuda No. 1, Tree and House* it is not valid to suggest that in the spread-eagled

CHARLES DEMUTH
Bermuda No. 1, Tree and House
(detail of plate 145)

tree trunks and their gaping central aperture (to which Demuth draws attention by inscribing his initials, "C. D.," and "Bermuda" tantalizingly just inside and just outside the rim) we have a fascinating example of cloaked male and/or female imagery, particularly accented by the rising shafts of the buildings above. Not only are these 1917 Bermuda pictures significant in Demuth's oeuvre, but, to cite Sherman Lee, "[The 1916–18] landscapes, with the narrative and circus pictures, . . . are of great importance in modern art and they should be considered equally with the work of men such as Braque, Gris, Ozenfant, Feininger, Klee, and Picasso."[101]

Another Stieglitz protégé, Arthur G. Dove (1880–1946), sought during most of his life to evoke the mystery, mood, and vital force of nature through a highly personal, organic, abstract style. After working for several years as a successful illustrator, he visited Paris from 1907 to 1909 and absorbed, among other influences, that of the Fauves. Back in America, he in 1910 produced a series of abstractions that, while grounded in nature, as most of his art would be, gave him a claim to being not only one of the century's first abstract artists but also an important precursor of post–World War II Abstract Expressionism. Dove painted mainly in oil and produced most of his watercolors late, in the 1930s. These are often quite small in size and represent self-contained studies for other paintings. Done in washes alone or in combination with thickly inked pen lines, the watercolors are typically executed with what seems to be an ingenuous, childlike directness. Often whimsical, but almost always suggesting a concern for essences, Dove's warm, gentle, rhythmic art frequently carries a possible multiplicity of meanings.[102] Although the Stieglitz group, of which Dove was a member, valued "instinct," the lessons of Freud, and a spirit of rebellion against traditional restraints, there was "a period of gestation before sexual imagery appeared in Dove's art. Then, in 1935, it appears full-blown."[103] Closely related to his identically titled large oil in the Metropolitan Museum, *Goat* (1935; plate 141) features not only an inventive interweaving of animal, landscape, and halo-like blue sky, but also what may be an intriguing mixture of male and female symbolism (in the apparent X-ray view of a womb and baby goat that ride pictorially just above what has been called an erect phallus).[104] Quivering with potential sexuality, *Tree (41)* (1935; plate 142) suggests comparisons with such sexually charged Dove oils as *Moon* (1935) and with Georgia O'Keeffe's erotically provocative, 1930 Jack-in-the-Pulpit series.

Often considered, with Marin, one of the two greatest twentieth-century American watercolorists, Charles Burchfield (1893–1967) developed a unique style of compelling fantasy and communicative power. Utilizing opaque as well as transparent paint, he devised a bold technique that gave his watercolors—often initially large in size and frequently enlarged and reworked later—a feeling of breadth and substance approaching that of oil painting.[105] "For me," Burchfield said, "the only divine reality is the unspeakable beauty of the world as it is."[106] Inspired by vivid childhood memories of the outdoors, during his long life he managed to communicate not only the changing conditions, rhythms, and moods of nature, but also her sounds (titles like *The Insect Chorus* and *Clatter of Crows in Spring* suggest an ear as well as an eye keenly attuned to the natural world).[107] His works range in spirit from the joyful to the macabre and have provoked comparison with the animated cartoons of Walt Disney. Burchfield considered "1917 to be the 'Golden Year' of my career."[108] Reflecting his mystical

empathy with the woods and buzzing with life, *Dandelion Seed Balls and Trees* (1917; plate 150) seems electrified by what would be the artist's lifelong pantheistic fervor.

One of the many modernist artists who felt a close connection between art and music, the expressionistic landscape painter Oscar Bluemner (1867–1938) once stated, "I would be a composer, but being all retina, I saw it all as color."[109] "Landscape," Bluemner also once said, "is *semiself portraiture*."[110] German-born, Bluemner came to America in 1892 and practiced with increasing disillusionment as a licensed architect in Chicago and New York. After a 1912 trip to Europe, and with Stieglitz's encouragement, he turned fully to painting. An exhibitor in the 1913 Armory Show and the 1916 Forum Exhibition of Modern American Painters, he had his first important museum exhibit only posthumously, in 1988.[111] In watercolor or oil, he painted many scenes of the small towns of Long Island and New Jersey, often personalizing his unpopulated landscapes with buildings. In 1924 Bluemner embarked on what was to become a special series of fifty-nine watercolors emphasizing the expressive force of color.[112] Two powerfully composed pieces from this set are the urgently rhythmic, chromatically intense *Glowing Night* (1924; plate 125) and the haunting *Flag Station, Elizabeth, New Jersey* (1925; plate 126), with its swaying objects, enigmatic space, and effective juxtaposition of voids against the hermetic solidity of windowless architecture. This painting seems inexorably to pull us inward into communion with a luminous beyond. A year later, following his wife's traumatizing death, Bluemner wrote that "between me and all things lies death, in the death of space and time all things exist, all life lives."[113] Some of the watercolors he subsequently made, before committing suicide, include a series entitled Suns, Moons, Etc.—Facts and Fancy—Strains or Moods, suggesting the mystical celestial images painted by his friend Arthur Dove.[114]

"My aim," wrote Edward Hopper (1882–1967), "has always been the most exact transcription possible of my most intimate impressions of nature."[115] Perhaps this century's foremost American realist painter, Hopper had largely developed his characteristic style by 1923, during which year he began working in watercolor. Shunning white body color for highlights, he typically applied overlapping transparent washes steadily across white paper, which in places he strategically left entirely or almost untouched. Close to his oils in feeling, Hopper's watercolors also treat similar subject matter, an important exception being that they rarely feature the human figure. He cast his expressively objective eye upon Victorian mansions, rural roads, the New England coast, and New York's drab old masonry facades and empty streets. Like Homer—whom he admired and with whom numerous other parallels can be drawn[116]—Hopper was a master of geometric clarity and formal simplification. Solitude, loneliness, alienation, isolation—these are all characteristic of Hopper's art, as is his preoccupation with sharply revealing light and solid forms, often placed against an "empty space [that] becomes the carrier of wordless feeling."[117] These qualities seem fully embodied in his famous *House of the Fog Horn, I, Two Lights, Maine* (plate 144). Adopting his frequent worm's-eye vantage point, Hopper here takes what was by photographic record a stumpy, commonplace structure and injects it with mystery and solitary power.[118] Growing out from the barrier-like rock formation before us, the building rises to the vertical climax of its chimney, beside which, at artistically the most potent interval, Hopper places his pictori-

CHARLES BURCHFIELD
Dandelion Seed Balls and Trees
(detail of plate 150)

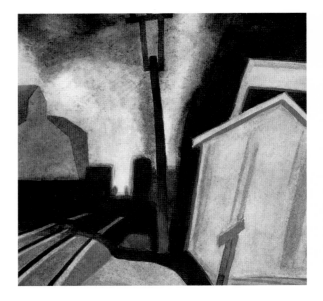

OSCAR BLUEMNER
Flag Station, Elizabeth, New Jersey
(detail of plate 126)

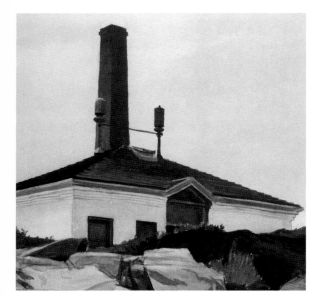

EDWARD HOPPER
House of the Foghorn, I, Two Lights, Maine
(detail of plate 144)

ally crowning touch, the American flag. While its blue box of stars echoes the compactness of the structure, the flag's gently rippling stripes pick up the horizontal striations under the roof line and carry us rightward out of the picture.

E. P. Richardson once remarked that in art "the qualities to seek are imaginative force and intensity. . . . The aim is freshness."[119] As Homer, Sargent, and so many other artists in this book bear witness, there is perhaps no better medium for the communication of freshness—or, indeed, of life itself—than watercolor, masterfully handled.

ACKNOWLEDGMENTS AND NOTES

I would like to express my deepest appreciation to the Oklahoma Foundation for the Humanities and to the University of Oklahoma for several generous research grants in connection with the preparation of my essay in this publication. At the University of Oklahoma my special thanks go to Kenneth L. Hoving, Eddie Carol Smith, and the Research Council. I would also like to thank the following cherished people for their invaluable help and inspiration: Tatiana Koshkin-Youritzin; Anthony Wentworth Morss; S. Lane Faison, Jr.; and Cynthia Lee Kerfoot.

1. Quoted in Lloyd Goodrich, *American Watercolor and Winslow Homer* (Minneapolis, 1945), p. 45.
2. Quoted in Kathleen A. Foster, "The Pre-Raphaelite Medium: Ruskin, Turner, and American Watercolor," in Linda S. Ferber and William H. Gerdts, *The New Path: Ruskin and the American Pre-Raphaelites* (exhib. cat., Brooklyn Museum, 1985), p. 79.
3. Sherman E. Lee, "A Critical Survey of American Watercolor Painting" (Ph.D. diss., Western Reserve University, 1941), p. 2. This monumental, highly useful study was the first extensive scholarly exploration of American watercolor painting.
4. Ibid., p. 12.
5. Donelson F. Hoopes, *American Watercolor Painting* (New York, 1977), p. 11.
6. Theodore E. Stebbins, Jr., *American Master Drawings and Watercolors: A History of Works on Paper from Colonial Times to the Present* (New York, 1976), p. 54. This major study, which has been extremely valuable to me in the preparation of this essay, is, regrettably, no longer in print.
7. In the 1946 *Annual Report of the Museum of the City of New York* (p. 13), Grace M. Mayer called *Collect Pond* "probably the most wholly delightful of all New York views."
8. George C. Groce and David H. Wallace, *The New-York Historical Society's Dictionary of Artists in America, 1564–1860* (New Haven and London, 1957), p. 98.
9. John Gross, "Images of an Earlier America—from a Spot of Cannibalism to Exquisite Interiors," *New York Times*, 13 November 1988, section H, p. 40. Bennett did some engravings after paintings by George Harvey, whose work initiated a fundamental stylistic shift in American watercolor in the 1830s. Harvey popular-

ized the English technique of closely juxtaposing a myriad of colored dots—thereby intensifying color, luminosity, and atmospheric effects. See Stebbins, *American Master Drawings*, p. 143; and Christopher Finch, *American Watercolors* (New York, 1986), p. 72.

10. Donald A. Shelley, "William Guy Wall and His Watercolors for the Historic 'Hudson River Portfolio,'" *New-York Historical Society Quarterly*, vol. 31 (January 1947), p. 38.

11. Finch, *American Watercolors*, p. 72.

12. Luke Vincent Lockwood, "The St. Memin Indian Portraits," *New-York Historical Society Quarterly Bulletin*, vol. 12 (April 1928), p. 6.

13. A. Hyatt Mayor, *Prints and People: A Social History of Printed Pictures* (New York, 1971) n.p.; see page on which figure 292 appears.

14. Schools for the instruction of drawing and watercolor painting proliferated during the nineteenth century; in 1791 Archibald Robertson and his brother Alexander founded an important early one, the Columbian Academy in New York.

15. On the subject of this watercolor portrait, see Albert Ten Eyck Gardner, *History of Water Color Painting in America* (New York, 1966), p. 33. The quotation from Herman Melville's *Pierre; or, The Ambiguities*, ed. Henry A. Murray (New York, 1949), is on pp. 83–84. See also p. 454 n. 83.30.

16. In this opinion, Svinin found a formidable supporter in Alexis de Tocqueville, who remarked in 1835: "There are at the present time two great nations in the world, which . . . seem to tend towards the same end. I allude to the Russians and the Americans. . . . Their starting-point is different and their courses are not the same; yet each of them seems marked out by the will of Heaven to sway the destinies of half the globe." See de Tocqueville, *Democracy in America*, English trans. ed. Phillips Bradley (New York, 1953), vol. 1, p. 434.

17. *Picturesque United States of America, 1811, 1812, 1813*, ed. Avrahm Yarmolinsky, intro. R. T. H. Halsey (New York, 1930).

18. Quoted in Frank Weitenkampf, "As Early Foreign Artists Saw Us," *New-York Historical Society Quarterly*, vol. 32 (October 1948), p. 274.

19. Weitenkampf, "Early Foreign Artists," p. 274.

20. *101 American Primitive Water Colors and Pas-tels from the Collection of Edgar William and Bernice Chrysler Garbisch*, foreword by John Walker, text by William P. Campbell (exhib. cat., National Gallery of Art, Washington, D.C., 1966), p. 7. See also p. 13.

21. Frank O. Spinney, "Joseph H. Davis," in Jean Lipman and Alice Winchester, eds., *Primitive Painters in America 1750–1950* (reprint, New York, 1971), p. 100. See also pp. 97, 102, 105.

22. Readers interested in Davis should also consult the following: Arthur and Sybil Kern, "Joseph H. Davis: Identity Established," *The Clarion*, Summer 1989, pp. 45–53; and Esther Sparks, "Joseph H. Davis," in Jean Lipman and Tom Armstrong, eds., *American Folk Painters of Three Centuries* (New York, 1980), p. 69.

23. Jean Lipman, *American Primitive Painting* (London, 1942), p. 8.

24. Finch, *American Watercolors*, pp. 21, 25. See also Marjorie B. Cohn, *Wash and Gouache: A Study of the Development of the Materials of Watercolor* (Cambridge, Mass., 1977), pp. 16–20.

25. Gardner, *History of Water Color Painting*, p. 8. See also p. 7.

26. Stebbins, *American Master Drawings*, pp. 146–47.

27. Ibid., p. 148.

28. Foster, "Pre-Raphaelite Medium," p. 81.

29. Helen A. Cooper, *Winslow Homer Watercolors* (New Haven and London, 1986), p. 18.

30. Stebbins, *American Master Drawings*, pp. 169–70.

31. See "Pre-Raphaelite Medium," p. 79, where Foster also notes that by 1860 the adherents of the Hudson River School "rarely used watercolor at all."

32. Linda S. Ferber, *William Trost Richards, American Landscape and Marine Painter, 1833–1905* (exhib. cat., Brooklyn Museum, 1973), p. 24.

33. Foster, "Pre-Raphaelite Medium," p. 93. See also pp. 94, 189, 287.

34. Quoted in Kenneth W. Maddox, "William Trost Richards," *Arts*, vol. 60, no. 9 (May 1986), p. 105.

35. Ferber, *William Trost Richards*, p. 24.

36. Quoted in Ferber, *William Trost Richards*, p. 32.

37. Stebbins, *American Master Drawings*, pp. 153–54.

38. Natalie Spassky et al., *American Paintings in the Metropolitan Museum of Art*, vol. 2 (New York, 1985), p. 398.

39. Stebbins, *American Master Drawings*, pp. 235–36.

40. Ibid., p. 233.

41. Doreen Bolger Burke, *American Paintings in the Metropolitan Museum of Art*, vol. 3 (New York, 1980), p. 310.

42. Goodrich, *American Watercolor and Winslow Homer*, p. 23.

43. Hereward Lester Cooke, "The Development of Winslow Homer's Water-Color Technique," *Art Quarterly*, vol. 24, no. 2 (Summer 1961), p. 190.

44. On Homer's study of Chevreul's work, see Cooper, *Winslow Homer Watercolors*, pp. 28–29; on his "refined understanding of color theory and of the interaction of color," see pp. 208, 210.

45. Finch, *American Watercolors*, p. 120.

46. Bryson Burroughs, in *Metropolitan Museum of Art Bulletin*, vol. 6 (January 1911), p. 2.

47. Quoted in Cooper, *Winslow Homer Watercolors*, p. 208.

48. Ibid., p. 212.

49. Quoted in Cooper, ibid., p. 226. See also p. 227 n. 17.

50. Donelson F. Hoopes, *Winslow Homer Watercolors* (New York, 1969), p. 76.

51. Cooper, *Winslow Homer Watercolors*, p. 16; Donelson F. Hoopes, *Eakins Watercolors* (New York, 1971), p. 12.

52. Lloyd Goodrich, foreword to Hoopes, *Eakins Watercolors*, p. 6.

53. Ibid., p. 7.

54. Finch, *American Watercolors*, p. 105.

55. Hoopes, *Eakins Watercolors*, p. 15.

56. Goodrich, foreword to Hoopes, *Eakins Watercolors*, p. 6.

57. Quoted in Spassky et al., *American Paintings in the Metropolitan*, p. 344.

58. Richard Ormond, *John Singer Sargent: Paintings, Drawings, Watercolors* (London, 1970), p. 88.

59. *Britannica Encyclopedia of American Art*, ed. Milton Rugoff, s.v. "Sargent, John Singer," by David W. Scott.

60. Finch, *American Watercolors*, p. 159.

61. Ormond, *John Singer Sargent*, p. 69.

62. Carter Ratcliff, *John Singer Sargent* (New York, 1982), p. 213.

63. On Sargent's watercolor technique, see Or-

mond, *John Singer Sargent*, p. 70. See also Natalie Spassky, *John Singer Sargent: A Selection of Drawings and Watercolors from The Metropolitan Museum of Art* (exhib. cat., Metropolitan Museum of Art, New York, 1971), n.p.

64. Donelson F. Hoopes, *Sargent Watercolors* (New York, 1970), p. 12.

65. Finch, *American Watercolors*, p. 164.

66. Ibid., p. 169.

67. Ormond, *John Singer Sargent*, p. 77.

68. Henry James, *Notes of a Son and Brother* (New York and London, 1914), p. 85.

69. "John La Farge Dead," *New York Tribune*, 15 November 1910. Quoted in Henry Adams, "The Mind of John La Farge," in Henry Adams et al., *John La Farge* (New York, 1987), p. 70. According to Adams, p. 77 n. 149, this unsigned obituary "was undoubtedly written by Royal Cortissoz."

70. John R. Lane and Charles C. Eldredge, foreword to Henry Adams et al., *John La Farge*, p. 7.

71. Henry Adams, "John La Farge," in *American Drawings and Watercolors in the Museum of Art, Carnegie Institute* (Pittsburgh, 1985), p. 64.

72. *Britannica Encyclopedia of American Art*, s.v. "La Farge, John," by Theodore E. Stebbins.

73. William H. Gerdts and Russell Burke, *American Still-Life Painting* (New York, 1971), p. 187.

74. John La Farge, *Painting, Studies, Sketches, and Drawings: Mostly Records of Travel 1886 and 1890–91* (exhib. cat., Durand-Ruel Galleries, New York, 1895), p. 4, no. 76.

75. Kathleen Foster et al., "American Drawings, Watercolors, and Prints," *Metropolitan Museum of Art Bulletin*, vol. 37, no. 4 (Spring 1980), p. 50.

76. Quoted in William H. Gerdts, *American Impressionism* (New York, 1984), p. 91.

77. Lee, "Critical Survey," p. 224, dates *The Brush House* (plate 119) to the year 1906.

78. Charlotte Streifer Rubinstein, *American Women Artists from Early Indian Times to the Present* (Boston and New York, 1982), pp. 179–80.

79. Burke, *American Paintings in the Metropolitan*, p. 339.

80. Finch, *American Watercolors*, p. 238.

81. The Metropolitan Museum of Art Archives lists the source for this information as Miss Antoinette Kraushaar.

82. Stebbins, *American Master Drawings*, p. 288.

83. Ibid., p. 289.

84. Matthew Baigell, *Dictionary of American Art* (New York, 1982), p. 42.

85. Walt and Roger Reed, *The Illustrator in America 1880–1980: A Century of Illustration* (New York, 1984), p. 41.

86. Burke, *American Paintings in the Metropolitan*, p. 304.

87. "F. Luis Mora Dies," *Art Digest*, 1 July 1940, p. 24.

88. Theodore F. Wolff, "Parrish: An Illustrator Deserving More Respect," *Christian Science Monitor*, 3 March 1989; *Time*, 17 February 1936, quoted in the foreword to Coy Ludwig, *Maxfield Parrish* (New York, 1973), n.p.

89. Kenneth Neal, "Frederick Maxfield Parrish," in *American Drawings and Watercolors in the Museum of Art, Carnegie Institute* (Pittsburgh, 1985), p. 107.

90. Reed, *Illustrator in America*, p. 67.

91. Albert Eugene Gallatin, *American Water-Colourists* (New York, 1922), p. 17.

92. Quoted in Sheldon Reich, *John Marin: A Stylistic Analysis and Catalogue Raisonné*, Part 1 (Tucson, Ariz., 1970), p. 174.

93. Quoted in ibid., pp. 54–55.

94. *John Marin by John Marin*, ed. Cleve Gray (New York, 1977), p. 11.

95. Finch, *American Watercolors*, p. 189.

96. Quoted in Henry Geldzahler, *American Painting in the Twentieth Century* (New York, 1965), p. 138. Regarding this quotation's authenticity, see Barbara Haskell, *Charles Demuth* (exhib. cat., Whitney Museum of American Art, New York, 1987), pp. 51, 63 n. 9.

97. S. Lane Faison, Jr., *Handbook of the Collection, Williams College Museum of Art* (Williamstown, Mass., 1979), n.p. (see entry for plate 52).

98. Haskell, *Charles Demuth*, p. 59.

99. Gallatin, *American Water-Colourists*, p. 23.

100. Emily Farnham, "Charles Demuth's Bermuda Landscapes," *Art Journal*, vol. 25, no. 2 (Winter 1965–66), p. 133.

101. Lee, "Critical Survey," pp. 297–98.

102. Daniel Catton Rich remarked in *Paintings and Water Colors by Arthur G. Dove* (exhib. cat., Worcester Art Museum, Worcester, Mass., 1961), p. 12, "that a [key] part of Dove's appeal resides in a quality of ambiguity.... Dove states—and at the same time—suggests.... Decisive in design, [his]... pictures present a certain indecision." See also Sherrye Cohn, *Arthur Dove: Nature as Symbol* (Ann Arbor, Mich., 1985), p. 214 n. 101.

103. Cohn, *Arthur Dove*, p. 78.

104. Ibid. See also pp. 16–17, 75–77, 79–80.

105. John I. H. Baur, *The Inlander: Life and Work of Charles Burchfield, 1893–1967* (New York and London, 1982), pp. 156–57.

106. Quoted in John I. H. Baur, "Charles Burchfield and John Marin: A Comparison," in *Watercolors by Charles Burchfield and John Marin* (exhib. cat., Kennedy Galleries, New York, 1985), n.p.

107. Morton Gould in 1981 composed a lengthy piece of music, *Burchfield Gallery*, based on the artist's paintings.

108. Baur, *The Inlander*, p. 58.

109. Quoted in Jeffrey R. Hayes, *Oscar Bluemner: Landscapes of Sorrow and Joy* (exhib. cat., Corcoran Gallery of Art, Washington, D.C., 1988), p. ix.

110. Quoted in ibid., p. 71.

111. A major traveling exhibit of Bluemner's paintings was held in 1988 at the Corcoran Gallery of Art, Washington, D.C.; the Amon Carter Museum, Fort Worth, Texas; and the New Jersey State Museum, Trenton.

112. Hayes, *Oscar Bluemner*, p. 44.

113. Quoted in ibid., p. xii.

114. Ibid., p. 53.

115. Quoted in Goodrich, *American Watercolor and Winslow Homer*, p. 73.

116. Ibid., p. 77.

117. Barbara Novak, *American Painting of the Nineteenth Century*, 2d ed. (New York, 1979), p. 174.

118. Gail Levin, *Hopper's Places* (New York, 1985), pp. 11, 12, 29–30.

119. Edgar P. Richardson, *Painting in America* (New York, 1965), pp. 423–24.

AMERICAN WATERCOLORS FROM THE METROPOLITAN MUSEUM OF ART

With commentaries on the plates by Stephen Rubin

The organization of the catalogue is as follows. After a selection of watercolors by folk artists, which is arranged by type or subject matter, the order is governed by the artists' birthdates. When two or more artists have the same year of birth, the one who died first precedes. If an artist is represented by more than one work, the works are arranged by date of execution or, if this is not known, by style and subject matter. The date of execution is given after the title of a work only if it is clearly inscribed on the work.

1. JOHANN HENRICH OTTO
(active 1772–1797)
Fraktur Motifs
Watercolor, iron gall ink, and graphite on off-white
laid paper, 13⅛ × 16½ in.
Gift of Edgar William and Bernice Chrysler
Garbisch, 1966
66.242.1

Johann Henrich Otto, a seminal figure in the Pennsylvania German folk-art tradition, was a skillful practitioner of *Frakturschriften*, a style of decorative penmanship derived from a sixteenth-century typeface called *Fraktur*. Today, the term "fraktur" refers to the entire body of Pennsylvania German illuminations, including works with little text or no text as well as birth and baptismal certificates and penmanship examples—to name but a few categories of fraktur in which script appears prominently.[1] Henrich Otto—as he is commonly called—excelled in both calligraphy and design and was admired not only for his elegant script but also for his freely drawn and boldly conceived motifs.

Few biographical facts are known about Otto, who emigrated from Germany to Pennsylvania in 1753.[2] After seeking employment as a weaver, Otto moved to Lancaster County, where he probably taught in the parochial schools. To supplement his meager schoolmaster's earnings, he produced and sold brilliantly colored and highly decorated fraktur. Credited with having introduced the printed baptismal certificate to Pennsylvania, Otto exerted tremendous influence on fraktur design through his popular mass-produced compositions. In particular, his baptismal certificates decorated with wood-cut border designs featuring paired birds and flowering vines were much copied by rival artists and early-nineteenth-century followers.

Most fraktur served a practical purpose. *Fraktur Motifs*, however, is a "presentation drawing," an ambiguous category for works in which there is no identifying text and whose purpose, consequently, remains purely speculative. Otto's motifs—the crowns, the paired peafowl, and the plants bearing different kinds of stylized flowers upon one stem—derive from a European folk-art tradition. In the past, much has been written about the symbolism of specific motifs employed by Otto and other Pennsylvania German scriveners. Recent studies, however, suggest that the iconographic vocabulary of the fraktur artists should be viewed as elements of design and not be read as a coherent allegorical program.

Contained within the limits of its neat yellow and green border and bound by the strictures of the Pennsylvania German aesthetic preference for symmetry and flattened form, *Fraktur Motifs* nevertheless conveys a sense of energy, exuberance, and joy. Otto has created an elaborate fantasy of vibrant color and striking design by utilizing an idiosyncratic amalgam of robust drawing and finicky detail. The artist's irresistible impulse to embellish—a classic example of *horror vacui*—is demonstrated by the calligraphic flourishes in red ink that he nervously penned in the margins of his composition.

1. For further information on fraktur, see Frederick S. Weiser, "Fraktur," in Scott T. Swank et al., *Arts of the Pennsylvania Germans* (New York, 1983), pp. 230–64.
2. See Frederick S. Weiser and Bryding Adams Henley, "Daniel Otto: the 'Flat Tulip' artist," *The Magazine Antiques*, September 1986, p. 509.

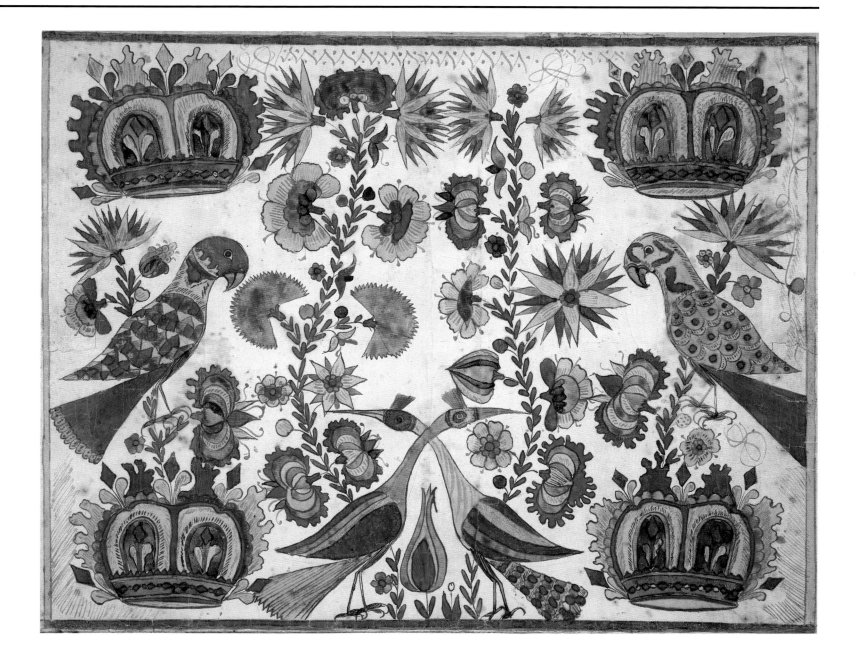

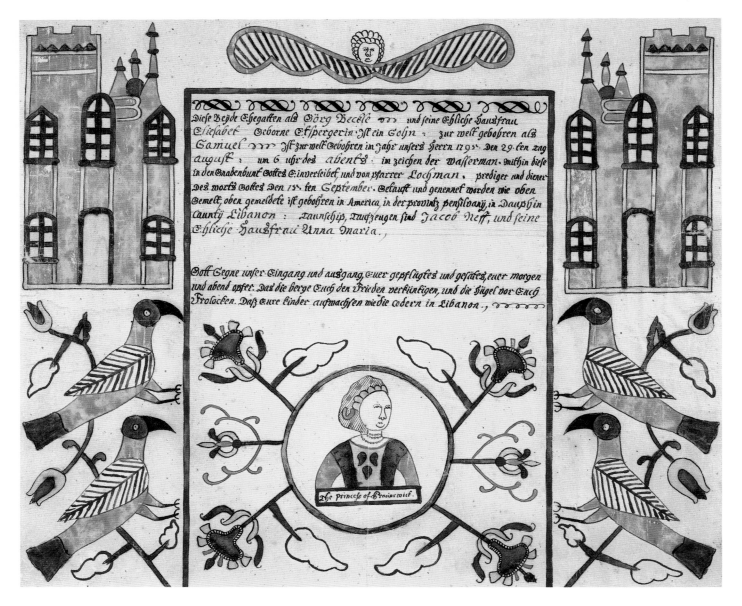

2. ATTRIBUTED TO CHRISTIAN MERTEL
(formerly known as the C. M. Artist)
(active 1795–d. 1802)
***Birth and Baptismal Certificate for Samuel
Beckle*** (b. 1795)
Watercolor and iron gall ink on off-white laid paper,
12¼ × 14¾ in.
Gift of Mrs. Robert W. de Forest, 1933
34.100.64

3. ATTRIBUTED TO THE CROSS-LEGGED
ANGEL ARTIST
*Birth and Baptismal Certificate for Anamaria
Weidner* (b. 1802)
Watercolor, gum arabic, and iron gall ink on off-
white laid paper, 12¹⁵⁄₁₆ × 15¹⁵⁄₁₆ in.
Rogers Fund, 1944
44.109.7

41

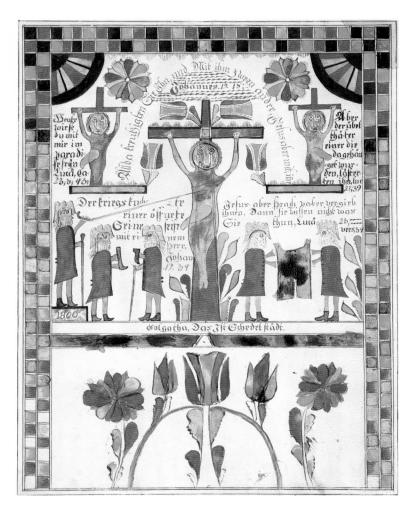

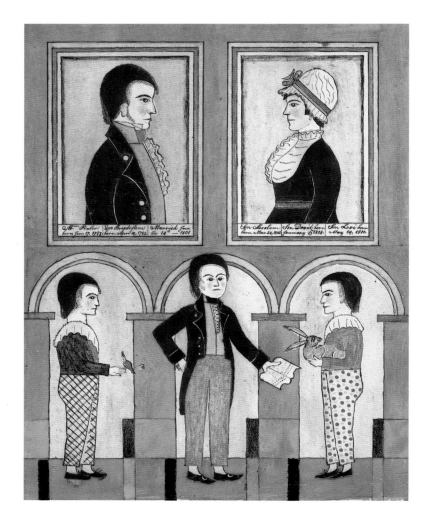

4. UNIDENTIFIED ARTIST
The Crucifixion
Watercolor, gum arabic, and iron gall ink on off-
white wove paper, 13⅝ × 10½ in.
Gift of Mrs. Robert W. de Forest, 1933
34.100.75

5. UNIDENTIFIED ARTIST
The Abraham Pixler Family
Watercolor, gouache, and ink on off-white laid paper,
9¾ × 7¹⁵⁄₁₆ in.
Inscribed below upper left portrait: Abᵐ Pixler/born
Jun 17, 1782; Eve Broadestone/born April 15, 1782;
Married Jun/the 14ᵗʰ — 1801; below upper right
portrait: Son Absalom/born Mar 24, 1802; Son
David born/January 5, 1808; Son Levi born/May 14,
1810.
Gift of Edgar William and Bernice Chrysler
Garbisch, 1966
66.242.3

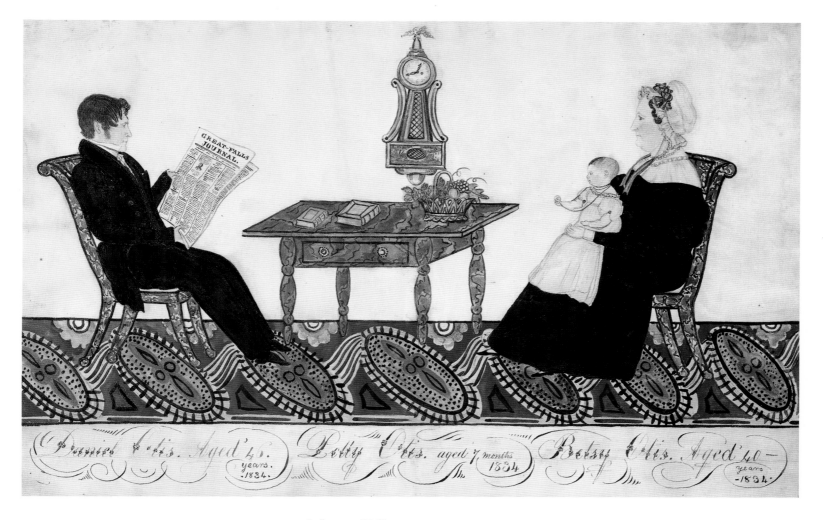

6. Joseph H. Davis
(1811–1865)
Mr. and Mrs. Daniel Otis and Child, 1834
Watercolor, gum arabic, and graphite on off-white
wove paper, 10¾ × 16⅝ in.
Inscribed and dated at lower left: Daniel Otis. Aged
46./years./.1834.; at center bottom: Polly Otis. aged
7 months/1834; at lower right: Betsy Otis. Aged
40 − /years/ − 1834.
Gift of Edgar William and Bernice Chrysler
Garbisch, 1972
1972.263.6

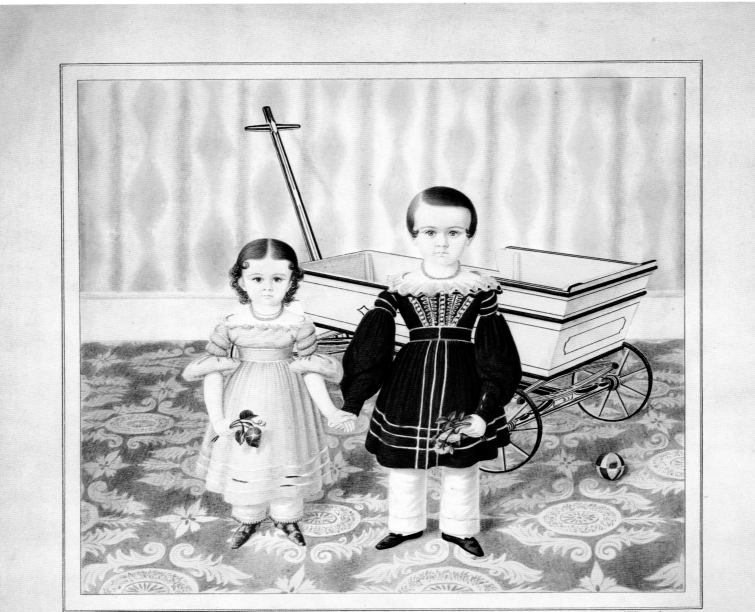

Painted by H.Walton. Ithaca.

FRANCES. ISABELLE, M. COWDREY. AGED 1 Y.ᴿ 8 Mᵗʰˢ CHARLES. EDWARD COWDREY. AGED 3 Yʳˢ 9Mᵗʰˢ

The sophisticated watercolor technique and elegant design that distinguish Henry Walton's portrait of Frances and Charles Cowdrey, painted about 1839, challenge long-standing assumptions about folk art and dramatize the fact that the line separating folk art and academic art is not always easily drawn. Compared with Joseph H. Davis's portrait of the Otis family (plate 6), which demonstrates the artistic innocence and charming ineptitudes often associated with folk art, Walton's work clearly belongs to a different and more accomplished tradition. His ability to model realistically the features of his sitters and to place his subjects in a convincing three-dimensional space differentiates his work from that of many other folk artists. The portrait of the Cowdrey children, however, with its rigid frontal pose is not without some elements of artistic naiveté.

Walton—painter, lithographer, farmer, and surveyor—led the proverbial itinerant life, traveling far afield from the Finger Lakes region of New York State to Michigan and California. The major portion of his work was painted between 1836 and 1851 in upper New York State, near the cities of Ithaca and Elmira.

The father of the stylishly attired and delicately featured Frances Isabelle, known as Belle, and Charles Edward was a blacksmith with social aspirations. He succeeded in becoming president of the village of Ithaca, and his imposing residence, the setting for his children's portrait, was considered the village showpiece.[1] In 1922, when Belle died, the walls of the Cowdrey house were still papered in the same pattern that Walton depicted in this painting—proof of the artist's accuracy in portraying interior settings.

Walton's artistic vision is always sharply focused and his attention to even the most minute detail is remarkable. Every feature of the Cowdrey children's clothing, hairstyles, and accessories and of the room in which they stand is recorded with extreme precision. The pleated lace collar, button trim, and soutache embroidery of Charles's bright ultramarine dress are painstakingly reproduced, as are the details of his sister's dainty pink frock and eyelet-trimmed white pantalets. Brother and sister posing hand in hand are accompanied by two favorite toys, a small multicolored ball and a large wagon. This imposing and elegant vehicle, the antithesis of a common toy cart, is provided with springs for added comfort. In a newspaper article enumerating the more interesting lots in Belle Cowdrey's estate sale, mention is made of a "child's spring wagon, presumably about a century old which sold for $18."[2] Given Belle's eccentric predilection for collecting and saving all sorts of oddments, it would have been completely in character for her to have kept for more than eighty years the toy wagon featured in Walton's portrait.

7. HENRY WALTON
(1804–1865)
Frances and Charles Cowdrey
Watercolor, gouache, and graphite underdrawing on off-white wove paper, 11¹³/₁₆ × 12⅜ in.
Inscribed and signed at lower right: PAINTED BY H. WALTON. ITHACA. Inscribed at bottom: FRANCES ISABELLE M. COWDREY. AGED 1 Yʳ 8 Mᵗʰˢ
CHARLES EDWARD COWDREY AGED 3 Yʳˢ 9 Mᵗʰˢ
Gift of Edgar William and Bernice Chrysler Garbisch, 1966
66.242.12

1. For more detailed biographical information on the Cowdrey children, see Leigh Rehner Jones, *Artist of Ithaca: Henry Walton and His Odyssey* (exhib. cat., Herbert F. Johnson Museum of Art, Cornell University, Ithaca, N.Y., 1988), p. 38.
2. *Ithaca Journal-News*, 23 November 1923. I am indebted to Brian Nevin for providing me with copies of newspaper clippings about Belle Cowdrey's estate sale.

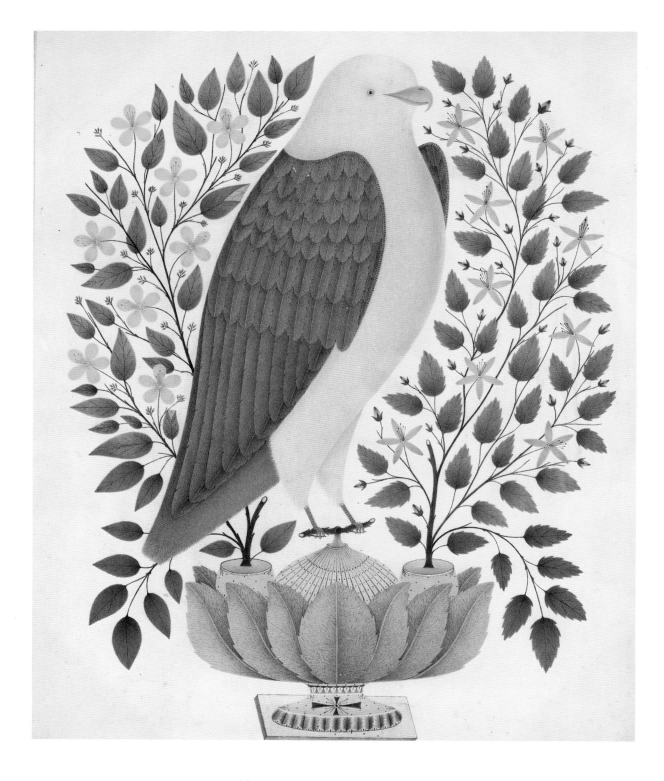

8. UNIDENTIFIED ARTIST
Stylized Bird
Watercolor on off-white wove paper,
17 1/16 × 14 5/16 in.
Gift of Edgar William and Bernice
Chrysler Garbisch, 1966
66.242.8

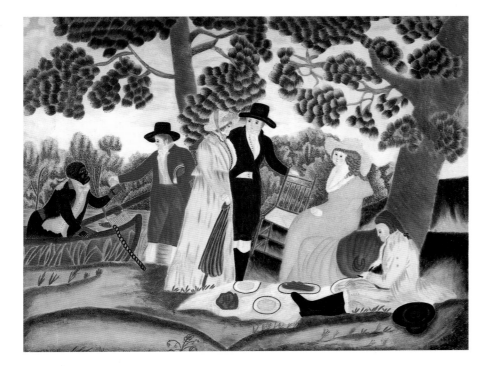

9. UNIDENTIFIED ARTIST
The Picnic
Watercolor and gouache on off-white wove paper,
13⅛ × 16¾ in.
Gift of Edgar William and Bernice Chrysler
Garbisch, 1966
66.242.2

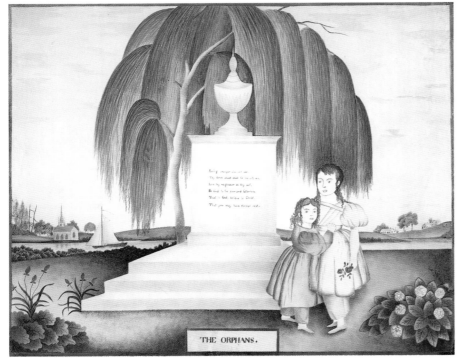

THE ORPHANS.

10. UNIDENTIFIED ARTIST
The Orphans
Watercolor, gum arabic, gouache, graphite, and black
ink on white wove paper, 18 × 22¼ in.
Gift of Edgar William and Bernice Chrysler
Garbisch, 1966
66.242.9

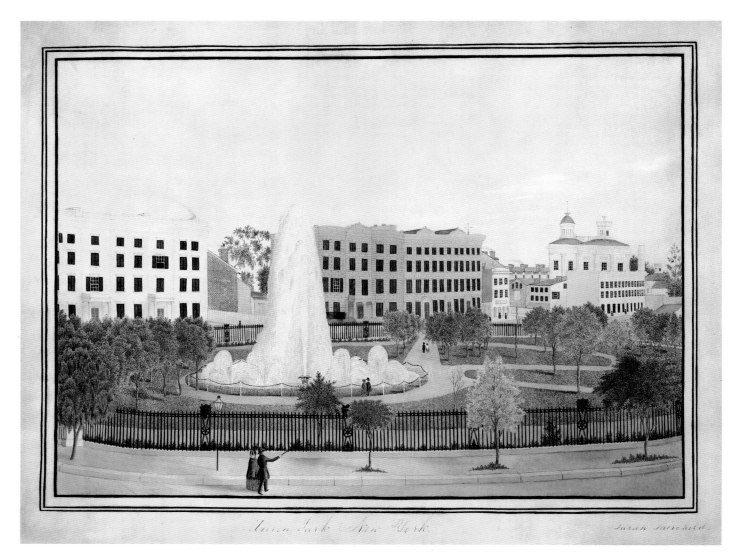

11. SARAH FAIRCHILD
(active 1840s)
Union Park, New York
Watercolor, gum arabic, and gouache on off-white
wove paper, 13¹³⁄₁₆ × 17¹³⁄₁₆ in.
Signed at lower right: Sarah Fairchild. Inscribed at
bottom: Union Park, New York.
Bequest of Edgar William and Bernice Chrysler
Garbisch, 1979
1980.341.3

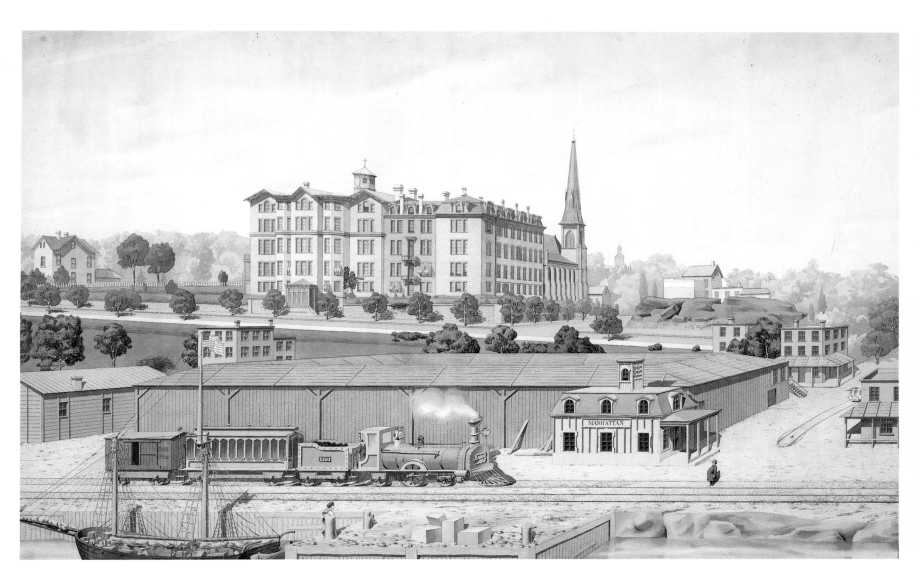

12. UNIDENTIFIED ARTIST
***Hudson River Railroad Station, with a View of
Manhattan College***
Watercolor and ink on off-white wove paper,
22½ × 35½ in.
The Edward W. C. Arnold Collection of New York
Prints, Maps, and Pictures, Bequest of Edward W. C.
Arnold, 1954
54.90.159

NEW YORK.

13. ARCHIBALD ROBERTSON
(1765–1835)
Collect Pond, New York City, 1798
Watercolor on off-white laid paper, 17⅞ × 23⅛ in.
Inscribed at bottom: NEW YORK. Inscribed and
dated at lower right: Newyork March 1798.
The Edward W. C. Arnold Collection of New York
Prints, Maps, and Pictures, Bequest of Edward W. C.
Arnold, 1954
54.90.168

14. JOHN HILL
(1770–1850)
View from My Work Room Window in Hammond Street, New York City, 1825
Watercolor used with brush and pen and graphite underdrawing on off-white wove paper (reverse: aquatint), 9⅞ × 13¾ in.
Inscribed, signed, and dated on reverse: View from my Work Room Window in Hammond St./by I. Hill — 1825 —
The Edward W. C. Arnold Collection of New York Prints, Maps, and Pictures, Bequest of Edward W. C. Arnold, 1954. 54.90.283

15. CHARLES BALTHAZAR JULIEN FÉVRET DE
SAINT-MÉMIN
(1770–1852)
Osage Warrior
Watercolor on off-white wove paper, 7¼ × 6⅜ in.
Signed and inscribed at lower left: Sᵗ Memin fecit.
The Elisha Whittelsey Collection, The Elisha
Whittelsey Fund, 1954
54.82

Paintings in watercolor are considered a rarity in the oeuvre of Charles Balthazar Julien Févret de Saint-Mémin, an aristocrat who sought asylum in the United States during the French Revolution. Saint-Mémin, a military man by profession, was an amateur artist who supported himself and his family during their long exile by executing portrait drawings in black and white chalk. These likenesses were produced with the aid of a physiognotrace, an apparatus that mechanically reproduced an outline of a sitter's profile. From 1796 to 1810, he drew more than 800 profile portraits, creating a pictorial record of almost everyone of note during the early Federal period.

Osage Warrior,[1] drawn "with an exactitude perfectly geometrical,"[2] delineates the appearance of an unidentified member of one of three delegations of Plains Indians who visited Washington between 1804 and 1807 at the invitation of President Jefferson. Jefferson wished to establish friendly contact with several of the influential chiefs who inhabited the vast uncharted territory recently acquired as the result of the Louisiana Purchase. The Indian visitors were lionized in Washington, Baltimore, Philadelphia, and New York and their exotic appearance and noble bearing elicited much interest and favorable comment.[3]

Among the many spectators who were fascinated by the Indian dignitaries was Sir Augustus John Foster, then serving in Washington as Secretary to the British Minister. In his memoirs, Foster describes in vivid detail the arrival of the delegations of 1806 and 1807. Stimulated by his keen interest in the "wild natives of the woods," Foster not only commissioned David Boudon, a Swiss miniaturist, to paint the portrait of a visiting Sac chieftain, but also acquired the *Osage Warrior*, together with four other Saint-Mémin watercolor likenesses of Indians. These five watercolor portraits are most likely pantographic reductions of Saint-Mémin's almost life-size profile studies of the same subjects executed in black and white chalk on tinted paper.

In his sensitive portrayal of the warrior's face, the artist has contrasted a refined miniaturist's technique of careful stippling and precise cross-hatching with the bolder, coarser brushwork employed to suggest the texture of the white blanket. The sitter's ears are decorated with metal rim bands, most likely fashioned of German trade silver, and wampum ear drops strung on leather.[4] All facial and cranial hair has been either plucked or shaved except for eyelashes and a scalp lock, from which hang a hair pipe and leather ties. The subject of *Osage Warrior*, with his serious expression and restrained appearance, provides visual corroboration of a contemporary newspaper description of the older Indian visitors: "Their countenances indicate profound mental powers and the dignity of their manners is truly philosophic and impressive."[5]

1. Formerly known as *Cachasunghia, an Osage Warrior*, this portrait is now titled *Osage Warrior*. The sitter is clearly not the same person depicted in the drawing inscribed by the artist "Cachasunghia," now in the collection of the New-York Historical Society, New York City. The misidentification occurred in the sale catalogue of the Lockwood Collection, Parke-Bernet Galleries, New York, 13–15 May 1954, lot 438.
2. Ph[ilippe] Guignard, "Historical Notice of the Life and Works of M. Fevret de Saint-Memin," in Elias Dexter, *The St.-Memin Collection of Portraits; Consisting of Seven Hundred and Sixty Medallion Portraits, Principally of Distinguished Americans* (New York, 1862), p. 2.
3. A detailed account of Saint-Mémin's likenesses of American Indians is provided in Ellen G. Miles, "Saint-Mémin's Portraits of American Indians, 1804–1807," *American Art Journal*, vol. 20, no. 4 (1988), pp. 2–33.
4. I am indebted to Jonathan Holstein for the identification of the warrior's accouterments.
5. *The Palladium* (Frankfort, Ky.), 25 November 1805, quote in John C. Ewers, "'Chiefs from the Missouri and Mississippi' and Peale's Silhouettes of 1806," *Smithsonian Journal of History*, vol. 1 (Spring 1966), p. 12.

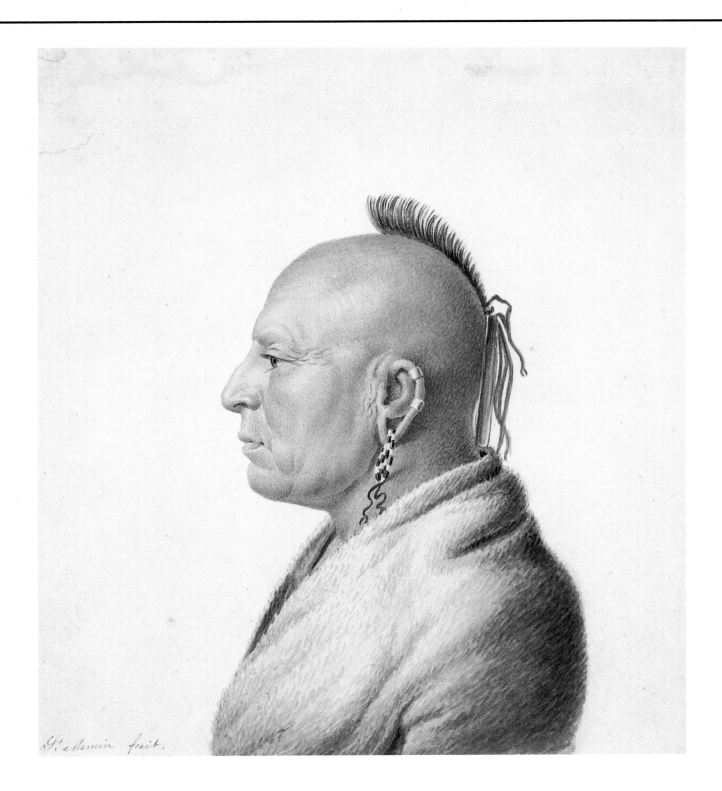

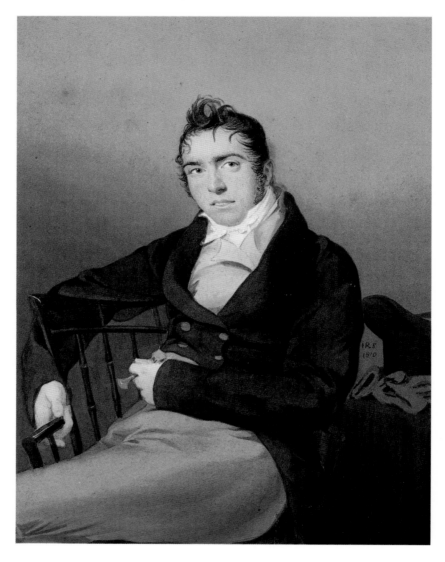

16. JOHN RUBENS SMITH
(1775–1849)
Allan Melville, 1810
Watercolor and ink on off-white wove paper,
8⅞ × 6¾ in.
Signed and dated at right: J R S/1810
Bequest of Charlotte E. Hoadley, 1946
46.192.4

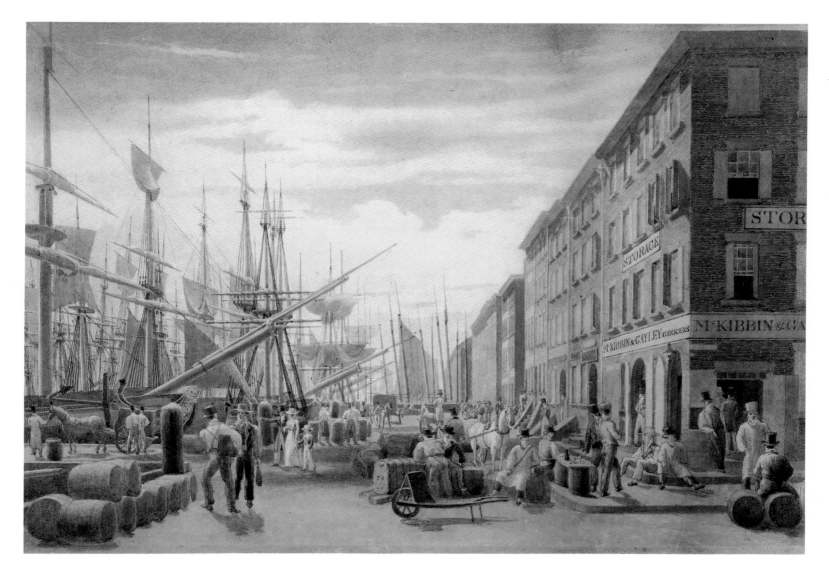

17. WILLIAM JAMES BENNETT
(c. 1784–1844)
*View of South Street, from Maiden Lane, New
York City*
Watercolor used with brush and pen on off-white
wove paper, 9⅝ × 13⅝ in.
The Edward W. C. Arnold Collection of New York
Prints, Maps, and Pictures, Bequest of Edward W. C.
Arnold, 1954
54.90.130

18. PAVEL PETROVITCH SVININ
(1787/88–1839)
Merrymaking at a Wayside Inn
Watercolor, black ink, and graphite on off-white laid
paper, 7⅛ × 9³⁄₁₆ in.
Rogers Fund, 1942
42.95.12

19. PAVEL PETROVITCH SVININ
(1787/88–1839)
"Worldly Folk" Questioning Chimney
Sweeps and Their Master before Christ
Church, Philadelphia
Watercolor, gouache, and black ink on off-white
laid paper, 9⁷⁄₁₆ × 6⁷⁄₈ in.
Rogers Fund, 1942
42.95.15

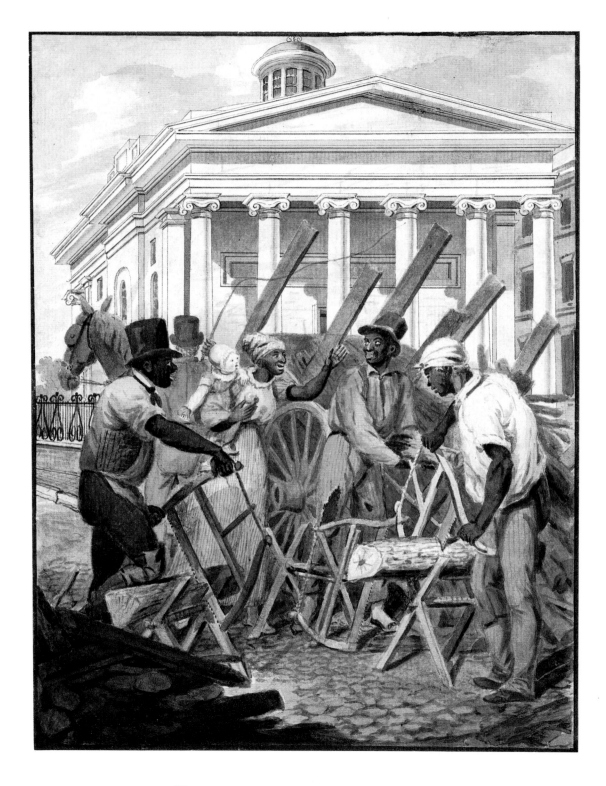

20. PAVEL PETROVITCH SVININ
(1787/88–1839)
Negroes in front of the Bank of
Pennsylvania, Philadelphia
Watercolor and black ink on off-white laid
paper, 9³⁄₁₆ × 6¹¹⁄₁₆ in.
Rogers Fund, 1942
42.95.16

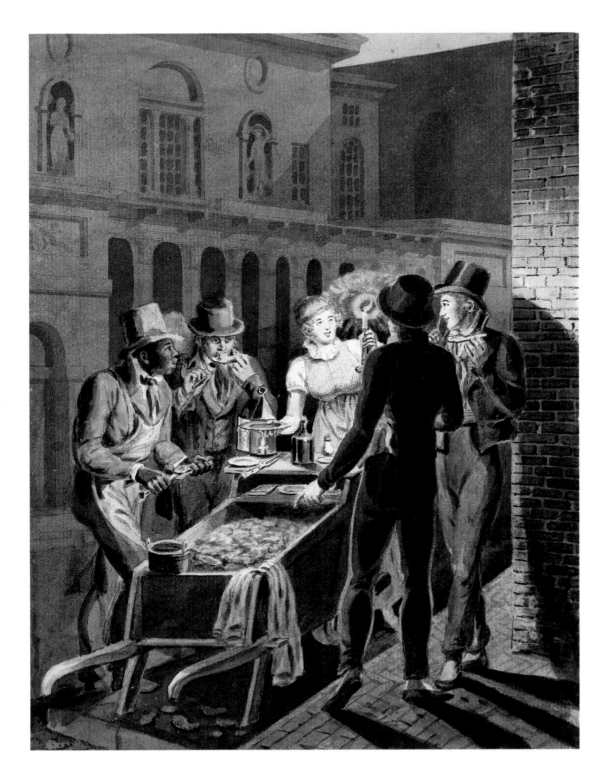

21. PAVEL PETROVITCH SVININ
(1787/88–1839)
***Night Life in Philadelphia—an Oyster
Barrow in front of the Chestnut Street
Theatre***
Watercolor, black ink, and graphite
underdrawing on off-white laid paper,
9⅛ × 6¹³⁄₁₆ in.
Rogers Fund, 1942
42.95.18

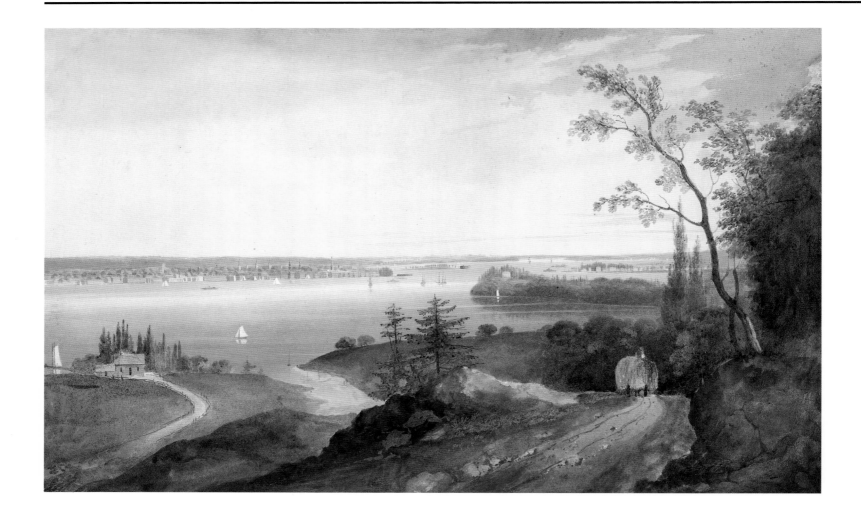

22. WILLIAM GUY WALL
(1792–after 1863)
New York from Weehawk
Watercolor, gouache, and graphite on off-white wove
paper, 16¹/₁₆ × 25¹/₈ in.
The Edward W. C. Arnold Collection of New York
Prints, Maps, and Pictures, Bequest of Edward W. C.
Arnold, 1954
54.90.109

"This gentleman has been indefatigable in studying American landscape, and his reputation stands deservedly high,"[1] wrote William Dunlap of the Irish immigrant artist William Guy Wall. Wall arrived in New York in 1818 as a skilled artist, having been trained as a watercolorist in the British topographical tradition. In the summer of 1820, he toured the Hudson River Valley and produced a series of watercolor views, which were engraved and published under the title *Hudson River Portfolio*. The *Portfolio* proved an immediate success. It was reissued several times between 1821 and 1828 and firmly established the artist's reputation in the New York art world of the 1820s. A founding member of the National Academy of Design, Wall contributed many works to its annual exhibitions, and his submissions attracted much favorable comment.

New York from Weehawk is one of a pair of watercolors representing New York from two different vantage points, Weehawken, New Jersey, and Brooklyn Heights. Wall painted these views with the intention of having them engraved by John Hill, the artist who was currently engaged in engraving the plates for the *Hudson River Portfolio*. Announcing his proposal to publish the two views of New York, Wall informed the readers of the *Commercial Advertiser* on 26 June 1823:

> Correct views of the City of New-York, have long been a desideratum, and it has been a subject of surprise, that no attempt has been made to exhibit to the public, the leading features of a city, which possesses so great an interest from its political and commercial importance, as well as from the natural beauties of its situation. Mr. Wall has been induced by these considerations, to offer to the patronage of the public, two aqua tinta engravings of this City, from drawings taken, one from Weehawk, the other from Brooklyn Heights.[2]

There are considerable variations between the print *New York from Weehawk* and this original watercolor, particularly in the foreground, where Hill substituted a man on horseback and his pedestrian companion for Wall's rustic farmer and hay wagon. The engravings sold well, necessitating several reprintings, and proved so popular that they were reproduced on dark blue Staffordshire china by an English potter, Andrew Stevenson, who was eager to attract the American market.[3]

In his history of arts in America, published in 1834, Dunlap reported: "Mr. Wall's practice of late is to colour all his drawings from nature on the spot, 'the only way,' as he says, 'to copy nature truly.'"[4] *New York from Weehawk* was executed approximately ten years earlier, when the artist evidently was working in a different mode, characterized by a distinctive, stylized, and unrealistic palette of harmonious shades of green, blue, and brown. In *New York from Weehawk*, Wall has created a delicate, poetic, and idiosyncratic vision of Manhattan as opposed to a prosaic, realistically colored view.

1. William Dunlap, *History of the Rise and Progress of the Arts of Design in the United States* (New York, 1834), vol. 2, p. 321.
2. Quoted in I. N. Phelps Stokes, *The Iconography of Manhattan Island* (New York, 1918), vol. 3, p. 578.
3. See L. Earle Rowe, "William Guy Wall," *Antiques*, vol. 4, no. 1 (July 1923), pp. 18–22.
4. Dunlap, *History*, vol. 2, p. 322.

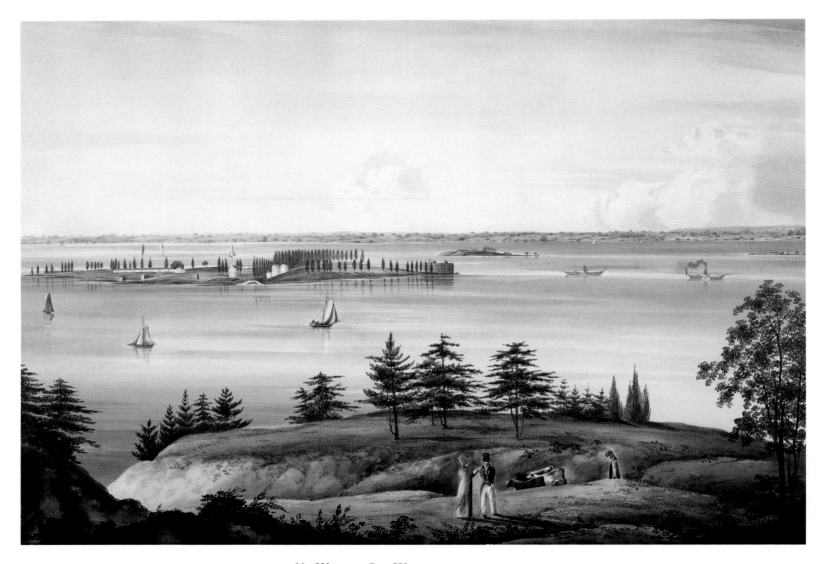

23. WILLIAM GUY WALL
(1792–after 1863)
The Bay of New York and Governor's Island Taken from Brooklyn Heights
Watercolor on white wove paper, 21 × 30³/₁₆ in.
The Edward W. C. Arnold Collection of New York Prints, Maps, and Pictures, Bequest of Edward W. C. Arnold, 1954
54.90.108

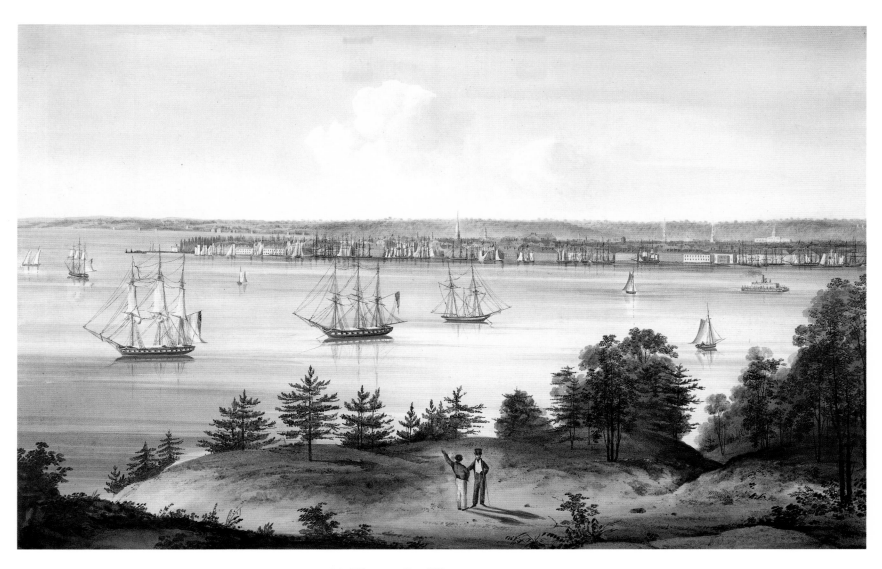

24. WILLIAM GUY WALL
(1792–after 1863)
The Bay of New York Taken from Brooklyn Heights
Watercolor on white wove paper, 21³⁄₁₆ × 32⅝ in.
The Edward W. C. Arnold Collection of New York Prints, Maps, and Pictures, Bequest of Edward W. C. Arnold, 1954
54.90.158

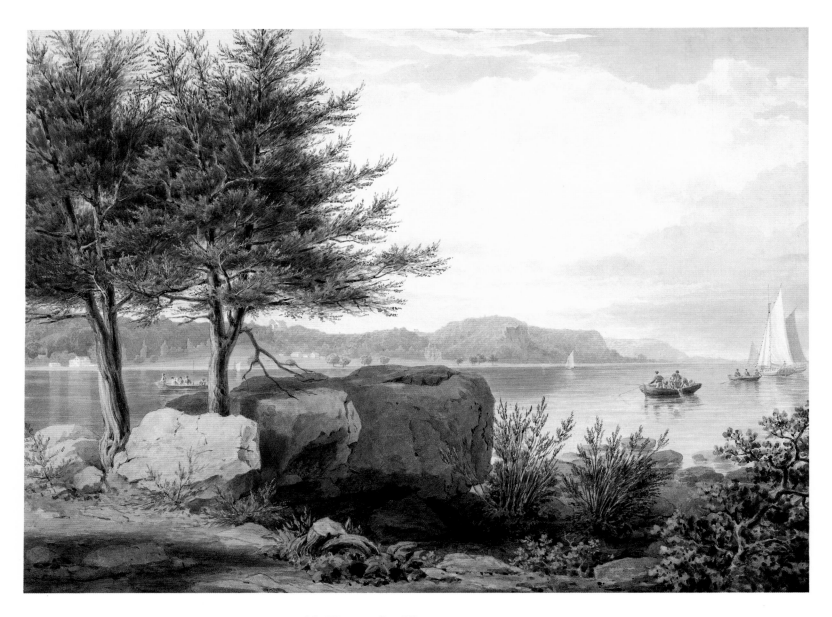

25. WILLIAM GUY WALL
(1792–after 1863)
View on the Hudson River
Watercolor, gouache, and graphite on off-white wove
paper, 15 1/16 × 20 1/16 in.
The Edward W. C. Arnold Collection of New York
Prints, Maps, and Pictures, Bequest of Edward W. C.
Arnold, 1954
54.90.107

26. DAVID CLAYPOOLE JOHNSTON
(1799–1865)
At the Waterfall
Watercolor, gum arabic, and gouache on off-white
wove paper, 8⅝ × 12⅝ in.
Signed at lower right: D C J
Gift of Mr. and Mrs. Stuart P. Feld, 1978
1978.512

27. NICOLINO CALYO
(1799–1884)

View of the Tunnel of the Harlem Railroad
Gouache on off-white wove paper, $18 \times 26\frac{1}{8}$ in.
Inscribed at bottom: View of the Tunnel of the
Harlem Rail Road.
The Edward W. C. Arnold Collection of New York
Prints, Maps, and Pictures, Bequest of Edward W. C.
Arnold, 1954
54.90.155

Nicolino Calyo, an immigrant artist born in Italy in 1799, is best known today for his picturesque views of New York City. By the time he arrived in the United States, Calyo was an accomplished professional artist, working in a refined, if somewhat conservative, gouache technique. Whereas most of his contemporaries used gouache to highlight compositions executed in transparent wash, Calyo used the opaque medium to cover the entire sheet. His renderings of urban views are skillful and charming, rich in detail that imparts much vital information about the way our cities and their residents looked during the mid-nineteenth century.

Relatively little is known about Calyo. As a young man he studied at the fine-arts academy at Naples, but his academic training there ended abruptly when he joined the rebellion against the oppressive rule of Ferdinand IV, king of Naples. After the insurrection was quelled, Calyo was forced to flee and spent the next eight years traveling through Europe, pursuing his study of art. Once again, however, political unrest—this time the outbreak of the Carlist Wars in Spain—interfered with his professional career, and he left Europe for America, arriving in Baltimore in 1834.

By 1835, he was working in New York City, where he witnessed the Great Fire of December 16 and 17, in which seventeen blocks in the commercial center of the city were destroyed. Calyo documented this dramatic event with a series of historically important and artistically successful views depicting the progress of the conflagration and its aftermath.[1]

Calyo's interest in and talent for pictorial reportage are further exemplified by the *View of the Tunnel of the Harlem Railroad*, executed about two years later. The event recorded here is the completion, in 1837, of the Yorkville tunnel on Fourth Avenue (now Park Avenue), between 88th and 95th streets. The tunnel, a remarkable feat of engineering, described in a contemporary account as a "specimen of the skill and art of man that will be considered as one of the greatest works in our country,"[2] was part of a costly and ambitious project to construct the first railroad on Manhattan Island. It took seven years to complete the entire route, which stretched from City Hall in lower Manhattan to the village of Harlem.

The handsome porticoed structure seen against the background of a luminous sunset is Prospect Hall, an elegant hotel erected by the railroad company at the Yorkville station terminus. Here visitors could enjoy "pure air and comfortable accommodations,"[3] and "were furnished with every delicacy of the season at short notice."[4]

Calyo has recorded a dramatic incident in which an explosion has frightened several spectators who had come to admire the marvelous rock-cut tunnel. In the foreground two women seek the assistance of their male companion, while another gentleman gestures in astonishment. The historic significance of this specific explosion in the northern approach to the tunnel has not been identified.

1. For further information on Calyo and the Great Fire of 1835, see Margaret Sloane Patterson, "Nicolino Calyo and His Paintings of the Great Fire of New York, December 16th and 17th, 1835," *American Art Journal*, vol. 14, no. 2 (Spring 1982), pp. 4–22.
2. *New York Express*, 27 October 1837, quoted in Joseph Greene, Jr., "New York City's First Railroad. The New York and Harlem, 1832 to 1867," *New-York Historical Society Quarterly Bulletin*, vol. 9 (January 1926), p. 117.
3. *New York Gazette*, May 1834, quoted in Greene, ibid., p. 115.
4. *New York Courier and Enquirer*, 30 July 1834, quoted in Greene, ibid., p. 114.

View of the Tunnel of the Harlem Rail Road.

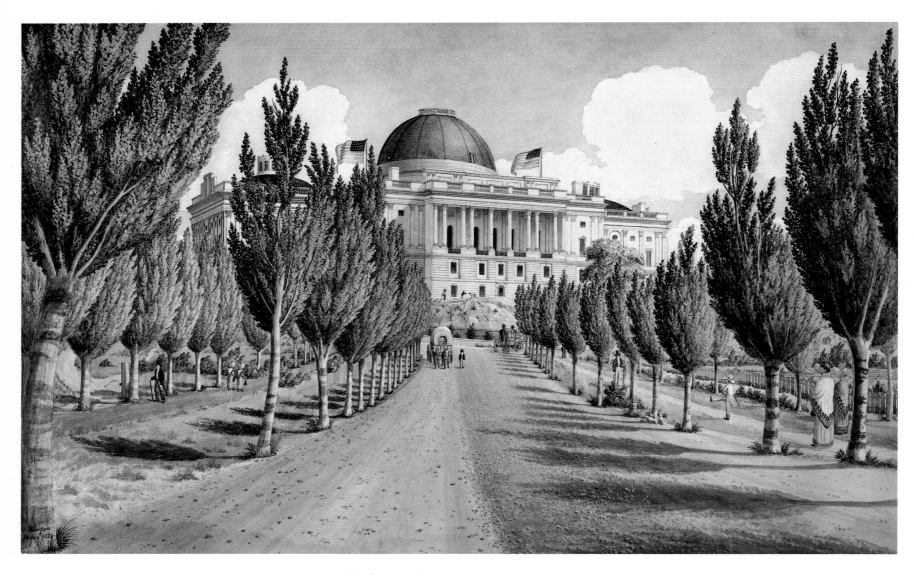

28. CHARLES BURTON
(active c. 1819–1842)
View of the Capitol, 1824
Watercolor, gum arabic, and graphite on off-white
wove paper, 16 × 24¾ in.
Signed, inscribed, and dated at lower left:
C. Burton/Delint 1824.
Purchase, Joseph Pulitzer Bequest, 1942
42.138

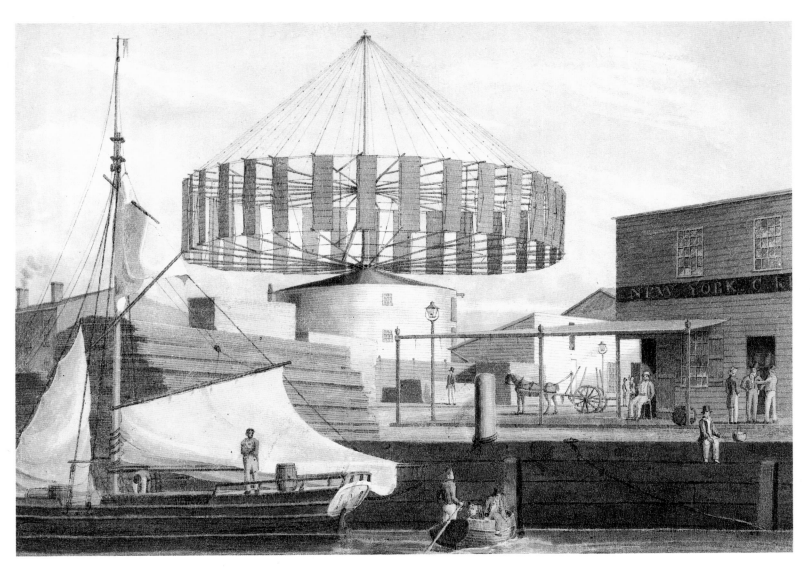

29. JOHN WILLIAM HILL
(1812–1879)
Circular Mill, King Street, New York City
Watercolor on off-white laid paper, $9^{11}/_{16} \times 13^{1}/_{2}$ in.
Inscribed, signed, and dated at lower right: Drawn by
J. W. Hill New York 18 [illegible]
The Edward W. C. Arnold Collection of New York
Prints, Maps, and Pictures, Bequest of Edward W. C.
Arnold, 1954
54.90.170

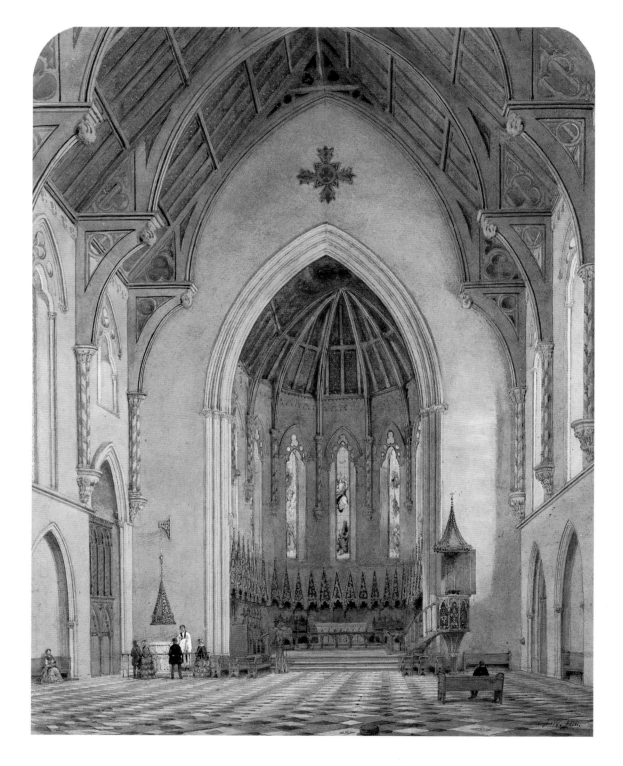

30. JOHN WILLIAM HILL
(1812–1879)
Interior of Trinity Chapel, New York City,
1856
Watercolor, gouache, and graphite underdrawing
on off-white wove paper, $18^{11}/_{16} \times 14^{1}/_{2}$ in.
Signed at lower right: J. W. Hill.
Inscribed and dated on reverse: Interior of Trinity
Chapel/West 25th St. 1856/Drawn by J. W. Hill
The Edward W. C. Arnold Collection of New
York Prints, Maps, and Pictures, Bequest of Edward
W. C. Arnold, 1954
54.90.157

31. JOHN WILLIAM HILL
(1812–1879)
Landscape: View on Catskill Creek, 1867
Watercolor, gouache, and graphite underdrawing on
off-white wove paper, 9¹¹/₁₆ × 15¹/₁₆ in.
Signed and dated at lower left: J. W. Hill/1867
Gift of John Henry Hill, 1882
82.9.6

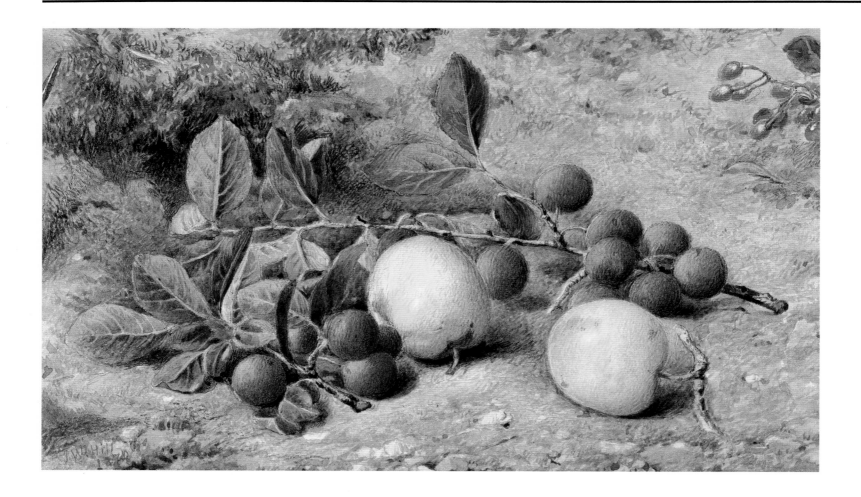

32. JOHN WILLIAM HILL
(1812–1879)
Plums, 1870
Watercolor and graphite underdrawing on off-white
wove paper, 7 1/16 × 11 15/16 in.
Signed and dated at lower left: J. W. Hill/1870
Gift of John Henry Hill, 1882
82.9.1

After reading the first volume of John Ruskin's *Modern Painters,* John William Hill, an established watercolorist working in the tradition of English topographical views, underwent an aesthetic conversion. Embracing the tenets of Pre-Raphaelitism as propounded by Ruskin, he abandoned his former conventional landscape style and devoted himself to painting directly from nature in a technique favoring brilliant color, elaborate finish, and an exacting attention to detail.

In 1863, Hill joined other like-minded American Pre-Raphaelites to form the Association for the Advancement of Truth in Art. He served briefly as the association's first president. The aim of the new organization was to initiate a reform of American art based on the principle of "truth to nature."[1]

The impact of the American Pre-Raphaelites, with their obsessive concern for botanical specificity and topographical accuracy, was short-lived. The public taste turned in favor of a painterly, more personal style and repudiated the extreme Ruskinian concept of "artist as lens"— rejecting nothing and selecting nothing. So absolute and swift was the disavowal of American Pre-Raphaelitism that by 1882, merely three years after J. W. Hill's death, John Henry Hill, the artist's son, wishing to make a donation of several of his father's best works to the Metropolitan Museum of Art, was uncertain whether the museum would deem the gift worthy of acceptance. At the younger Hill's suggestion, the opinion of the distinguished landscape painter Frederic E. Church was sought in the matter and, in fact, Church's recommendation did insure that the museum would accept the watercolors.[2]

Plums, painted in brilliant shades of purple, red, green, and yellow, is executed in a meticulous miniaturist technique of hatching and stippling. In an effort to make still life appear more natural, the artist has set forth his arrangement of fruit directly upon a carefully studied pebble-strewn patch of earth. The idea of choosing a natural, outdoor setting instead of the traditional tabletop or stone plinth as a support for still life had been popularized by the English watercolorist William Henry Hunt. In his writings, Ruskin had recommended the study of Hunt's work and canonized him as "the best painter of still life . . . that ever existed."[3] However attractive such an outdoor arrangement may be, in actual fact it is also as contrived and artificial as any traditional method of presenting still life. The use of this odd conceit by Hill and his confreres, who styled themselves "determined realists," did not escape negative comment, even from among their own ranks. Russell Sturgis, a member of the Association for the Advancement of Truth in Art and art critic for *The Nation* wrote: "There is something incongruous in the juxtaposition by bank-side of a pear and a bunch of grapes, or an apple, three plums, and a handful of nuts. But the same group on a plate or table-cloth is comprehensible and looks real."[4]

1. A detailed chronicle of the American Pre-Raphaelite Movement is provided in Linda S. Ferber and William H. Gerdts, *The New Path: Ruskin and the American Pre-Raphaelites* (exhib. cat., Brooklyn Museum, 1985).
2. John Henry Hill's letters to the museum about the proposed gift are in The Metropolitan Museum of Art Archives.
3. John Ruskin, *The Elements of Drawing* (reprint; New York, 1971), p. 220.
4. *The Nation,* 28 December 1865, pp. 819–20.

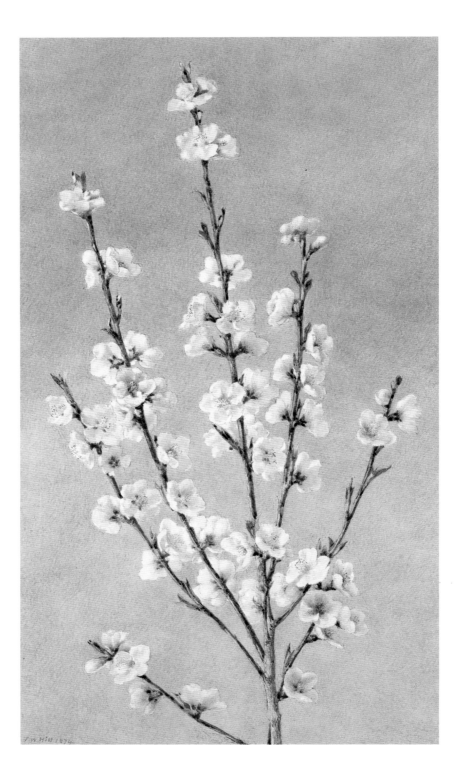

33. JOHN WILLIAM HILL
(1812–1879)
Peach Blossoms, 1874
Watercolor and graphite on off-white wove paper,
16⁹/₁₆ × 9⅝ in.
Signed and dated at lower left: J. W. Hill 1874.
Inscribed on reverse: Peach Blossom $30.
Gift of John Henry Hill, 1882
82.9.5

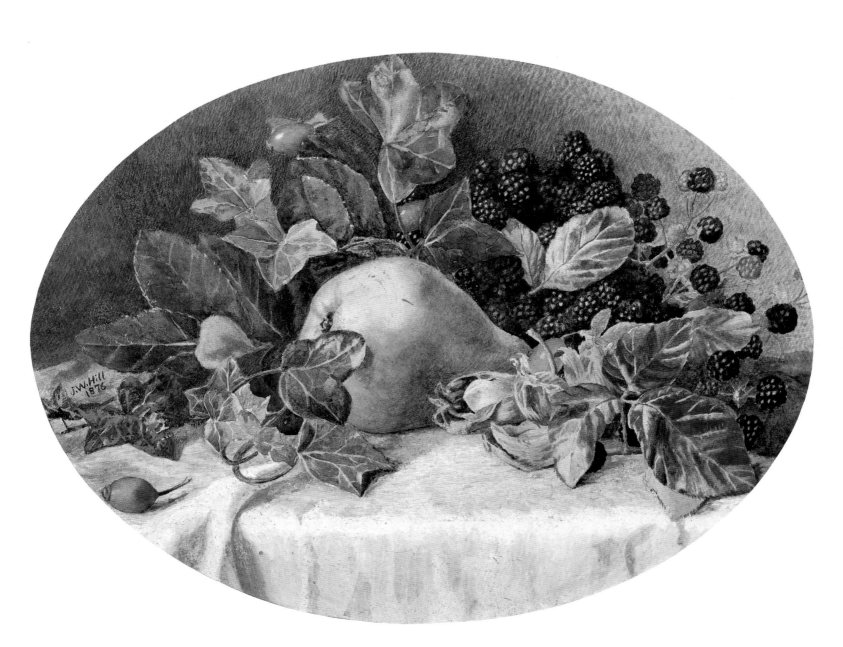

34. JOHN WILLIAM HILL
(1812–1879)
Still Life with Fruit, 1876
Watercolor and gouache on paperboard, 10¹¹⁄₁₆ × 13 in.
Signed and dated at left: J. W. Hill/1876
Maria DeWitt Jesup Fund, 1979
1979.452

35. DAVID JOHNSON KENNEDY
(1816/17–1898)
Entrance to Harbor—Moonlight, 1881
Gouache on off-white wove paper, $9\frac{1}{4} \times 14^{15}/_{16}$ in.
Signed and dated at lower left: D. J. Kennedy. 1881.
Rogers Fund, 1968
68.41

36. WILLIAM RICKARBY MILLER
(1818–1893)
Catskill Clove, 1856
Watercolor, gouache, and graphite on green wove
paper (now discolored), 19⅞ × 14⅜ in.
Signed, inscribed, and dated at lower right: W. R.
Miller/Catskill Clove 1856
Gift of Mrs. A. M. Miller, 1893
93.24.3

37. WILLIAM RICKARBY MILLER
(1818–1893)
Catskill Clove in Palingsville, 1856
Watercolor, gum arabic, gouache, and graphite on
light green wove paper, 19⅞ × 14¹⁄₁₆ in.
Signed and inscribed at lower left: W. R. Miller/Del.
Inscribed and dated at lower right: Catskill Clove in
Palingsville/Aug 1856/N.Y.
Gift of Mrs. A. M. Miller, 1893. 93.24.4

38. JAMES HAMILTON
(1819–1878)
Beach Scene
Watercolor and gouache on off-white wove paper,
11¾ × 15⅞ in.
Signed at lower right: J. Hamilton
Rogers Fund, 1966
66.142

James Hamilton, a marine and landscape painter who numbered Thomas Moran among his more illustrious pupils, was born in Ireland and came to America at the age of fifteen. Settling in Philadelphia, he was encouraged to study painting by John Sartain, an editor and engraver, who in 1852 published a biographical sketch of the artist.[1] According to Sartain, Hamilton began his career as a watercolorist working in the "modern English method" of topographical painting. By 1850 he was an established artist who exhibited regularly in both oil and watercolor at the local Artists' Fund Society and at the Pennsylvania Academy of the Fine Arts. His contemporaries admired the bold and free technique that he employed to create poetic compositions in which mood, rather than topographical information, was the most important element.

Beach Scene, with its broad handling and moody atmospheric effects, at first suggests comparison with the works of J. M. W. Turner, whose marine subjects and landscapes inspired many nineteenth-century American artists. Indeed, Hamilton himself was referred to as "The American Turner." In describing the artist's early career, Sartain emphasized Hamilton's admiration for and study of the work of the great English master, whose paintings he knew only through engraved copies. A trip to England in 1854 enabled the artist to view the originals at first hand, but the extent of Turner's influence on Hamilton remains problematic. The author of the introductory remarks to the catalogue of the artist's studio sale in 1875 explained, "that Mr. Hamilton's peculiar science of color and effect was worked out before he could possibly have seen a painting of Turner's" and suggested that the use of the sobriquet "The American Turner" was for "those minds which can only admire by reflection."[2]

The striking colors and execution of *Beach Scene*, painted about 1865, appear to be of Hamilton's own invention and bear only a superficial resemblance to Turner's work in watercolor. Although both artists shared a common interest in subject matter and disdain for detailed, highly finished surfaces, Hamilton did not emulate the delicate, evanescent Turneresque vision evoked with veils of overlapping transparent wash but rather composed a spare, palpable, solidly constructed coastal scene. He is known to have painted along the East coast at Atlantic City, Cape May, Newport, and Cape Cod; however, the specific site of *Beach Scene* with its sun-drenched reflections on sand and sea remains unidentified.

1. John Sartain, "James Hamilton," *Sartain's Union Magazine of Literature and Art*, vol. 10 (April 1852), pp. 331–33.
2. E[mily] S[artain], "Remarks on the Collection," *Catalogue of Paintings: From the Studio of James Hamilton*, sold by Messrs. James S. Earle & Sons (Philadelphia, 21, 22 April 1875), n.p.

39. WILLIAM LOUIS SONNTAG
(1822–1900)
Frontier Cabin, 1894
Watercolor and gouache on off-white wove paper,
9¾ × 15³⁄₁₆ in.
Signed and dated at lower left: W. L. Sonntag 94
Morris K. Jesup Fund, 1977
1977.475

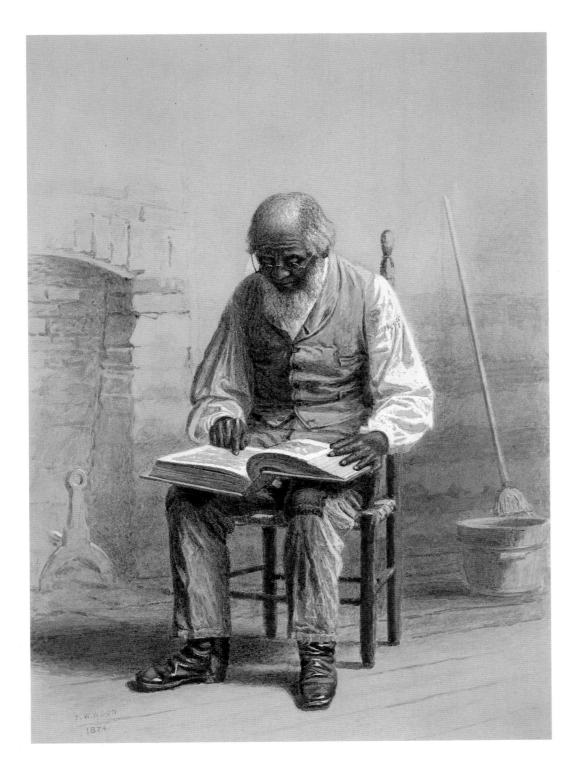

40. THOMAS WATERMAN WOOD
(1823–1903)
Reading the Scriptures, 1874
Watercolor and gouache on light tan paper,
14¹⁵/₁₆ × 10¾ in.
Signed and dated at lower left: T. W. Wood/1874
Rogers Fund, 1966
66.140

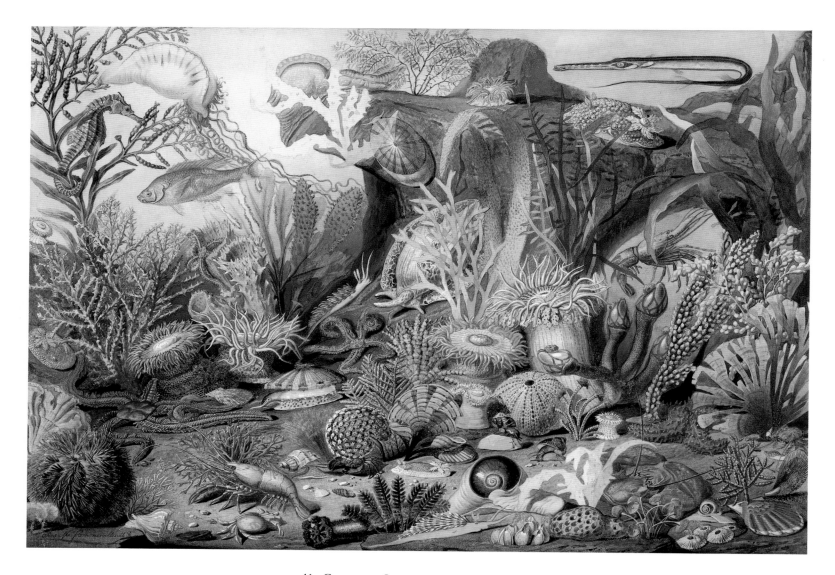

41. CHRISTIAN SCHUESSELE (1824/26–1879)
and JAMES SOMMERVILLE (d. 1899)
Ocean Life
Watercolor, gum arabic, gouache, and graphite
underdrawing on light green wove paper, 18⅞ × 27½ in.
Signed at lower right: C. Schuessele; at lower left: Jas
M Sommerville M.D.
Gift of Mr. and Mrs. Erving Wolf, 1977
1977.181

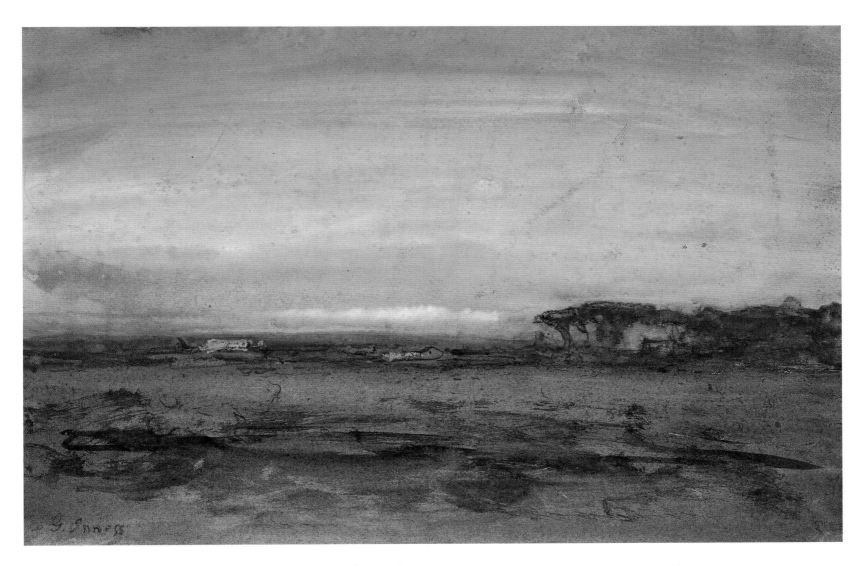

42. GEORGE INNESS
(1825–1894)
Across the Campagna, 1872
Watercolor, gouache, and graphite on off-white wove
paper (reverse: graphite drawing), $6^{13}/_{16} \times 10^{3}/_{8}$ in.
Signed at lower left: G. Inness. Inscribed and dated on
reverse: Ostia Dec. 1872
Bequest of Susan Dwight Bliss, 1966
67.55.145

43. GEORGE INNESS
(1825–1894)
Olive Trees at Tivoli, 1873
Watercolor, gouache, and black chalk on off-white
wove paper, $7 \times 12\frac{1}{4}$ in.
Signed and inscribed at lower left: G. Inness/Tivoli.
Inscribed and dated on reverse: Tivoli/April 1873
Morris K. Jesup Fund, 1989
1989.287

By 1894, the year of his death, George Inness had reached the pinnacle of fame as America's foremost landscape painter. Recognition had been hard won and came late in his career—during the last decade of a life spent out of the mainstream of art and out of step with other artists. Inness's poetic, subjective approach to landscape and his painterly style set him apart from the members of the contemporary Hudson River School, who favored precise descriptions of nature executed in a crisp, tightly painted manner. He was an intensely private person, imbued with spirituality and a fierce sense of independence. An archetypal romantic genius working "at white heat and under great emotion,"[1] Inness isolated himself from the art establishment.

Paintings in watercolor represent a small and particularly private segment of Inness's enormous artistic output. His work in the medium is not only rare—consisting of approximately fifty examples—but also relatively unfamiliar to the general public. Almost never exhibited or offered for sale during his lifetime, the watercolors remained in Inness's studio until after his death.

Olive Trees at Tivoli, one of a group of thirty-eight watercolors inherited by the artist's daughter, Mrs. Jonathan Hartley, was painted in Italy in 1873 during Inness's third trip abroad. More than half of his existing watercolors date from this period. From the point of view of subject matter, composition, and emphasis on detail, *Olive Trees* resembles several of Inness's oil paintings of Italian subjects, in particular *The Alban Hills* of 1873 (Worcester Art Museum, Worcester, Massachusetts). However, the watercolor is not a study but an entirely independent work— almost none of the artist's watercolors have direct relationships with known paintings. Inness's stay in Italy was financed by his Boston dealers, Williams and Everett, in exchange for the paintings he produced while abroad. Although he had been staunchly unwilling to compromise his approach to painting the American landscape, Inness evidently now felt it necessary to modify his style to produce commercially acceptable work. The Italian views, unlike many of his American ones, depict popular scenic attractions in a finished, detailed manner. This attempt to make concessions to popular taste may explain Inness's uncharacteristic interest in topography and picturesque detail as demonstrated in *Olive Trees.*[2]

With its harmonious palette and effective use of both gouache and transparent wash, *Olive Trees* is an accomplished, completely realized example of the artist's command of a difficult and challenging medium. The compositional format of a dark foreground overlooking a sunlit panorama in the middle ground demonstrates Inness's familiarity with the precepts of the classical Claudian landscape tradition.

1. Elliott Daingerfield, introduction to George Inness, Jr., *Life, Art, and Letters of George Inness* (New York, 1917), p. xiv.
2. For further information on the commercialization of Inness's style see Nicolai Cikovsky, Jr., "The Civilized Landscape," in Nicolai Cikovsky, Jr., and Michael Quick, *George Inness* (exhib. cat., Los Angeles County Museum of Art, 1985), p. 29.

44. ENOCH WOOD PERRY
(1831–1915)
A Month's Darning, 1876
Watercolor, gum arabic, and gouache on off-white
wove paper, 20 × 15¾ in.
Signed and dated at lower left: E. W. Perry/1876
Gift of Mr. and Mrs. Ferdinand H. Davis, 1966
66.240

From 1875 to 1902, Enoch Wood Perry, a genre painter who studied in Düsseldorf and Paris, was a regular exhibitor at the American Water Color Society, an organization he joined in 1877. Surprisingly, only two of the many watercolors he contributed to the Society's annual exhibitions have been located.[1] One of these, *A Month's Darning,* was described at length in the *Art Journal* when it was displayed at the society in 1876. As the reviewer noted, it was "one of the pleasant old-time domestic scenes"[2] that Perry made his specialty in the 1870s and 1880s. Works of this kind fulfilled a demand generated by the popular late-nineteenth-century taste for simple domestic scenes that celebrate the dignity of common household chores.

To portray the young model, Perry skillfully laid on his pigments with a dry brush, a technique that enabled him to render in a fastidious, detailed manner the dainty printed pattern of the sprigged muslin dress, the intricate weave of the wicker basket, and the carefully differentiated leaves and flowers of the various species of houseplants. The domestic scene represented is not a contemporary one, but rather a re-creation of the American past. Feelings of nostalgia are evoked by the leg-of-mutton sleeves and Empire cut of the old-fashioned dress and the outmoded furnishings of the simple interior. Considering that Perry also contributed *A Month's Darning* to the Centennial Exposition held in Philadelphia in 1876, we may be correct in detecting a patriotic leitmotif in the repetitive use of a red, white, and blue color scheme, seen in the young woman's neckerchief, the balls of wool in her lap, and the many socks tossed in studied disarray in the basket.

Although *A Month's Darning* attracted generally favorable critical notice, an observant writer for the *New York Daily Tribune* gently ridiculed the work for its lack of proper scale: "We are sorry that the sweet-faced girl in No. 18 should have such large-footed men-folk to darn for, for a family of such would almost be able to make a corner in yarn, by their yearly demand for stockings."[3]

1. *A Month's Darning* was number 18 in the American Society of Painters in Water Colors catalogue of 1876, and *Spun Out* was number 36 in the American Society of Painters in Water Colors catalogue of 1877. *Spun Out* reappeared on the art market in 1981: Skinner sale, Boulton, Mass., 19 November 1981, lot 54.
2. "Notes," *Art Journal,* vol. 2 (1876), p. 31.
3. "The Water-color Exhibition," *New York Daily Tribune,* 19 February 1876, p. 7.

45. WILLIAM TROST RICHARDS
(1833–1905)
Lake Squam and the Sandwich
Mountains, 1872
Watercolor, gouache, and graphite on
gray green wove paper, 8³⁄₁₆ × 14⁵⁄₁₆ in.
Signed and dated at lower right:
W. T. Richards. 1872
Gift of The Reverend E. L. Magoon,
D.D., 1880
80.1.8

46. WILLIAM TROST RICHARDS
(1833–1905)
Sunset on Mount Chocorua, New
Hampshire, 1872
Watercolor, gouache, and graphite on
green wove paper, 8¹⁄₈ × 14³⁄₈ in.
Signed and dated at lower right: Wᵐ T.
Richards, 1872
Gift of The Reverend E. L. Magoon,
D.D., 1880
80.1.10

47. WILLIAM TROST RICHARDS
(1833–1905)
The Franconia Mountains from Campton, New Hampshire, 1872
Watercolor, gouache, and graphite on tan wove paper, 8³⁄₁₆ × 14³⁄₁₆ in.
Signed and dated at lower right: Wᵐ T. Richards 1872
Gift of The Reverend E. L. Magoon, D.D., 1880
80.1.5

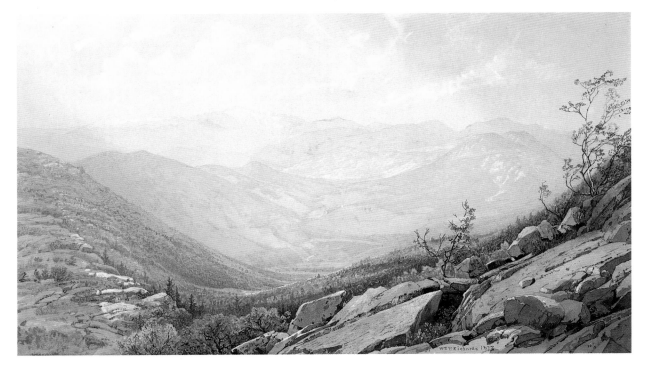

48. WILLIAM TROST RICHARDS
(1833–1905)
The Mount Washington Range, from Mount Kearsarge, 1872
Watercolor, gouache, and graphite on gray green wove paper, 8¹⁄₁₆ × 14³⁄₁₆ in.
Signed and dated at lower right: Wᵐ T. Richards 1872
Gift of The Reverend E. L. Magoon, D.D., 1880
80.1.4

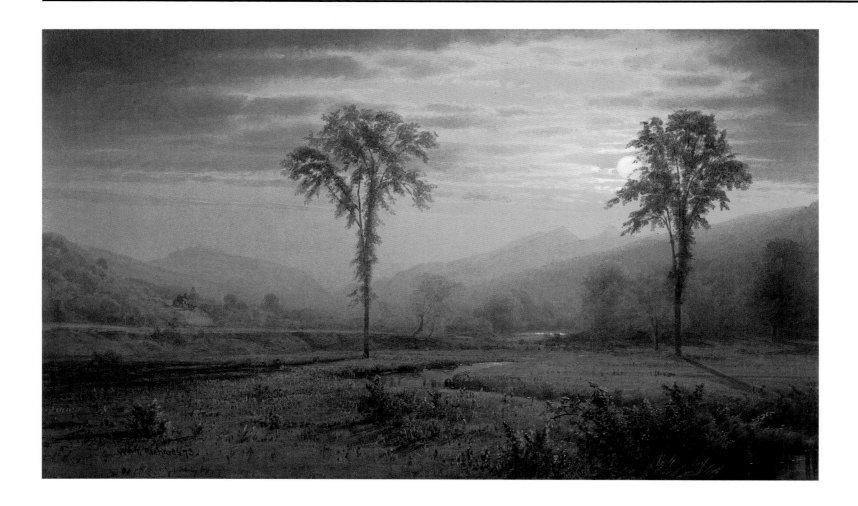

The landscapes of William Trost Richards, a Philadelphian who in the mid-1870s was praised by the critics as one of America's foremost artists working in the watercolor medium, are imbued with lofty moral and religious sentiments. Richards himself viewed landscape painting with high seriousness, considering it among the "foremost means for teaching and elevating human nature."[1] A letter written to the artist by the Reverend Elias L. Magoon, an avid collector and connoisseur of watercolors, confirms in extravagant terms Richards's skill in incorporating into his paintings a sense of God's immanence. He writes: "To me nothing is religious in modern art save the best of our landscape school, and your own is to my innermost being food the most refining for it is the truth of God."[2] Richards's and Magoon's belief in the ability of landscape to reveal spiritual truths reflects the reverential attitude toward nature prevalent during the mid-nineteenth century, when American scenery was recognized as the source of our national virtue and the visible manifestation of the hand of God.

Moonlight on Mount Lafayette, New Hampshire is one of twenty-three works depicting the White Mountains and their environs that were commissioned by Magoon and executed between 1872 and 1874. Magoon, born and brought up in New Hampshire, was an important patron and friend of the artist and he accompanied Richards on several excursions to gather material for the White Mountain pictures.

Although Richards's exquisitely detailed watercolors of the mountainous New Hampshire scenery reveal a world of tranquil beauty, described by a contemporary guidebook as a "quotation from Arcadia, or a suburb of Paradise,"[3] it is interesting to note that these seemingly peaceful and sublime landscapes were not visited and described without considerable physical discomfort. In a letter of 1872 recounting a sketching excursion in and about North Conway, an important center for tourism in the White Mountains, Richards complained that he "came down wounded and sore," suffering from intense heat and from "a pervading atmosphere of black flies."[4]

The view looking north from the Pemigewasset Valley toward Mount Lincoln, Mount Lafayette, and the Franconia Notch is a conventional one, appearing in other paintings and engravings of the period, but Richards's poetic choice of a nocturnal, moonlit setting for this scene is unusual and demonstrates the artist's interest in capturing evocative atmospheric effects. He created a delicate chromatic harmony through the use of gray green paper and a limited palette of complementary olive-greens and grays. The silhouette of the distant peaks, realized by thin applications of wash, serves as a backdrop for the more densely worked, carefully delineated meadow. By skillfully varying the tone and density of paint, from the dark opaque gouache of the foreground to the light, transparent wash of the horizon, the artist enhanced our sense of aerial perspective.

49. WILLIAM TROST RICHARDS
(1833–1905)
Moonlight on Mount Lafayette, New Hampshire, 1873
Watercolor, gouache, and graphite on green wove paper, 8½ × 14³⁄₁₆ in.
Signed and dated at lower left: Wm T. Richards 73.
Gift of The Reverend E. L. Magoon, D.D., 1880
80.1.2

1. Quoted in Linda S. Ferber, *William Trost Richards: American Landscape and Marine Painter, 1833–1905* (exhib. cat., Brooklyn Museum, 1973), p. 15.
2. Elias L. Magoon to William Trost Richards, 4 May 1875, William Trost Richards Papers, Archives of American Art/Smithsonian Institution.
3. Thomas Starr King, *The White Hills: Their Legends, Landscape, and Poetry* (Boston, 1866), p. 152.
4. William Trost Richards to George Whitney, 2 July 1872, William Trost Richards Papers, Archives of American Art/Smithsonian Institution.

50. WILLIAM TROST RICHARDS
(1833–1905)
Lake Squam from Red Hill, 1874
Watercolor, gouache, and graphite on green wove
paper, 8⅞ × 13⅝ in.
Signed and dated at lower right: W^m T. Richards.
1874
Gift of The Reverend E. L. Magoon, D.D., 1880
80.1.6

"William T. Richards maintains his proud pre-eminence whether he dissolves his genius in water or oil,"[1] reported *The Aldine* in 1875. Initially, however, it was as a painter in oil that Richards established his reputation. The expressive possibilities of watercolor did not stimulate the artist's interest until 1870, when at the age of thirty-seven, he began to devote serious attention to working in the medium. From 1872 through 1875, two enthusiastic Philadelphian patrons, the Reverend Elias L. Magoon and the industrialist George Whitney, loaned numerous examples of the artist's work to the annual exhibitions of the American Society of Painters in Water Colors. As a result of this exposure, Richards soon achieved prominence as an acknowledged master of the American watercolor school and was particularly recognized for his coastal subjects.

Lake Squam from Red Hill, loaned by Magoon to the society's exhibition of 1875 (the picture was number 187 in the catalogue), is a superb example of the elaborate technique Richards developed during the first half of the 1870s. His method displays none of the characteristics of speed or spontaneity inherent in the transparent watercolor medium; instead, the artist relied upon an extensive use of gouache to create a rich, complex surface with a high degree of finish. Emphasis is placed on close observation and topographical accuracy; *Lake Squam* depicts an actual scene and is not a composite view. Magoon frequently visited the sites that Richards had painted to compare, in his mind's eye, nature's original with the artists' view "as to accuracy in lines and truth in coloring." Favorably impressed, he concluded, "Never from under any human hand have I recognized such minuteness of detail coupled with breadth of rendering."[2]

Squam Lake, described as "the most beautiful of all the small sheets of water in New England,"[3] was a popular tourist attraction for those en route to the White Mountains from Boston or New York. The excursion to the summit of Red Hill was particularly recommended, for its then unwooded peak was at the height from which the scenery looked the most "charming."

Critical response to *Lake Squam* was disappointing. The reviewers disapproved of the intense sunset colors of Richards's panoramic vision, preferring his more familiar tonal seascapes. In a review of the exhibition at the American Society of Painters in Water Colors, a reporter for the *New York Times* described the work as "*Lake Squam,* an evening scene, with a heavy sky, which we do not much admire."[4]

1. *The Aldine,* vol. 7 (May 1875), p. 339.
2. Elias L. Magoon to William Trost Richards, 4 May 1875, Wiliam Trost Richards Papers, Archives of American Art/Smithsonian Institution.
3. Thomas Starr King, *The White Hills; Their Legends, Landscape and Poetry* (Boston, 1866), p. 84.
4. *New York Times,* 7 February 1875, p. 9.

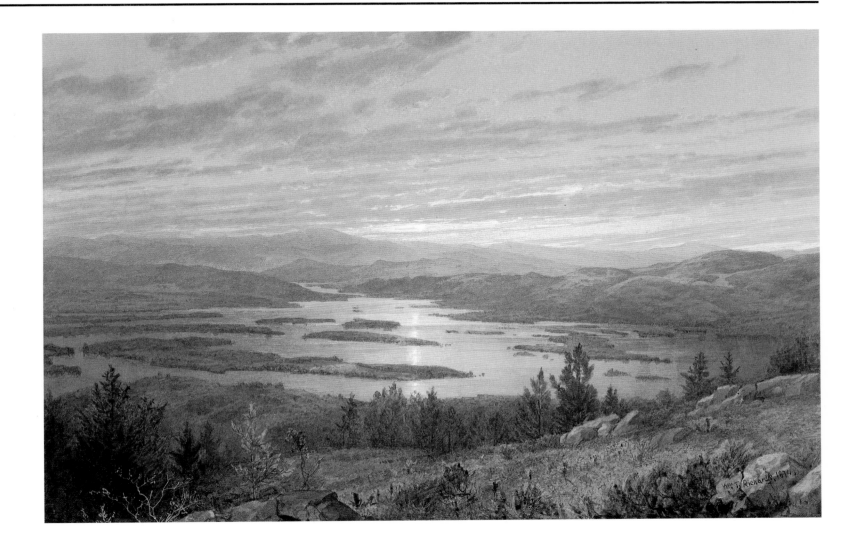

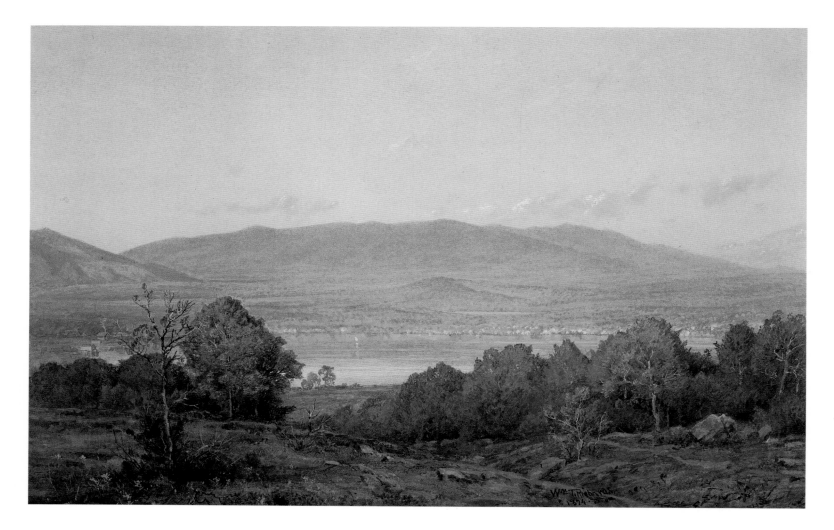

51. WILLIAM TROST RICHARDS
(1833–1905)
Sundown at Centre Harbor, New Hampshire,
1874
Watercolor, gouache, and graphite on green wove
paper, 8⅞ × 13⅝ in.
Signed and dated at lower right: Wm T. Richards/
1874
Gift of The Reverend E. L. Magoon, D.D., 1880
80.1.1

52. WILLIAM TROST RICHARDS
(1833–1905)
Purgatory Cliff, 1876
Watercolor, gouache, and graphite
underdrawing on tan wove paper, 13 × 10 in.
Signed and dated at lower left: Wm T.
Richards 1876
Bequest of Susan Dwight Bliss, 1966
67.55.141

53. WILLIAM TROST RICHARDS
(1833–1905)
A Rocky Coast, 1877
Watercolor and gouache on gray oatmeal wove paper,
22³/₁₆ × 36 in.
Signed and dated at lower right: Wᵐ T. Richards
1877
Bequest of Catharine Lorillard Wolfe, 1887
87.15.6

54. WILLIAM TROST RICHARDS
(1833–1905)
From Paradise to Purgatory, Newport, 1878
Watercolor, gouache, and graphite on tan wove
paper, 10$\frac{1}{16}$ × 14$\frac{1}{2}$ in.
Signed and dated at lower right: Wm T. Richards.
1878
Bequest of Susan Dwight Bliss, 1966
67.55.142

55. JAMES DAVID SMILLIE
(1833–1909)
The Ausable, September, 1869, 1869
Watercolor and gouache on green wove paper,
9$\frac{1}{2}$ × 12$\frac{7}{8}$ in.
Inscribed and dated at lower left: On the Au Sable/
Sept 1869
Purchase, J. William Middendorf II Gift, 1967
67.274

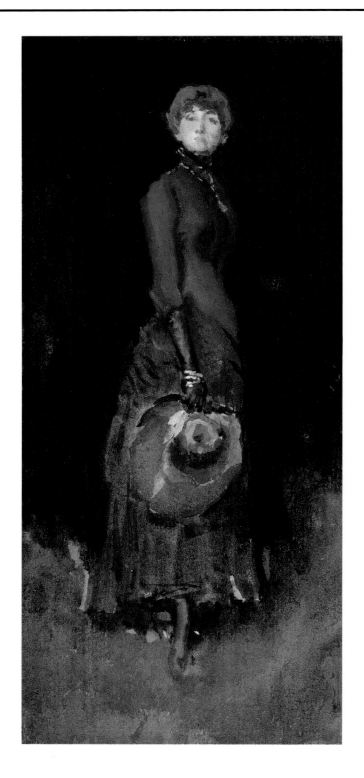

James McNeill Whistler, the innovative expatriate artist who moved in avant-garde circles in Paris and London, was supremely accomplished in a variety of mediums, working with equal facility in oil, watercolor, pastel, pencil, etching, and lithography. Although Whistler had used watercolor on occasion since his school days, it was not until the 1880s—relatively late in his career—that he turned to the medium as an important means of artistic expression.

The first major public showing of the artist's watercolors took place in May 1884, at the Dowdeswell Gallery, London, in a one-man exhibition entitled, in an idiosyncratic Whistlerian manner, " 'Notes'—'Harmonies'—'Nocturnes.' " Of the sixty-seven pictures exhibited—all quite small in scale—twenty-seven were watercolors, depicting a variety of subjects including seascapes, urban views, intimate genre scenes, and figure studies. The exhibition proved successful enough both financially and critically to encourage the gallery owner to show another selection of Whistler's small oils, watercolors, and pastels in 1886.

In June 1889, the Art Institute of Chicago included the gouache and watercolor portrait *Lady in Gray* in its "Second Annual Exhibition of American Paintings and Sculpture," and it was favorably mentioned in a local newspaper review.

> Whistler's haughty "Lady in Gray" is posing . . . , but she does it with absolute frankness. She is there to be impertinent, and no one can be as delightfully impertinent as Whistler— always intrusive and yet always welcome. . . . The little picture has been snapped up of course, and thus our supercilious English girl is destined to frown upon Chicago during the rest of her immortal youth.[1]

Watercolor as handled and interpreted by Whistler is frequently a delicate, evanescent medium; his studies in wash are often poetic impressions evoked with a few assured strokes of a wet brush without any reliance on preliminary outlines. In *Lady in Gray*, however, the artist attempted to achieve different effects—relying on gouache to provide a fully developed, dense image with a rich surface rather than on transparent watercolor, which would have sunk into the gray brown paper, a support that he ordinarily reserved for pastels and colored chalk drawings. Despite its small scale, *Lady in Gray* possesses all the authority and presence of Whistler's full-length portraits in oil. The artist has even chosen the same narrow, vertical format that he favored for his formal full-length figure studies.

The identity of the arrogant subject of *Lady in Gray* remains uncertain. Once believed to be the elegant Olga Caracciolo, godchild and perhaps illegitimate daughter of Albert Edward, Prince of Wales,[2] she now is thought to be Millie Finch,[3] a model who posed for several of Whistler's watercolors now in the Freer Gallery of Art in Washington, D.C., and for three of his oil paintings in the collection of the Hunterian Art Gallery, University of Glasgow.[4]

56. JAMES MCNEILL WHISTLER
(1834–1903)
Lady in Gray
Gouache and watercolor on gray brown wove paper,
11⅛ x 4⅞ in.
At right: [butterfly monogram]
Rogers Fund, 1906
06.312

1. *Chicago Tribune*, 9 June 1889, p. 26.
2. Philippe Jullian, "Olga the Wild: The Amazing Baroness de Meyer," *Vogue*, October 1971, pp. 158–59.
3. See *Notes, Harmonies and Nocturnes*, introduction by Margaret F. MacDonald (exhib. cat., M. Knoedler & Company, New York, 1984), p. 35.
4. For further information pertaining to Whistler's portraits of Millie Finch, see David Park Curry, *James McNeill Whistler at the Freer Gallery of Art* (New York and London, 1984), pp. 201–3.

57. JAMES MCNEILL WHISTLER
(1834–1903)
Scene on the Mersey
Watercolor and gouache on off-white wove paper,
8½ × 5 in.
At lower left: [butterfly monogram]
Harris Brisbane Dick Fund, 1917
17.97.4

58. WILLIAM STANLEY HASELTINE
(1835–1900)
Vahrn in Tyrol near Brixen
Watercolor and gouache on blue wove paper,
14¹³⁄₁₆ × 21¹³⁄₁₆ in.
Signed and inscribed at lower right:
Wm. S. Haseltine/Tyrol
Gift of Mrs. Roger Plowden, 1967
67.173.2

59. WILLIAM STANLEY HASELTINE
(1835–1900)
Castel Fusano—near Rome
Watercolor, gouache, and charcoal on blue wove
paper, 14¾ × 21⅜ in.
Inscribed on reverse: Castel Fusano by
Wm. S. Hase[ltine]/near Rome
Gift of Mrs. Roger Plowden, 1967
67.173.4

60. WILLIAM STANLEY HASELTINE
(1835–1900)
Sette Sale (Villa Brancaccio), Rome
Watercolor, gouache, and charcoal on blue wove
paper, 15⅛ × 22¹⁄₁₆ in.
Signed at lower right: W. S. H.
Gift of Mrs. Roger Plowden, 1967
67.173.1

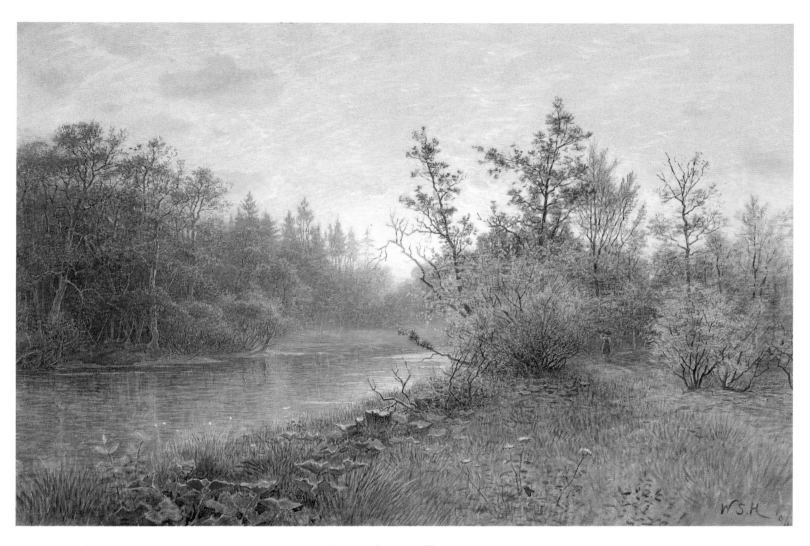

61. WILLIAM STANLEY HASELTINE
(1835–1900)
Mill Dam in Traunstein, 1894
Watercolor and gouache on blue wove paper,
15⅛ × 22¼ in.
Signed and dated at lower right: W. S. H./94
Gift of Mrs. Roger Plowden, 1967
67.173.5

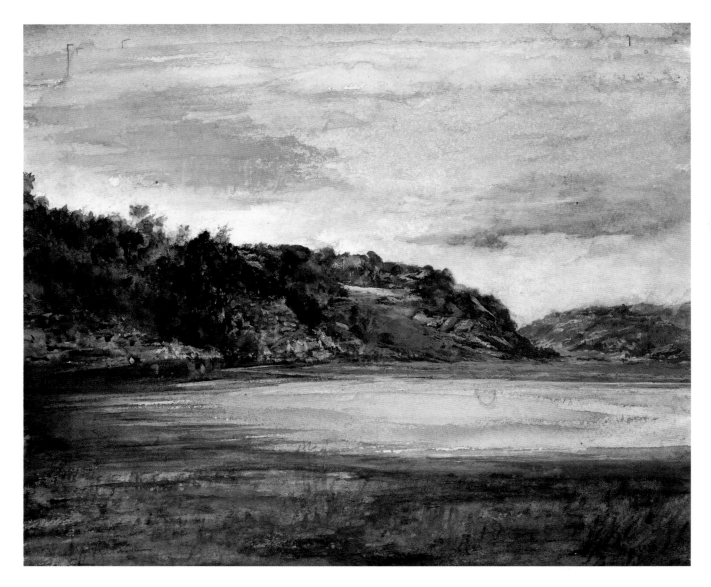

62. JOHN LA FARGE
(1835–1910)
***Paradise Rocks—Study at Paradise,
Newport, R. I.***
Gouache and watercolor on white wove paper,
8 × 9⁷⁄₁₆ in.
Signed at lower left: La Farge
Bequest of Susan Dwight Bliss, 1966
67.55.171

63. JOHN LA FARGE
(1835–1910)
***The Great Statue of Amida Buddha at
Kamakura, Known as the Daibutsu, from the
Priest's Garden***
Watercolor and gouache on off-white wove paper,
19³⁄₁₆ × 12½ in.
Gift of the family of Maria L. Hoyt, 1966
66.143

64. JOHN LA FARGE
(1835–1910)
Wild Roses and Irises, 1887
Gouache and watercolor on white wove paper, 14½
× 10⅞₁₆ in.
Signed and dated at upper left: L. F. 87; at lower right:
Jn La Farge/1887
Gift of Priscilla A. B. Henderson, 1950, in memory of
her grandfather, Russell Sturgis, a founder of the
Metropolitan Museum of Art
50.113.3

John La Farge's renderings of flowers, whether in watercolor, oil, or stained glass, are considered among the most beautiful works in the artist's oeuvre. La Farge's intention was not to produce a detailed, botanically accurate copy after nature but rather to capture the essence or soul of the flower. A contemporary critic, favorably impressed with the artist's poetic and lyrical approach to still-life painting, remarked, "His flowers have no botanical truth, but are burning with love and beauty."[1] Even after La Farge's death, when his reputation as a multitalented Renaissance man began to erode, critics still continued to admire the exquisite tonal harmonies and subtle nuances of his flower paintings.

The child of wealthy, refined French emigrés, La Farge grew up in a cosmopolitan household surrounded by old master paintings and books by the great French authors. His introduction to and early instruction in watercolor painting was administered by his maternal grandfather, himself a miniaturist; however, it was not until the late 1870s, when interior decoration assumed increasing importance for La Farge, that watercolor became his preferred medium of artistic expression. The inherent properties of watercolor, the speed and fluidity with which it can be manipulated, made it an ideal technique with which to make rapid sketches for designs in stained glass, textiles, and murals.

Unlike several of his watercolor studies of peonies and of hollyhocks that can be related to La Farge's stained-glass window designs, *Wild Roses and Irises* is a work entirely independent of the artist's decorative commissions. The choice of flowers, the rich blue-green tonal harmonies, and the ambiguous spatial relationships are derived from ideas the artist had explored earlier in the oil painting titled *Flowers. Blue Iris, with Trunk of Dead Apple-Tree in the Background. Newport* of 1871 (currently on the art market) and the watercolor *Blue Iris. Study* of 1879 (Jerald D. Fessenden). The subtle variation of original compositions to create new solutions is entirely consistent with La Farge's approach.

The artist included *Wild Roses and Irises* in a large collection of his works to be exhibited in Paris in the 1895 Salon of the Champ de Mars. Before their shipment to Europe, the paintings were displayed in New York City at the galleries of Durand-Ruel, for whom La Farge wrote an annotated catalogue filled with interesting comments and descriptions.[2]

In *Wild Roses and Irises*, the artist offers a convincingly realistic representation of irises viewed at close range against a highly stylized background. His use of bold asymmetry and flat patterning suggests the influence of Japan, a country whose art and culture had long fascinated and inspired the artist.

1. Quoted in Henry T. Tuckerman, *Book of the Artists: American Artist Life* (New York and London, 1867), p. 489.
2. *Wild Roses and Irises* was number 231 in *Paintings, Studies, Sketches and Drawings: Mostly Records of Travel 1886 and 1890–91 by John La Farge* (exhib. cat., Durand-Ruel Galleries, New York, 1895). The exhibition label remains adhered at the lower left.

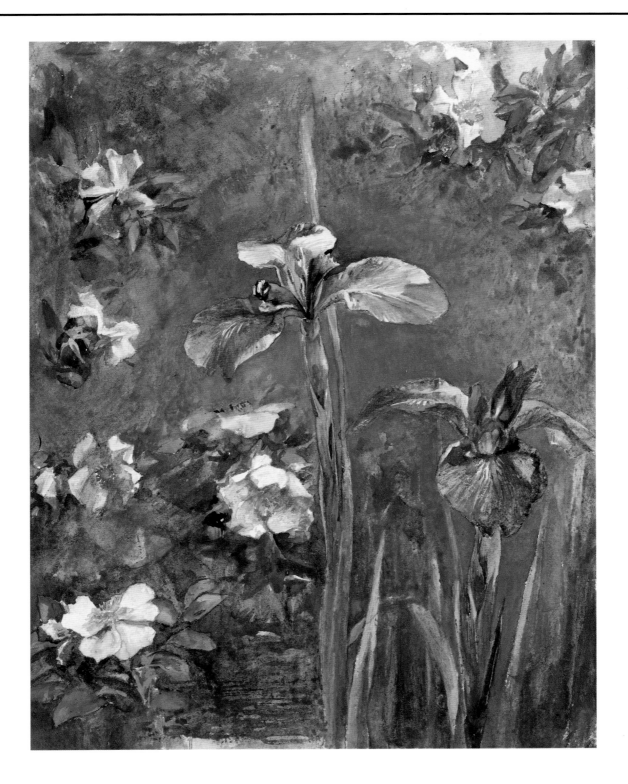

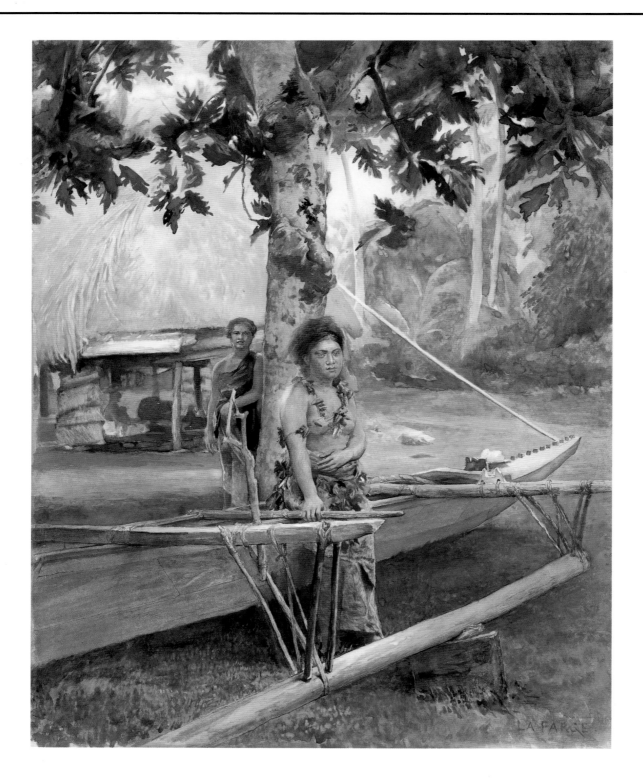

In 1890 John La Farge and the historian Henry Adams, his long-time friend, set forth on a journey to the distant South Seas. The two adventurers had been traveling companions before; in 1886 La Farge had accompanied Adams as his guest on a short trip to Japan. The South Seas tour was a more ambitious undertaking, lasting fifteen months, during which time La Farge produced nearly two hundred watercolor sketches of Hawaii, Samoa, Fiji, Tahiti, and Ceylon.[1]

At their first port of call, Hawaii, much of the indigenous culture had been destroyed by foreign influence and large areas of natural landscape had been ruined by the American-owned sugarcane plantations, but their next stop, Samoa, had rarely been visited by Western travelers and remained remarkably unspoiled. The innocence and beauty of the natives and the tropical exoticism of the landscape overwhelmed La Farge and Adams, who found in Samoa the island paradise they had been seeking. La Farge likened the Samoan culture to that of the Greek Golden Age and the handsome Polynesian women to Greek naiads.

Treated with the hospitality and respect owed to visiting dignitaries, the American travelers witnessed native ceremonies and were entertained by the spectacle of statuesque women dancing the graceful, traditional *siva*. One of the local beauties to whom they were introduced was Faase the Taupo, or Official Virgin, of Fagaloa Bay, the subject of this watercolor.[2] For La Farge, Faase represented the essence of South Seas culture. She figures prominently in several of his sketches, and the artist noted in detail the complexities of her many duties: "The Official Virgin is always chosen of good family . . . She ought to be innocent and gracious and know how to sing and dance and make herself agreeable, as a sort of leader of society. . . . It is also her privilege, in time of war, to dance and sing at the head of the combatants at the beginning of the fight."[3]

La Farge may well have relied on photography as a source for the composition of *Portrait of Faase*. The perspectival distortions of the outrigger canoe seen in the foreground are characteristic of those produced by a camera lens, and the high finish and large scale of the painting suggest that it is not an on-the-spot sketch but rather a studio re-creation, for which the artist relied on sketches, photographs, memory, and reflection. It is known that Adams and La Farge recorded their impressions of Samoan life with a camera. Adams described how he toiled over his Kodak, taking thirty or forty views in the hope that they might be of help to La Farge. Both travelers also purchased commercial photographs of the island.

When exhibited at the American Watercolor Society in 1893, La Farge's watercolors of the South Seas proved to be a critical and popular success. The critics of the *New York Times*, *New York Tribune*, and *Art Amateur* singled out the *Portrait of Faase* (number 309 in the exhibition catalogue) as particularly striking and deserving of praise.

65. JOHN LA FARGE
(1835–1910)
Portrait of Faase, the Taupo of Fagaloa Bay, Samoa
Watercolor and gouache on off-white wove paper, 23 1/16 × 17 5/8 in.
Signed at lower right: LA FARGE
Bequest of Susan Vanderpoel Clark, 1967
67.155.5

1. A detailed description of La Farge's trip to the South Seas is provided in James L. Yarnall, "John La Farge and Henry Adams in the South Seas," *American Art Journal*, vol. 20, no. 1 (1988), pp. 51–109.
2. This work has previously been known as *Faase and Her Duenna, Samoa*. It has been retitled *Portrait of Faase, the Taupo of Fagaloa Bay, Samoa*, the name La Farge exhibited it under in the American Water Color Society catalogue of 1893.
3. *Paintings, Studies, Sketches and Drawings: Mostly Records of Travel 1886 and 1890–91 by John La Farge* (exhib. cat., Durand-Ruel Galleries, New York, 1895), pp. 19–20.

66. JOHN LA FARGE
(1835–1910)
Girls Carrying a Canoe, Vaiala, Samoa, 1891
Watercolor and gouache on off-white wove paper,
18 1/16 × 21 7/8 in.
Signed and dated at lower left: La Farge 1891.
Inscribed at lower right: Samoa — girls with canoe; at
bottom: My dear Bam, I send this as it is . . .
Purchase, Mrs. Arthur Hays Sulzberger Gift, in
memory of Mr. Arthur Hays Sulzberger, 1970
1970.120

67. JOHN LA FARGE
(1835–1910)
*The Strange Thing Little Kiosai Saw in the
River,* 1897
Watercolor and gouache on thin off-white wove
paper laid down on white wove paper, 12 3/8 x 18 in.
Signed and dated at lower right: JLF/97
Rogers Fund, 1917
17.180.2

68. WINSLOW HOMER
(1836–1910)
Two Ladies, 1880
Watercolor and graphite on off-white wove paper,
6¹⁵⁄₁₆ × 7¹⁵⁄₁₆ in.
Signed and dated at lower right: HOMER/1880
Gift of Estate of Florence Baird Meyer, in her
memory, 1918
18.123.3

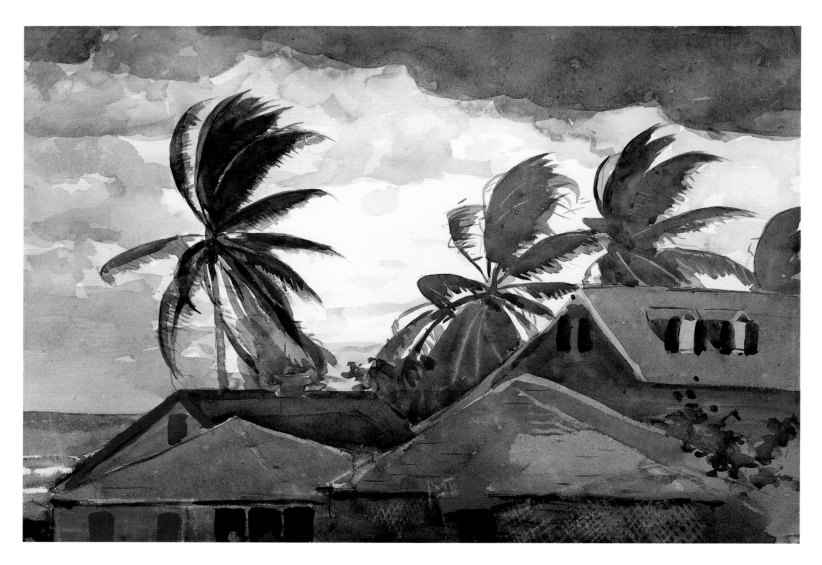

69. WINSLOW HOMER
(1836–1910)
Hurricane, Bahamas
Watercolor and graphite on off-white wove paper,
14½ × 21⅛ in.
Amelia B. Lazarus Fund, 1910
10.228.7

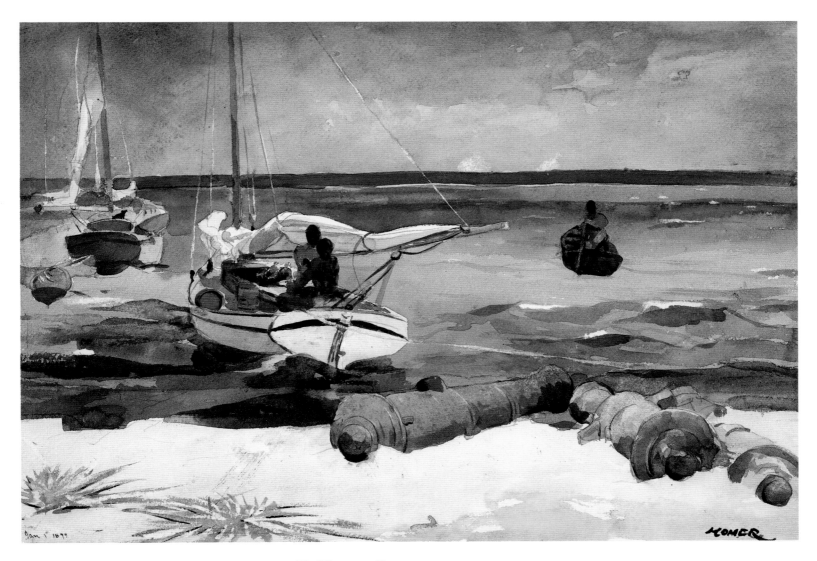

70. WINSLOW HOMER
(1836–1910)
Nassau, 1899
Watercolor and graphite on white wove paper,
14$^{15}/_{16}$ × 21$^{3}/_{8}$ in.
Signed at lower right: HOMER. Dated at lower left:
Jan 1st 1899
Amelia B. Lazarus Fund, 1910
10.228.4

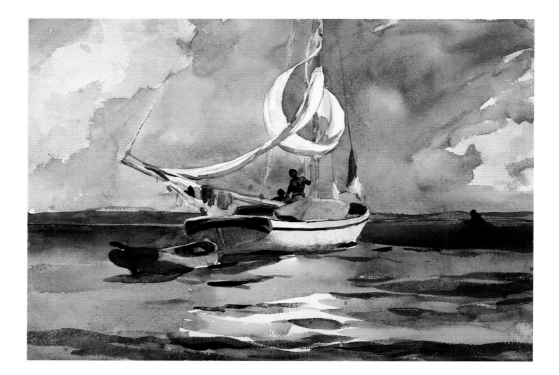

71. WINSLOW HOMER
(1836–1910)
Sloop, Nassau
Watercolor and graphite on off-white wove paper,
14⅞ × 21⁷⁄₁₆ in.
Amelia B. Lazarus Fund, 1910
10.228.3

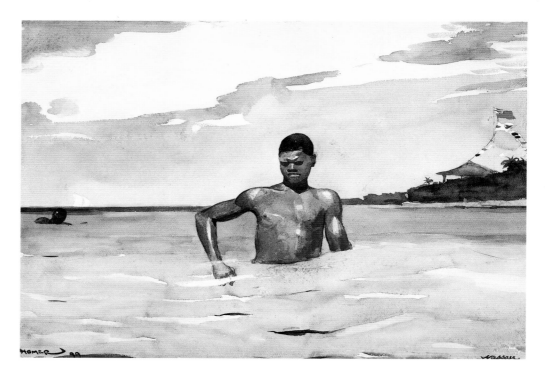

72. WINSLOW HOMER
(1836–1910)
The Bather, 1899
Watercolor and graphite underdrawing on off-white
wove paper, 14½ × 21¹⁄₁₆ in.
Signed and dated at lower left: HOMER 99. Inscribed
at lower right: Nassau.
Amelia B. Lazarus Fund, 1910
10.228.8

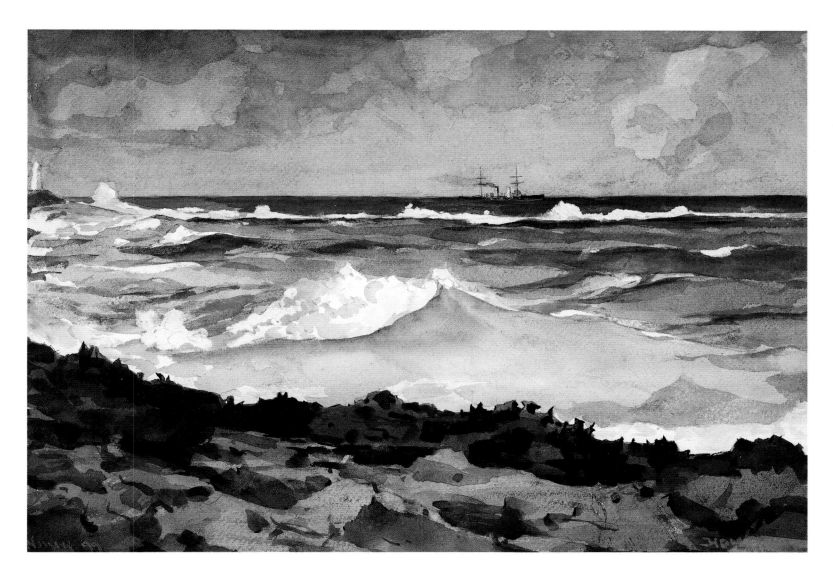

73. WINSLOW HOMER
(1836–1910)
Shore and Surf, Nassau, 1899
Watercolor and graphite on off-white wove paper,
14¹⁵⁄₁₆ × 21³⁄₈ in.
Signed at lower right: HOMER. Inscribed and dated
at lower left: Nassau 99
Amelia B. Lazarus Fund, 1910
10.228.5

74. WINSLOW HOMER
(1836–1910)
Natural Bridge, Bermuda
Watercolor and graphite on white wove paper,
14½ × 21 in.
Amelia B. Lazarus Fund, 1910
10.228.12

Winslow Homer, the archetypal Yankee, made his first visit to a tropical island in 1884, when *Century Magazine* commissioned him to illustrate a travel article on Nassau. His experience of the scintillating Caribbean sunlight and the saturated greens and azure blues of the tropical landscape utterly transformed his palette and liberated his watercolor style. Subsequent visits to Florida, a return trip to Nassau, and successive trips to Bermuda confirmed the artist's tropical vocabulary, in which he employed a stark, simplified format, brilliant sun-drenched color, broad brushstrokes and fluid, transparent washes.

During the winter of 1899–1900, Homer vacationed at the British Crown Colony of Bermuda. His six-week stay on the beautiful semitropical island must have been more than merely pleasant, for he visited Bermuda again in 1901 and during the period of both visits produced an inspired series of approximately nineteen works documenting his impressions of the island.[1]

Natural Bridge, painted about 1901, is one of three known watercolors in which Homer described the curious rock formations characteristic of the Bermuda coastline.[2] The artist included in each of these pictures one or more minuscule figures dressed in the red tunic of the British military. British soldiers were a common presence on the island between 1900 and 1902 since Boer prisoners taken during the South African War were detained there. In Homer's watercolors the tiny figures perform no military function; they are mere dots of bright color probably intended to provide proper scale and to dramatize man's insignificance within the grand, expansive context of the natural environment.

In subject and composition, *Natural Bridge* is reminiscent of an earlier work, *Glass Windows, Bahamas* of 1885 (Brooklyn Museum). However, the Brooklyn picture does not display the audacious patterning and denial of depth that renders *Natural Bridge*, in essence, an abstraction.

Homer himself regarded *Natural Bridge* as among his finest compositions. It was one of a group of watercolors he refused to sell, in the hope that they would be kept together to form a public record of his complete mastery of the medium. Eight months prior to his death, he agreed, in principle, to allow the Metropolitan Museum first choice before offering them to anyone else. He also added that he was not in any hurry to dispose of the works. Predictably, the paintings remained unsold during his lifetime. In 1910 the museum was finally successful in purchasing twelve works out of the original group from Charles Homer, the executor of his brother's estate.

1. For a detailed description of Homer's visits to Bermuda, see Helen A. Cooper, *Winslow Homer Watercolors* (New Haven and London, 1986), pp. 218–27.
2. The Natural Bridge was previously thought to be located on the island of Nassau. The site has now been identified in Bermuda. See Philip C. Beam, *Winslow Homer Watercolors* (exhib. cat., Bowdoin College Museum of Art, Brunswick, Maine, 1983), p. 31; and catalogue entry by Helen A. Cooper, in *American Traditions in Watercolor: The Worcester Art Museum Collection*, ed. Susan E. Strickler (New York, 1987), p. 112. Homer painted at least two other Bermuda watercolors combining similar rock formations with small military figures: *Rocky Shore, Bermuda* of 1900 (Museum of Fine Arts, Boston) and *Coral Formations* of 1901 (Worcester Art Museum, Worcester, Mass.).

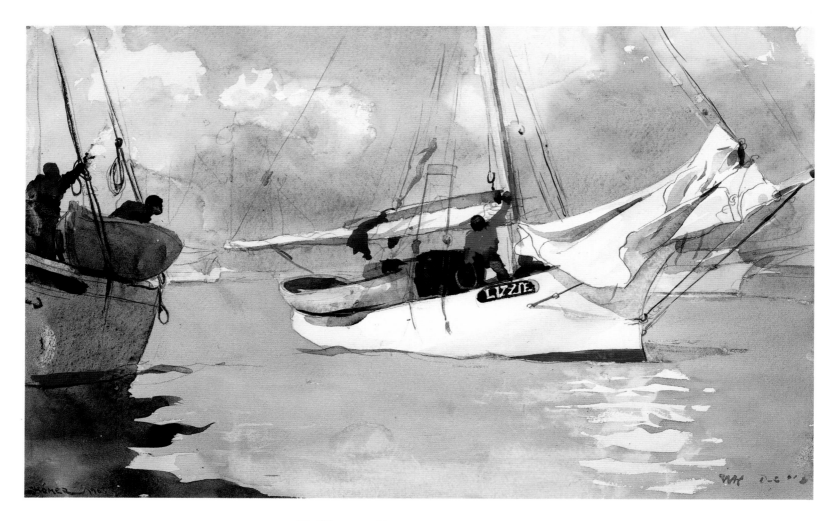

75. WINSLOW HOMER
(1836–1910)
Fishing Boats, Key West, 1903
Watercolor and graphite on white wove paper,
13⅞ × 21¾ in.
Signed and dated at lower left: HOMER 1903; at
lower right: W H Dec[?]
Amelia B. Lazarus Fund, 1910
10.228.1

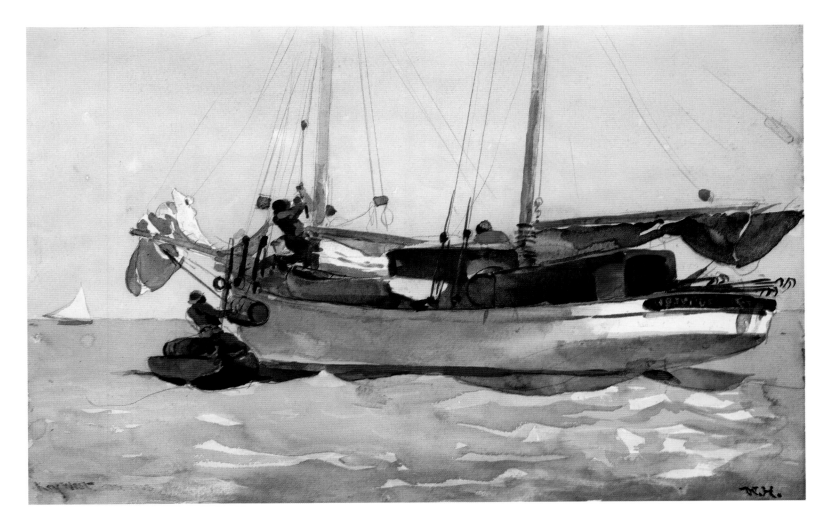

76. WINSLOW HOMER
(1836–1910)
Taking On Wet Provisions, 1903
Watercolor and graphite on white wove paper,
14 × 21¾ in.
Signed at lower right: W. H. Inscribed and dated at
lower left: Key West Dec[?] 1903
Amelia B. Lazarus Fund, 1910
10.228.11

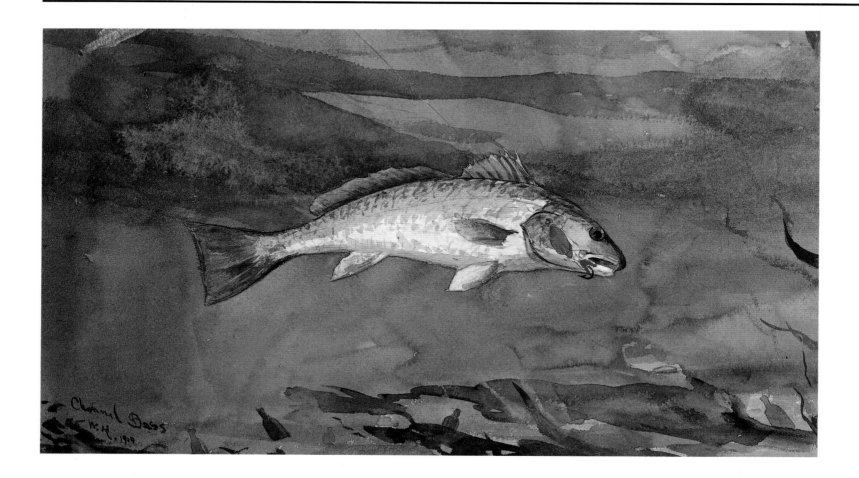

77. WINSLOW HOMER
(1836–1910)
Channel Bass, 1904
Watercolor and graphite underdrawing on white
wove paper, 11¼ × 19⅜ in.
Inscribed, signed, and dated at lower left: Channel
Bass/W. H./1904. Inscribed on reverse: No 13
Channel Bass Florida
George A. Hearn Fund, 1952
52.155

"He did not go in much for expensive or elaborate tackle, but he usually caught the biggest fish," said Charles Homer of his brother Winslow's enthusiasm for and knowledge of the sport of fishing.[1] This interest is clearly reflected in the variety and number of Homer's compositions detailing and documenting fishing themes. Such was the artist's passion for the angler's art, that he frequently planned vacations that combined both fishing and sketching in such diverse locales as the Canadian wilderness and the Florida coast.

On one of these vacations, in January 1904, when the artist was not quite sixty-eight years old, he visited Homosassa, a village on the Gulf of Mexico located north of Tampa.[2] The village was not a fashionable resort, its major attraction being its reputation as an angler's paradise. In an undated letter to his brother Arthur, Homer expressed his delight in Homosassa, "Fishing the best in America as far as I can find." Rather than describing to his brother the kinds of fish native to the area, the artist characteristically made simple annotated sketches of the day's catch. For example, under the drawing of the channel bass, the subject of this watercolor, he noted that it resembled "a new $20 gold piece."[3]

Homer returned to Homosassa on several occasions but produced watercolors only on his first visit. Among the Homosassa subjects are several that depict black bass leaping out of the water in their futile efforts to escape the cruel fishhooks. These active, dramatic scenes are reminiscent of Homer's earlier compositions of leaping trout and salmon painted in the Adirondacks and Canada.

Channel Bass, with its sumptuous, stained-glass colors and symmetrical, static composition establishes an entirely different tone, although it, too, recalls some of Homer's earlier watercolors of fish subjects. In *Channel Bass* the artist disassociates the fish from its ichthyological context and elevates it to a level of aesthetic contemplation—the creature has been transformed into an object of beauty. The bold red of the fly, the dabs of yellow on the fins, and the brilliant green of the underwater vegetation are jeweled highlights in an environment created by many layers of transparent lapis-blue wash. The composition is essentially decorative and ambiguous, not unlike the watercolors of still-life subjects painted by Homer's friend John La Farge (see plate 64). The viewer cannot confirm with certainty even so fundamental a perception as whether or not the fish is in or out of the water. What Homer has, in fact, produced is a still life of a live subject, with all its corresponding contradictions and mystery.

1. Quoted in Lloyd Goodrich, introduction to *Winslow Homer in the Adirondacks* (exhib. cat., Adirondack Museum, Blue Mountain Lake, N.Y., 1959), p. 8.
2. For a more detailed description of Homer's visit to Homosassa, see Helen A. Cooper, *Winslow Homer Watercolors* (New Haven and London, 1986), pp. 234–37.
3. The undated letter that includes this drawing is in the Homer Collection, Bowdoin College Museum of Art, Brunswick, Maine.

78. HENRY FENN
(1838–1911)
Everglades
Watercolor, gum arabic, gouache, and graphite
underdrawing on off-white wove paper,
7⁵⁄₁₆ × 10¾ in.
Signed and dated at lower left: H. Fenn 70[?]
Purchase, Frederick H. Rohlfs Gift, 1973
1973.290.1

79. HENRY FENN
(1838–1911)
Caesarea Philippi (Banias), 1878
Watercolor, gouache, brown ink, and
graphite on light brown wove paper,
12¹¹⁄₁₆ × 20⅝ in.
Inscribed, signed, and dated at lower left:
Caesarea-Philippi Banias—/(Paneas)
H. F. May 22 78/(Luke IX.51)/
(Matt. XVI 13.20 XVII 1.13)/
Camel/too large
Maria DeWitt Jesup Fund and Morris
K. Jesup Fund, 1980
1980.298

80. WILLIAM JOHN HENNESSY
(1839–1917)
An Old Song, 1874
Watercolor, gum arabic, and gouache on
off-white wove paper, 14⅝ × 11⅛ in.
Signed and dated at upper left: WJH
(in monogram) ENNESSY 1874
Purchase, Gift of George A. Lucas, by
exchange, and Bequest of George D. Pratt,
by exchange, 1982
1982.314

81. GEORGE HENRY SMILLIE
(1840–1921)
Tremezzo, Lake Como, 1898
Watercolor, gouache, and graphite underdrawing on
light green wove paper, 13$^{15}/_{16}$ × 19$^{15}/_{16}$ in.
Signed, inscribed, and dated at lower left:
Geo. H. Smillie/Tremezzo – L. Como – /Aug 1898/
From Nature
Rogers Fund, 1970
1970.234.2

82. HENRY FARRER
(1843–1903)
City and Sunset
Watercolor on off-white wove paper, 9¹/₁₆ × 11⁵/₁₆ in.
Signed at lower left: H. Farrer
Purchase, Gifts of Mrs. Louis Lamson and Mrs.
Alfred N. Lawrence, Bequest of Antoinette D. T.
Throckmorton, in memory of Jules and Ella Turcas,
and Bequest of May Blackstone Huntington, by
exchange; Mr. and Mrs. Harry L. Koenigsberg,
Walter Knight Sturges and Vain and Harry Fish
Foundation Gifts and Maria DeWitt Jesup Fund, 1985
1985.107.2

83. HENRY RODERICK NEWMAN
(1843–1917)
East Entrance, Room of Tiberius, Temple of Isis, Philae, 1905
Watercolor on off-white wove paper, 26 × 17 in.
Signed, inscribed, and dated at lower left: H. R. Newman/Philae/1905
Morris K. Jesup Fund, 1990
1990.48

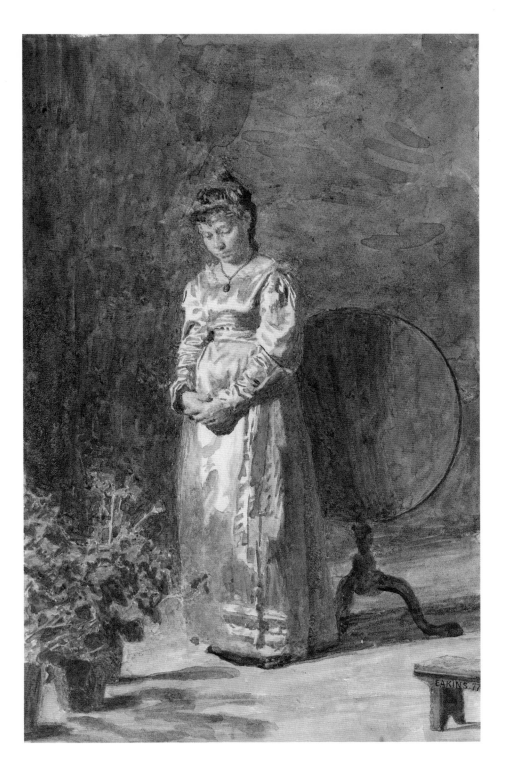

84. THOMAS EAKINS
(1844–1916)
Young Girl Meditating, 1877
Watercolor and gouache on off-white wove paper,
9⁹/₁₆ × 6⅛ in.
Signed and dated at lower right: EAKINS 77
Fletcher Fund, 1925
25.97.2

85. THOMAS EAKINS
(1844–1916)
The Pathetic Song
Watercolor on off-white wove paper, 16¾ × 11¼ in.
Bequest of Joan Whitney Payson, 1975
1976.201.1

Paintings in watercolor are a small and relatively unfamiliar segment of Thomas Eakins's oeuvre. We know of only twenty-seven works he executed in the medium, and all but three were painted early in his career, between 1873 and 1882. Eakins, who described himself as a realist, anatomist, and mathematician, valued his watercolors highly. Though he had been trained as a painter in oil in the Parisian studio of Jean-Léon Gérôme, it was primarily as a watercolorist that Eakins initially chose to exhibit his work to the American public. Beginning in 1874, for a period of eight years he was a frequent exhibitor at the annual shows of the American Society of Painters in Water Colors, where his work often received favorable notice.

In his watercolors, Eakins employed a subdued, restrained style. Each detail was judiciously planned and painstakingly rendered; nothing was spontaneous or accidental. His approach to watercolor was entirely cerebral and academic, often requiring elaborate perspective drawings and, in an interesting reversal of common practice, preparatory sketches executed in oil.

The Pathetic Song is a watercolor replica of the larger oil of the same title that Eakins painted in 1881 and which now is in the collection of the Corcoran Gallery of Art, Washington, D.C. The principal figure, posed in a shadowy Victorian interior, possibly the Eakins's drawing room, has been identified as Margaret Alexina Harrison, the sister of the artists Alexander and Birge Harrison. Eakins gave the watercolor to Miss Harrison in appreciation for her patience as a model, and the work remained in her family until about 1970.[1] At the time the picture was painted, Miss Harrison was one of Eakins's pupils, as was Susan Macdowell, her accompanist at the piano in this painting. Miss Macdowell married Eakins three years later. Mr. Stolte, the third member of the musical trio, was a professional cellist with the Philadelphia Orchestra.

The Pathetic Song serves as a testament to Eakins's profound interest in music, which was an important aspect of his family life. Although he himself was not a musician, his sisters played musical instruments, his wife was an accomplished pianist, and his home served frequently as the setting for intimate musicales.

The artist has chosen not to present a genre scene in which the viewer's eye is meant to travel with delight from one exquisitely realized detail of dress or interior decor to another. Instead, he has selected and narrowed our focus by varying the degree of finish and by employing dramatic chiaroscuro. The singer's sensitive face and elaborate taffeta gown are rendered in strong light and in a precise, highly detailed technique, whereas the subsidiary figures and background are plunged into shadows and painted in a sketchy manner.

The artist entitled his composition *The Pathetic Song*, but surely this clue is not necessary. Such is Eakins's consummate ability to capture and convey the mood of this moment that the viewer becomes not merely an observer but also a listener to Miss Harrison's now-imagined melody.

1. This information is provided in a letter written by Anna L. Lynes, the daughter of the sitter. A copy of this document is in the curatorial files of the Department of American Paintings and Sculpture, Metropolitan Museum of Art.

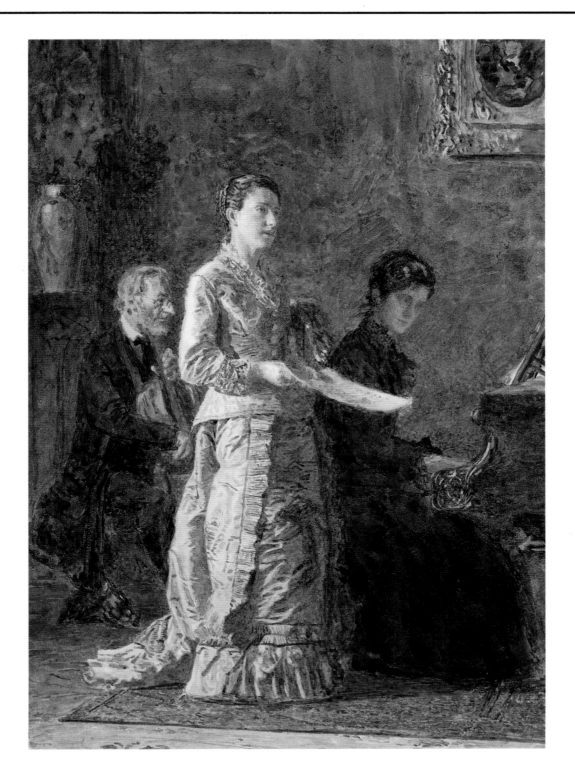

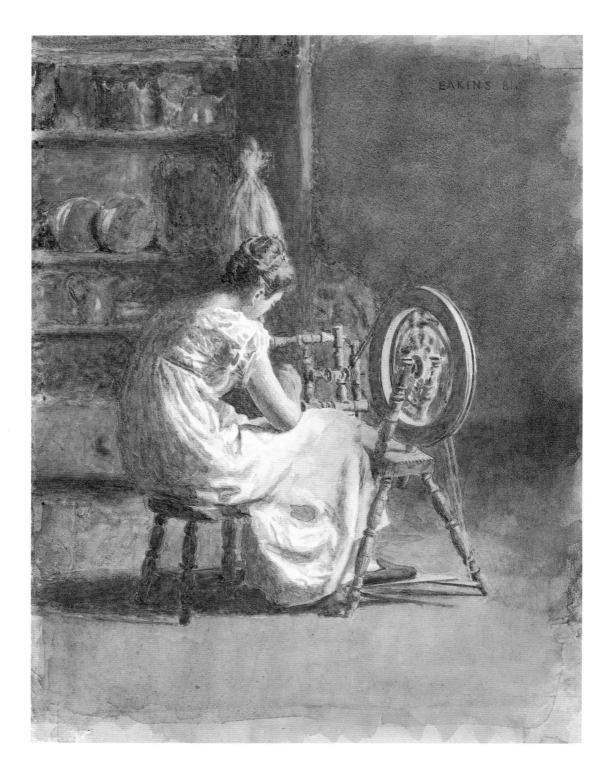

86. THOMAS EAKINS
(1844–1916)
Home-spun, 1881
Watercolor on off-white wove paper,
13⅞ × 10¾ in.
Signed and dated at upper right: EAKINS 81
Fletcher Fund, 1925
25.97.4

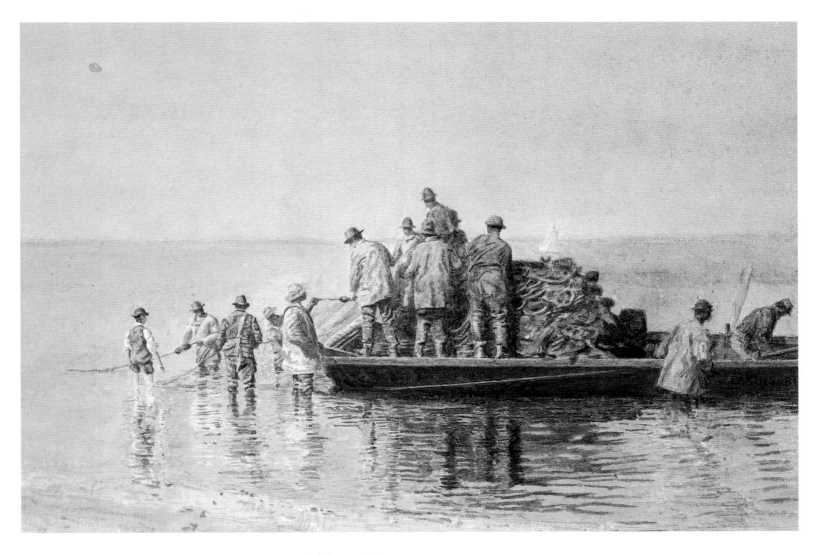

87. Thomas Eakins
(1844–1916)
Taking Up the Net, 1881
Watercolor on off-white wove paper, 9½ × 14¹/₁₆ in.
Signed and dated at right: EAKINS 81
Fletcher Fund, 1925
25.97.3

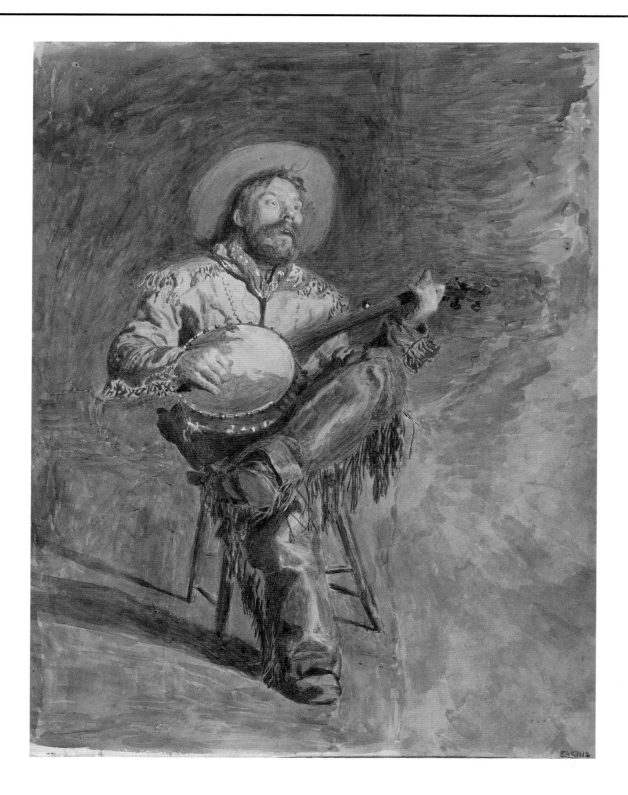

During the summer of 1887, Thomas Eakins spent ten weeks at the B-T Ranch in what was then known as the Dakota Territory. Ostensibly, he went West to study cowboy life as a new subject for painting. It is more likely, however, that the reason for the trip was to recover his health and restore his severely depressed spirits. For Eakins, the previous eighteen months had been a tribulation. A scandal precipitated by his removal of a loincloth from a male model at the Pennsylvania Academy's women's life class had forced Eakins to resign as chief instructor and director. Dismissal from the academy came as a blow, and Eakins found it difficult, if not impossible, to continue to paint. It may have been at the suggestion of Dr. Horatio Wood, a friend of Eakins's and a specialist in the cure of nervous diseases, that the artist decided to visit the Dakota Territory. Wood, a part-owner of the ranch, pioneered a treatment called "camp cure," which advocated total immersion in nature as a means to combat nervous disorders and psychological problems.[1]

The outdoor life at the B-T Ranch agreed with Eakins. Participating in the daily routine of roundups and hunting, he enjoyed the physical exercise and the rough camaraderie of the ranch hands. Eakins's letters to his wife, who had remained at home in Philadelphia, are filled with lively descriptions of exciting activities such as killing rattlesnakes and capturing a horse thief named Monte.[2] Aesthetic concerns, however, were not entirely forgotten; his letters mention sketching and photography as well.

Eakins returned to Philadelphia in October, relaxed, rejuvenated, and with plans for painting cowboy pictures. He brought with him not only the Western sketches and photographs but also a variety of mementos, including an Indian pony, a bronco, several guns, a lariat, and a fringed buckskin suit.

Cowboy Singing is one of four paintings, a watercolor and three oils, all probably painted in 1892, in which the model Franklin Schenck wears Eakins's fringed buckskin shirt, now in the collection of the Hirshhorn Museum and Sculpture Garden, Washington, D.C. Schenck, an impoverished bohemian, was a friend and pupil of the artist, and a fine musician. Eakins has depicted him not as a rugged ranch hand at work but rather as a self-absorbed musician, seated in a green kitchen chair, singing to the accompaniment of a banjo. His action is reminiscent of the artist's description of the apprehended horse thief, Monte, who "picked the banjo and blew the mouth organ and sung his comic songs."[3] Although the cowboy regalia is carefully delineated, the artist's focus is not on details of costume but rather upon the act of making music, an activity that fascinated and attracted Eakins throughout his career. The expressive brushstrokes that form the abstract background resonate—creating what amounts to a painterly equivalent of the sound of the cowboy's voice.

88. THOMAS EAKINS
(1844–1916)
Cowboy Singing
Watercolor and graphite on off-white wove paper,
18⅞ × 15¹⁄₁₆ in.
Signed at lower right: EAKINS
Fletcher Fund, 1925
25.97.5

1. For further information on Dr. Horatio Wood and the "camp cure," see Nancy K. Anderson, "'Cowboys in the Badlands' and the Role of Avondale," in *Eakins at Avondale and Thomas Eakins: A Personal Collection* (exhib. cat., Brandywine River Museum, Chadds Ford, Pa., 1980), pp. 21–23.
2. Eakins's letters from the Dakota Territory have been published. See Cheryl Leibold, "Thomas Eakins in the Badlands," *Archives of American Art Journal*, vol. 28, no. 2 (1988), pp. 2–15.
3. Eakins, quoted in Leibold, "Thomas Eakins," p. 12.

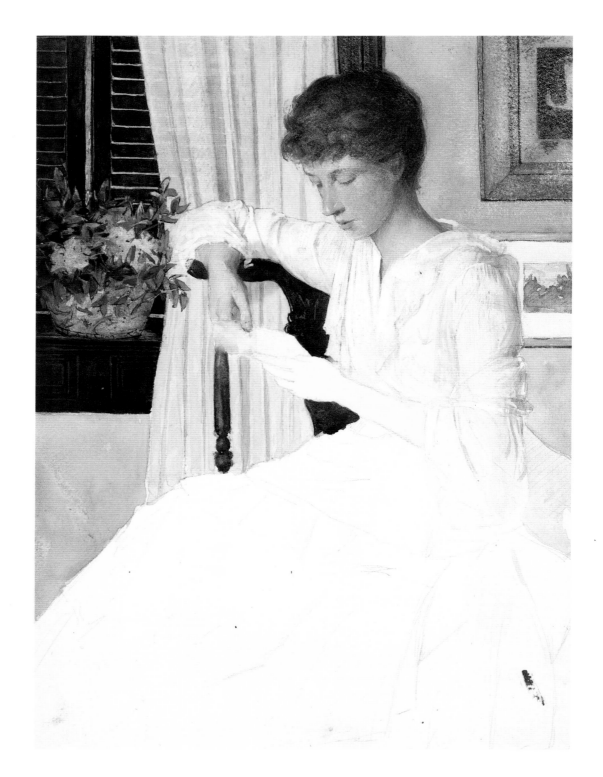

89. J. ALDEN WEIR
(1852–1919)
Anna Dwight Weir Reading a Letter
Watercolor, gouache, and graphite on white wove
paper, 12½ × 9½ in.
Purchase, Mr. and Mrs. Norman Schneider Gift,
1966
66.193

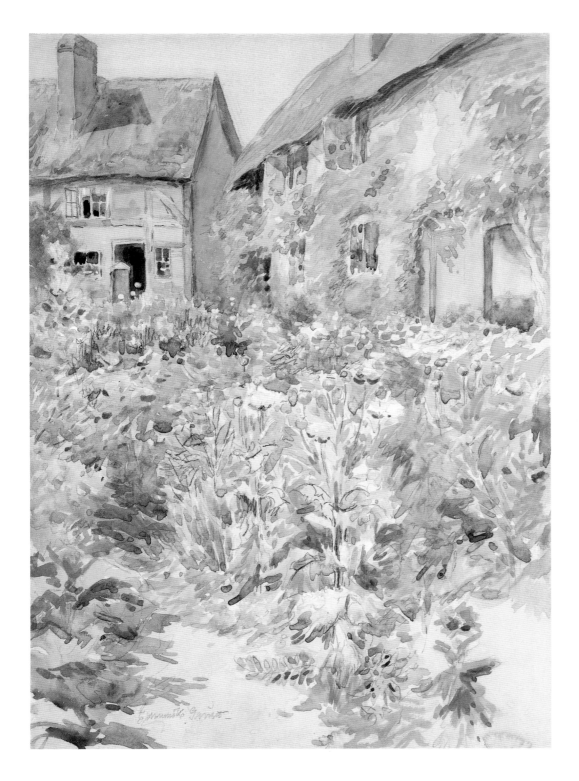

90. EDMUND H. GARRETT
(1853–1929)
Cottage Garden, Warwick, England
Watercolor, gouache, and graphite on off-white wove
paper, 13⅞ × 9¹⁵⁄₁₆ in.
Signed at lower left: Edmund H. Garrett
Gift of Mr. and Mrs. Stuart P. Feld, 1977
1977.426

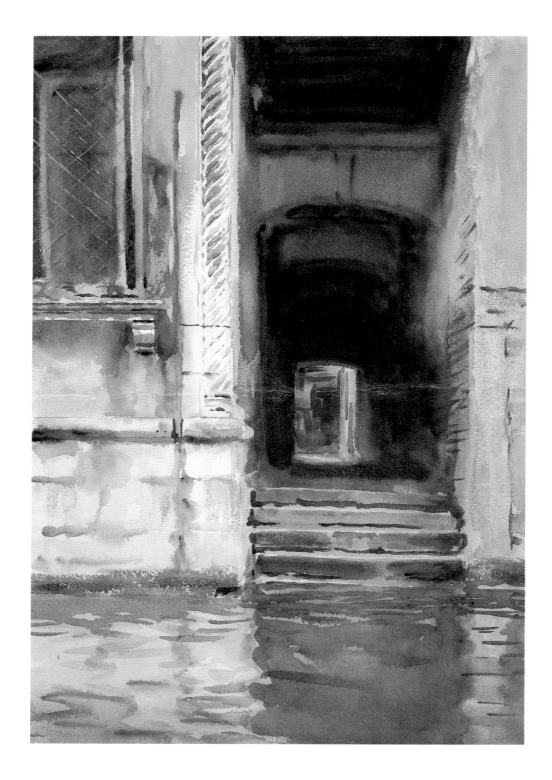

91. JOHN SINGER SARGENT
(1856–1925)
Venetian Doorway
Watercolor and graphite on white wove paper,
21¼ × 14½ in.
Gift of Mrs. Francis Ormond, 1950
50.130.77

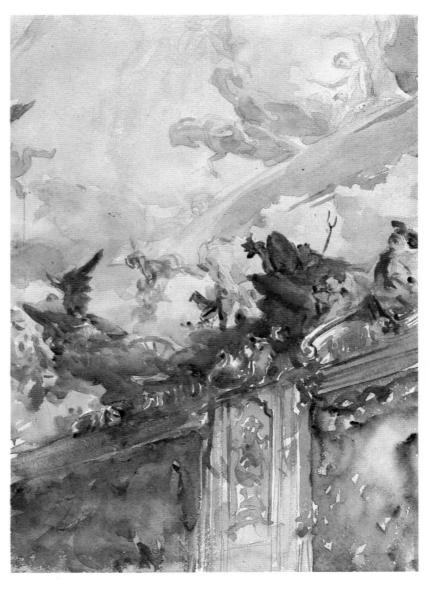

92. JOHN SINGER SARGENT
(1856–1925)
Woman with Collie
Watercolor, gouache, and graphite on white wove
paper, 13⅞ × 10 in.
Gift of Mrs. Francis Ormond, 1950
50.130.27

93. JOHN SINGER SARGENT
(1856–1925)
Tiepolo Ceiling—Milan
Watercolor and graphite on white wove paper,
14 × 9¹⁵⁄₁₆ in.
Numbered and inscribed on reverse: 136 Tiepolo
ceiling—Milan/ by J. S. Sargent
Gift of Mrs. Francis Ormond, 1950
50.130.25

94. JOHN SINGER SARGENT
(1856–1925)
Figure with Red Drapery
Watercolor and graphite underdrawing on white
wove paper, 14½ × 21³/₁₆ in.
Gift of Mrs. Francis Ormond, 1950
50.130.73

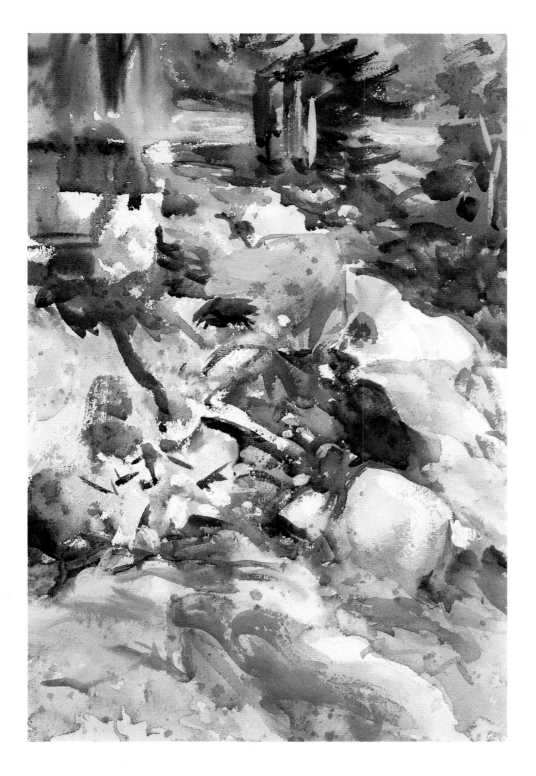

95. JOHN SINGER SARGENT
(1856–1925)
Rushing Brook
Watercolor, gouache, and graphite underdrawing on
off-white wove paper, 18⅜ × 12⅜ in.
Inscribed at lower right: SS [?]. Inscribed on reverse:
J. S. S. Purtud
Gift of Mrs. Francis Ormond, 1950
50.130.80i

96. JOHN SINGER SARGENT
(1856–1925)
Spanish Fountain
Watercolor and graphite on white wove paper,
21 × 13^{11}/$_{16}$ in.
Signed at upper right: John S. Sargent
Purchase, Joseph Pulitzer Bequest, 1915
15.142.6

In September 1912, John Singer Sargent traveled through Spain, visiting Toledo, Aranjuez, Seville, and Granada in the company of his sister Emily, herself an amateur watercolorist, and his artist friends Jane and Wilfred de Glehn. The Spanish trip was one of the annual excursions organized by Sargent between 1906 and 1914 to provide an escape from the burdensome responsibilities of his studio work in London. While on these late summer holidays, the artist traveled with an entourage of admiring friends and devoted family. In this relaxed, protective ambience, released from the public demands of portraiture and the formal strictures of mural commissions, Sargent was able to indulge in painting compositions of his own choosing, mostly plein-air landscape and figure studies executed in oil or watercolor.

Spanish Fountain, a product of Sargent's 1912 visit to Granada, depicts a close-up, snapshot view of a segment of the fountain in the courtyard of the Hospital de San Juan de Dios.[1] Another watercolor version of the same subject, similarly titled, is in the collection of the Fitzwilliam Museum, Cambridge. The Fitzwilliam variant has essentially the same composition but is seen from a slightly different vantage point and at a greater distance. The severely cropped compositional format utilized in both watercolors permits the viewer to see only a fragment of the fountain. Cropping and excerpting are pictorial devices that Sargent had adopted and developed in earlier architectural views such as *Bologna Fountain* of about 1906 (Ormond Family collection) and *In a Medici Villa* of 1907 (Brooklyn Museum).

The time spent in Granada was productive and Sargent was reluctant to return to London. In a letter of 6 November 1912, he wrote: "We are still here and working hard, both Emily and I— Emily has done some capital watercolours—The Von Glehns are just leaving and we must follow soon, alas—It is hard to leave Granada."[2] Approximately three weeks later, in London, Ralph Curtis, an artist friend, viewed Sargent's recent Spanish work and reported that they were mostly in oils with a "few masterly aquarelles as well."[3]

It is very likely that *Spanish Fountain* was one of the "masterly aquarelles" described by Curtis. A letter from the artist to his friend Edward Robinson, Director of the Metropolitan Museum of Art, firmly dates it as a work of 1912 and reveals that it is the earliest watercolor of the ten purchased by the museum from Sargent in 1915. In reply to Robinson's request for "eight or ten" watercolors to be chosen by the artist for the museum's collection, Sargent responded: "I am very flattered that the Metropolitan Museum should want a few of my water colours, and wish I had a choice to offer, but I have done very few this year, and sold two or three of them. I kept back the two best for myself, but I would sell at least one of them to the Museum for £75—it is one of a fountain in Granada."[4] Sargent's letter also implies that all the other watercolors he sold to the museum in this group should be dated between 1913 and 1915 and not earlier, as previously assumed.

1. The precise location of the fountain was identified by Richard Ormond, who has several photographs of the fountain taken by Sargent or by a companion. Copies of the photographs are in the curatorial files of the Department of American Paintings and Sculpture, Metropolitan Museum of Art.
2. John Singer Sargent to Mrs. Daniel Curtis, David McKibbin Collection, Boston Athenaeum.
3. Ralph Curtis to Isabella Stewart Gardner, 15 December 1912, Isabella Stewart Gardner Museum Archives, Boston, Massachusetts.
4. John Singer Sargent to Edward Robinson, 31 December 1912, The Metropolitan Museum of Art Archives.

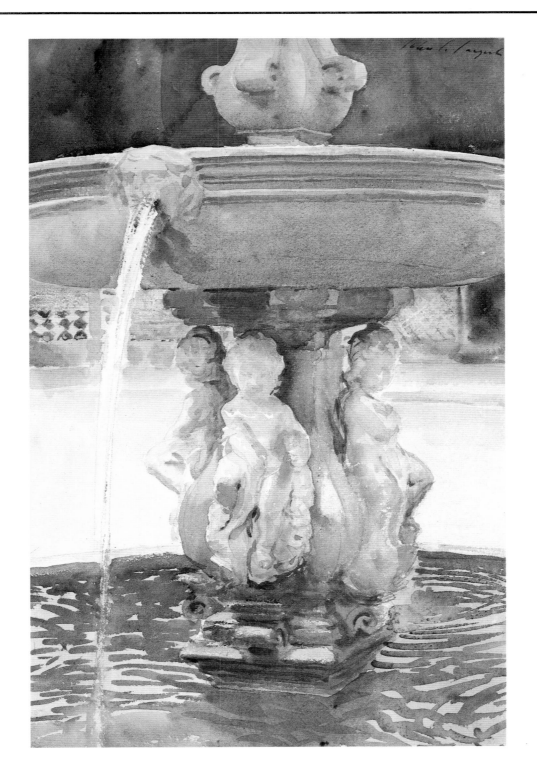

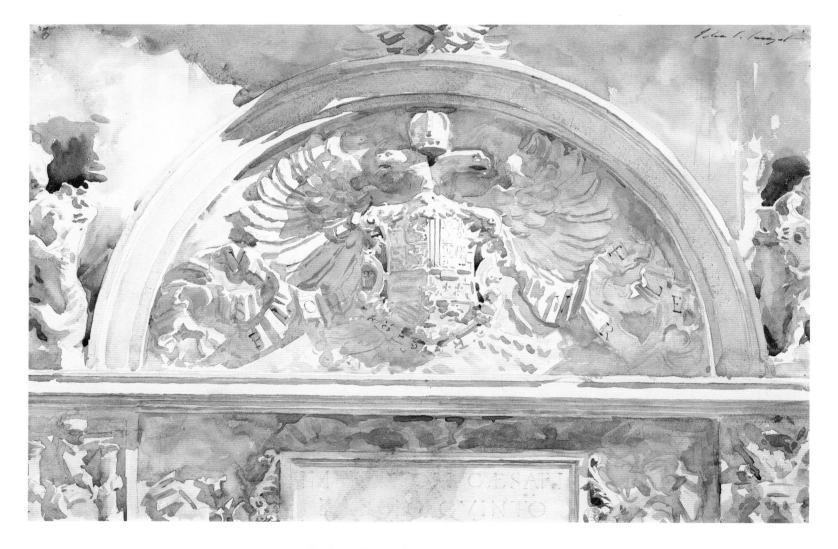

97. JOHN SINGER SARGENT
(1856–1925)
Escutcheon of Charles V of Spain
Watercolor and graphite underdrawing on off-white
wove paper, 11¹⁵⁄₁₆ × 17¹⁵⁄₁₆ in.
Signed at upper right: John S. Sargent
Purchase, Joseph Pulitzer Bequest, 1915
15.142.11

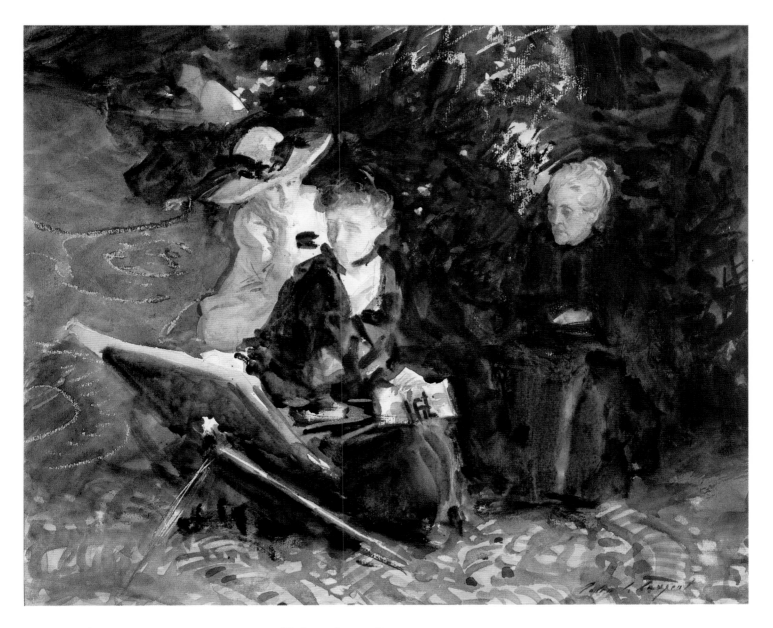

98. JOHN SINGER SARGENT
(1856–1925)
In the Generalife
Watercolor, wax, and graphite on white wove paper,
14⅞ × 18 in.
Signed at lower right: John S. Sargent
Purchase, Joseph Pulitzer Bequest, 1915
15.142.8

99. JOHN SINGER SARGENT
(1856–1925)
Sirmione
Gouache and watercolor on white wove paper,
15¾ × 21¹⁄₁₆ in.
Signed at lower right: John S. Sargent
Purchase, Joseph Pulitzer Bequest, 1915
15.142.5

100. JOHN SINGER SARGENT
(1856–1925)
Boats
Watercolor and graphite on white wove paper,
15¾ × 21 in.
Signed at lower left: John S. Sargent
Purchase, Joseph Pulitzer Bequest, 1915
15.142.9

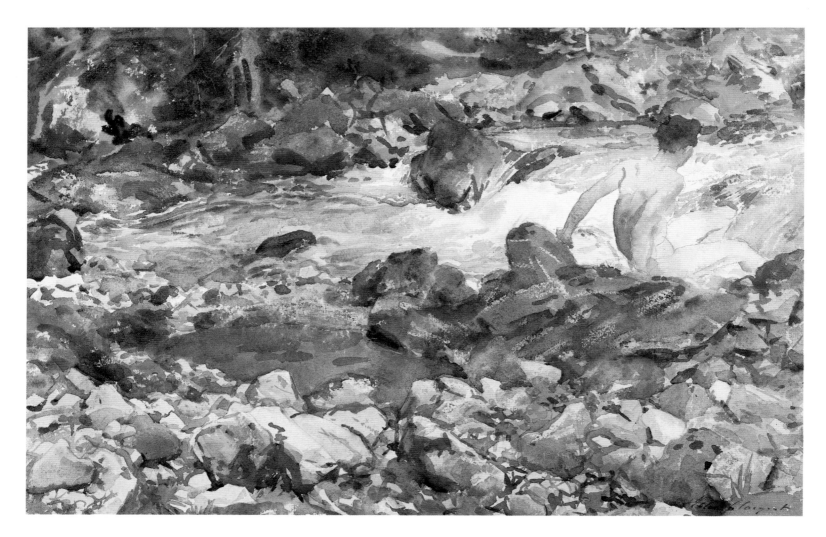

101. JOHN SINGER SARGENT
(1856–1925)
Mountain Stream
Watercolor, wax, and graphite on white wove paper,
13¾ × 21 in.
Signed at lower right: John S. Sargent
Purchase, Joseph Pulitzer Bequest, 1915
15.142.2

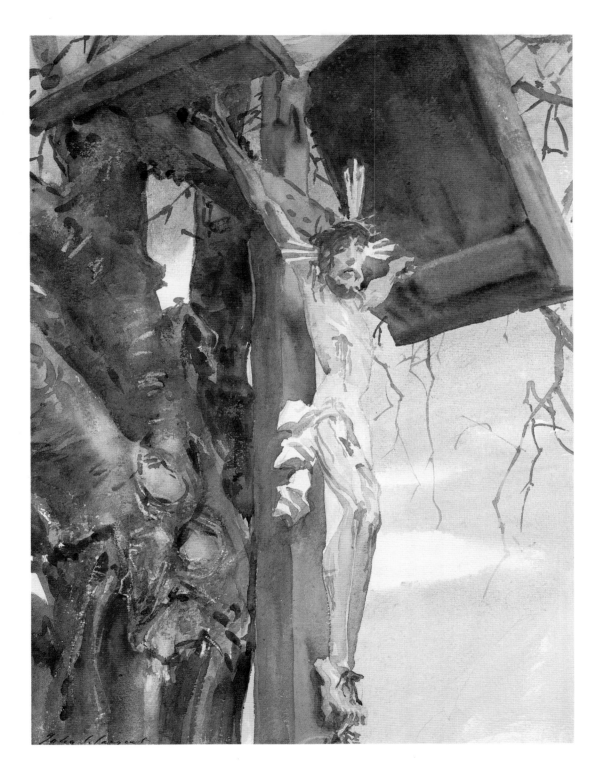

102. JOHN SINGER SARGENT
(1856–1925)
Tyrolese Crucifix
Watercolor and graphite on white wove paper,
21 × 15¹¹/₁₆ in.
Signed at lower left: John S. Sargent
Purchase, Joseph Pulitzer Bequest, 1915
15.142.7

147

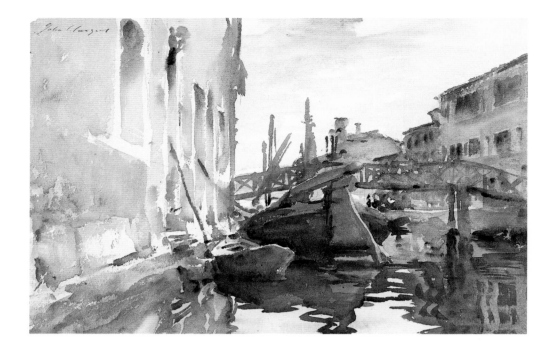

103. JOHN SINGER SARGENT
(1856–1925)
Giudecca
Watercolor and graphite underdrawing on white
wove paper, 13¾ × 21 in.
Signed at upper left: John S. Sargent
Purchase, Joseph Pulitzer Bequest, 1915
15.142.4

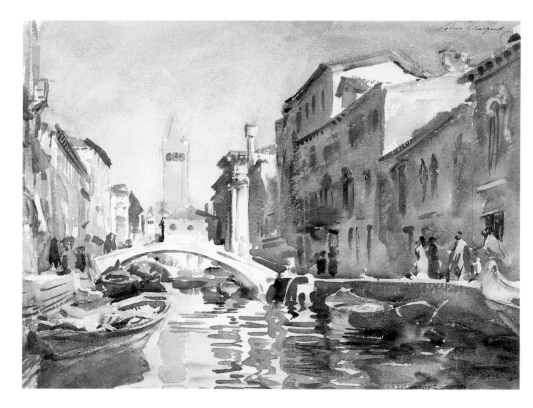

104. JOHN SINGER SARGENT
(1856–1925)
Venetian Canal
Watercolor and graphite underdrawing on white
wove paper, 15¾ × 21 in.
Signed at upper right: John S. Sargent
Purchase, Joseph Pulitzer Bequest, 1915
15.142.10

148

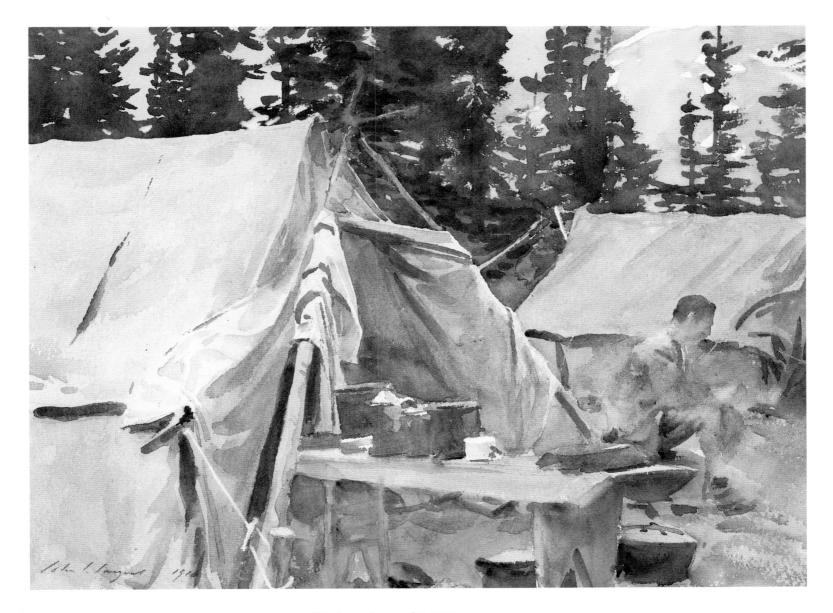

105. JOHN SINGER SARGENT
(1856–1925)
Camp at Lake O'Hara, 1916
Watercolor and graphite underdrawing on white
wove paper, 15¾ × 21 in.
Signed and dated at lower left: John S. Sargent 1916
Gift of Mrs. David Hecht, in memory of her son,
Victor D. Hecht, 1932
32.116

149

106. JOHN SINGER SARGENT
(1856–1925)
Figure and Pool
Watercolor, gouache, and graphite underdrawing on
white wove paper, 13¹¹⁄₁₆ × 21 in.
Gift of Mrs. Francis Ormond, 1950
50.130.62

A commission to paint the portrait of John D. Rockefeller at his winter home in Ormond Beach obliged John Singer Sargent to travel to Florida in February 1917. As early as 1907, at the height of his career as the Edwardian world's preeminent portrait painter, Sargent attempted to curtail the number of portrait commissions he would accept, declaring unequivocally, "No more mugs."[1] Despite his best intentions, however, the artist was never quite able to escape from portraiture. He viewed his acceptance of the Rockefeller commission (for which he was paid a huge fee) as only a temporary relapse, but with each successive year there seemed to be the inevitable exceptions to the "no more portraits" rule.

After working for about three weeks to complete the Rockefeller portrait, Sargent traveled to Brickell Point, near Miami, to visit his good friend Charles Deering, whose brother James was then engaged in building Vizcaya, an ornate villa in the Italian Renaissance style. Sargent stayed as a guest of the Deerings at Vizcaya where, as was characteristic of his holiday routine, he produced a magnificent series of watercolors—this time depicting the architectural splendors of the villa, the grace of its formal gardens, and the physical beauty of the young black workmen he encountered on the outskirts of the estate.[2]

Figure and Pool, one of a series of five related compositions portraying young nude men relaxing in the sun or water near Vizcaya,[3] presents a dramatically foreshortened view of a black Narcissus gazing at his reflection in the dark blue-green pool. The work is a virtual tour de force—bold and abstract in its composition, loose and spontaneous in its brushwork. *Figure and Pool* reveals another aspect of Sargent's sensibility, his modernist perspective.

An old label recorded as once having been on the reverse[4] identifies *Figure and Pool* as the watercolor exhibited under the title *Negro Drinking* in the memorial exhibition of the artist's work held in 1925 (number 104 in the catalogue) at the Museum of Fine Arts, Boston, and in 1926 (number 52 in the catalogue) at the Metropolitan Museum of Art.

1. Quoted in Stanley Olson, *John Singer Sargent: His Portrait* (New York, 1986), p. 228.
2. Eleven of Sargent's watercolors depicting Florida subjects were purchased by the Worcester Art Museum, Worcester, Massachusetts, in 1917. For a detailed discussion of these works, see Trevor J. Fairbrother's catalogue entries, numbers 82–88, in *American Traditions in Watercolor: The Worcester Art Museum Collection*, ed. Susan E. Strickler (New York, 1987), pp. 128–41.
3. Four of the watercolors of black male nudes are in the collection of the Metropolitan Museum of Art (*Figure and Trees, Florida; Bather in Florida; Figure on Beach, Florida;* and *Figure and Pool*). The fifth, titled *The Bathers*, is in the collection of the Worcester Art Museum.
4. This information comes from the curatorial files of the Department of American Paintings and Sculpture, Metropolitan Museum of Art.

107. JOHN SINGER SARGENT
(1856–1925)
Tommies Bathing
Watercolor and graphite underdrawing on white
wove paper, 15⅜ × 20¾ in.
Inscribed and dated [in error] on reverse:
Tommies bathing/1917
Gift of Mrs. Francis Ormond, 1950
50.130.48

108. JOHN SINGER SARGENT
(1856–1925)
Camouflaged Field in France
Watercolor, gouache, and wax on white wove paper,
13⁵⁄₁₆ × 20⅞ in.
Inscribed and dated [in error] on reverse:
Camouflaged field/in France 1917
Gift of Mrs. Francis Ormond, 1950
50.130.52

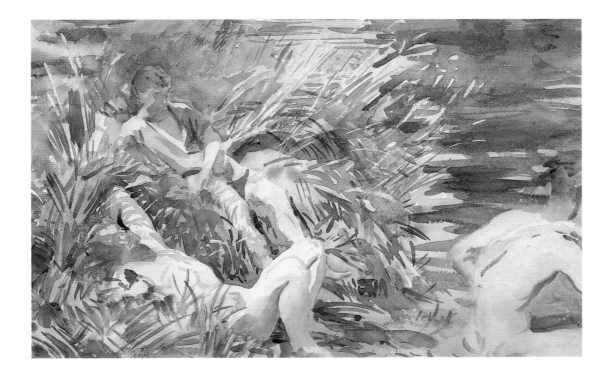

109. JOHN SINGER SARGENT
(1856–1925)
Tommies Bathing, France 1918
Watercolor, gouache, and graphite underdrawing
on white wove paper, 13⅜ × 20⅞ in.
Numbered and inscribed on reverse: 151/by
J. S. Sargent
Gift of Mrs. Francis Ormond, 1950
50.130.58

110. JOHN SINGER SARGENT
(1856–1925)
Army Mules
Watercolor, wax, and graphite
underdrawing on white wove paper,
13¼ × 20⅞ in.
Numbered and inscribed on reverse: 149/by
J. S. Sargent
Gift of Mrs. Francis Ormond, 1950
50.130.49

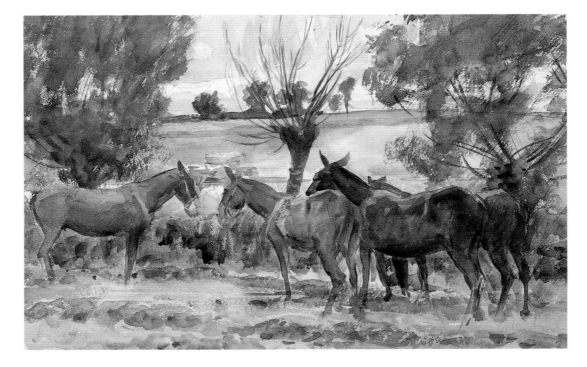

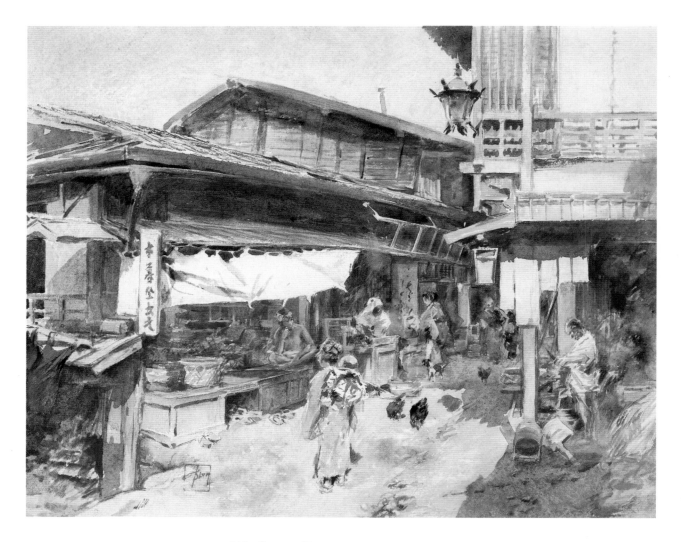

111. ROBERT BLUM
(1857–1903)
Street Scene in Ikao, Japan
Watercolor, gouache, and graphite on off-white wove
paper, 10⅝ × 15 in.
Stamped at lower left: Blum [within a square]
Gift of William J. Baer, 1904
04.30

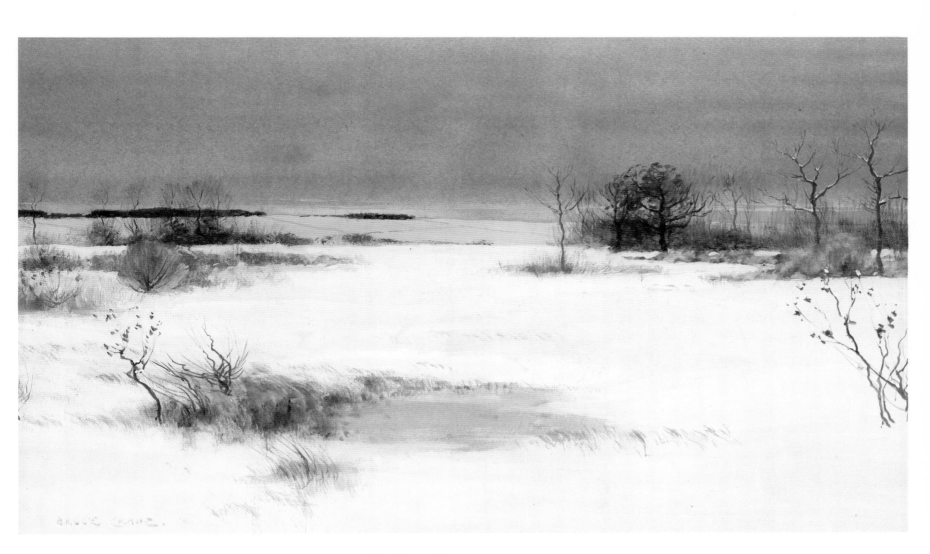

112. BRUCE CRANE
(1857–1937)
Snow Scene
Watercolor and gouache on blue wove paper,
10⅞ × 18⅝ in.
Signed at lower left: BRUCE CRANE
George A. Hearn Fund, 1968
68.40

113. MAURICE PRENDERGAST
(1858–1924)
Piazza di San Marco
Watercolor and graphite on white wove paper,
16⅝ × 15⁵⁄₁₆ in.
Signed at lower left: Prendergast
Gift of Estate of Mrs. Edward Robinson, 1952
52.126.6

The rich architectural legacy and bustling, festive crowds of Venice inspired Maurice Prendergast—who is often called America's first modern painter—to create some of his finest and most enchanting watercolors. By the mid-1890s Prendergast had made two trips to Europe to pursue his studies, notably in Paris, where he received his first formal art training, at the age of thirty-one, at the Atelier Colarossi and the Académie Julian. In Paris, too, he was influenced by the work of James McNeill Whistler and the theories of the Nabis, an avant-garde group, whose members included Pierre Bonnard, Edouard Vuillard, and Maurice Denis.

Prendergast's third European journey (1898–99), reputedly financed by Mrs. Montgomery Sears, a wealthy patron and fellow artist, lasted eighteen months, the better part of which was spent in Venice, where the artist was both happy and productive. Lodging on the Giudecca in a *pensione*-palace frequented by other artists, Prendergast spent most of his time in the heart of the city, frequently passing the afternoon at the Café Oriental, where he sketched the boats arriving from the Lido and the stylishly dressed girls at neighboring café tables.[1] Time also was fruitfully spent studying Renaissance paintings in museums and churches. The artist was particularly drawn to the work of the fifteenth-century master Vittore Carpaccio, whose complex paintings of gaily bedecked Venetians posed before detailed architectural backgrounds are not dissimilar in spirit from Prendergast's own. Venetian art was both inspiring and humbling. He wrote to his brother Charles: "It has been the visit of my life. I have been here almost a year and I have seen so many beautiful things it almost makes me ashamed of my profession today."[2]

Piazza di San Marco is a remarkable example of the artist's mastery of the watercolor medium and perhaps the boldest and most modern statement among his Venetian views. His originality is exemplified by a daring decision to extend the huge flag in the immediate foreground to the full length of the paper support. This red, white, and green banner, one of three that lead the eye back into the composition, past the truncated Campanile of St. Mark to the Column of St. Theodore, is the flag of the Kingdom of Italy, bearing in its center the identifying red shield and white cross of the House of Savoy. By choosing an eccentric and vertiginous vantage point, the artist reduced the crowd of sightseers, pigeon-feeders, and passersby to minuscule calligraphic notations. With authority and audacious economy, he indicated the ladies' white summer dresses by combining staccato strokes of light gray wash with the white of the paper reserve.

1. Van Wyck Brooks, "Anecdotes of Maurice Prendergast," in *The Prendergasts: Retrospective Exhibition of the Work of Maurice and Charles Prendergast* (exhib. cat., Addison Gallery of American Art, Phillips Academy, Andover, Mass., 1938), pp. 37–38.
2. Quoted in Eleanor Green, *Maurice Prendergast: Art of Impulse and Color* (exhib. cat., University of Maryland Art Gallery, College Park, 1976), p. 40.

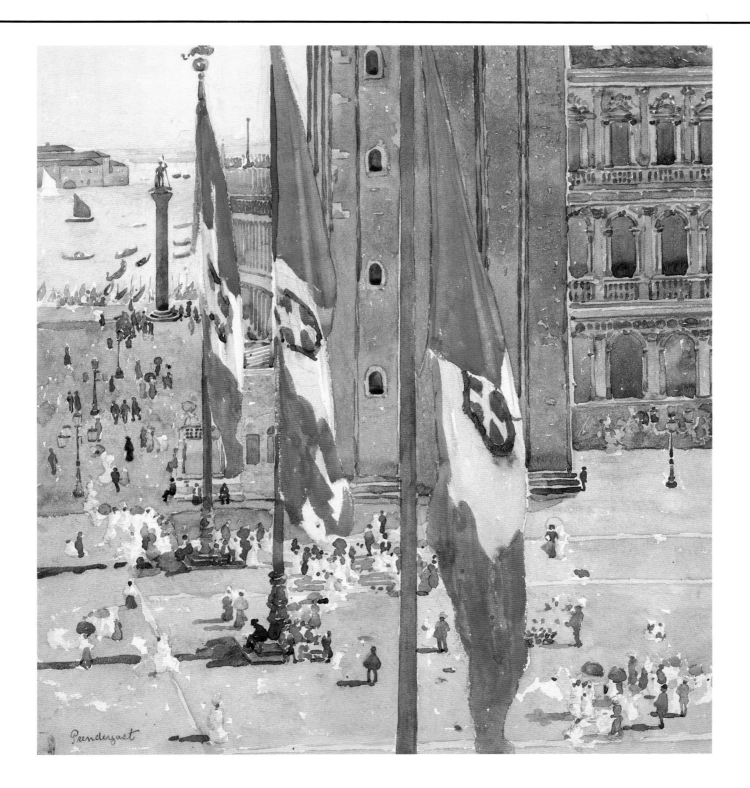

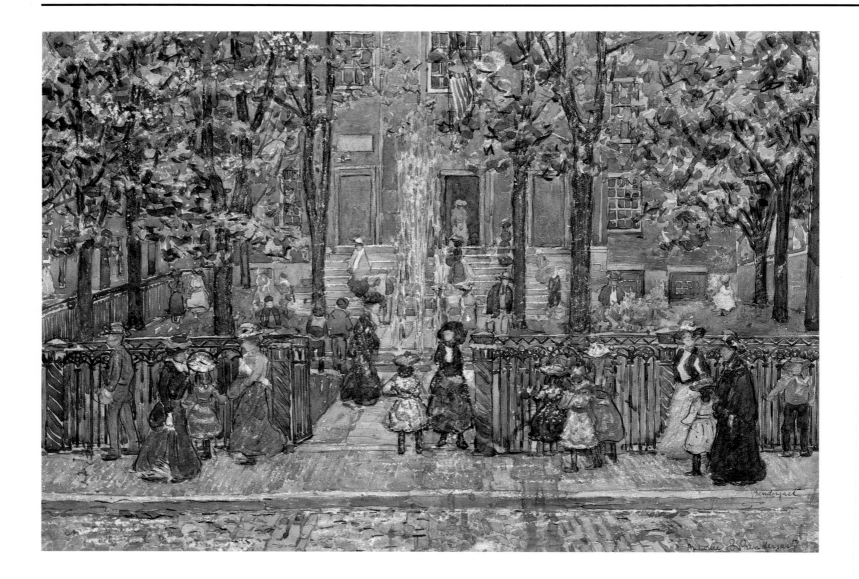

The West End Library in Boston, with its charming courtyard and fountain, provided Maurice Prendergast with the architectural setting for a series of six delightful watercolors, all probably executed in 1901. Designed as a church in 1806 by the architect Asher Benjamin, the building housed one of Boston's most distinguished congregations until its renovation and conversion to a branch public library in 1896. The historic edifice still stands, having been remodeled in the early 1960s and restored to its original use as the Old West Church.

According to Charles Prendergast, the artist's brother, it was the wife of the minister of the Old West Church who commissioned Prendergast to paint a watercolor of her husband's former place of worship. The artist particularly admired the beautiful faded green-blue tone of the doors and put off painting them until the last moment—when two housepainters arrived and repainted the doors a cold, raw blue right before his eyes.[1]

Prendergast often painted the same subject repeatedly, varying the composition by changing the vantage point or by modifying the degree of finish. Four of the views of the West End Library's courtyard—none is a replica of the others—offer an interesting case study of the artist's method of working.

West Church, Boston, in the collection of the Museum of Fine Arts, Boston, is the version closest to the Metropolitan Museum's picture. In both watercolors the artist uses a favorite compositional device, placing the architectural and figurative elements in horizontal, friezelike bands parallel to the picture plane; however, the Boston picture is painted in a tighter style and the crowd of people is dispersed across the paper in a different configuration.

The version in the collection of Mr. and Mrs. Arthur G. Altschul, also titled *West Church, Boston*, is a vertical composition depicting the entire facade of the building up to the weather vane on the top of the cupola. For this watercolor the artist chose a high vantage point from which to view the lively scene in the courtyard below. The fourth variant, *Fountain at West Church, Boston*, in the collection of Rita and Daniel Fraad, shows the same courtyard from the reverse direction, looking from the steps of the church toward the shop fronts across the street.

Court Yard, West End Library, Boston offers clear evidence of having been reworked significantly during its execution. As the artist's ideas evolved, he experimented with and rejected different compositional solutions. One can discern in the center foreground the faint outlines of two figures—a man and a young girl—outlined in graphite and wash but never completed. More dramatic changes were effected when Prendergast folded under a little more than an inch of the bottom of the sheet, obscuring the cobblestone street and bringing the figures in the middle ground forward to the approximate position in which they appear in the Boston picture. He then signed the watercolor a second time, on the curb at the lower right, because the original signature had disappeared under the fold—identifiable today by a sharp horizontal crease in the paper.[2]

114. MAURICE PRENDERGAST
(1858–1924)
Court Yard, West End Library, Boston, 1901
Watercolor, graphite, and charcoal on off-white wove paper (reverse: graphite drawing), 14⅞ × 21½ in.
Signed at right: Prendergast. Signed and dated at lower right: Maurice B. Prendergast/1901.
Inscribed at lower left: Co[ur]t Yard/[Wes]t End L[ibrar]y/Boston
Gift of Estate of Mrs. Edward Robinson, 1952
52.126.7

1. Van Wyck Brooks, "Anecdotes of Maurice Prendergast," in *The Prendergasts: Retrospective Exhibition of the Work of Maurice and Charles Prendergast* (exhib. cat., Addison Gallery of American Art, Phillips Academy, Andover, Mass, 1938), pp. 42–43.
2. I am indebted to Marjorie Shelley, conservator at the Metropolitan Museum, for her assistance in analyzing the evolution of Prendergast's composition *Court Yard, West End Library, Boston*.

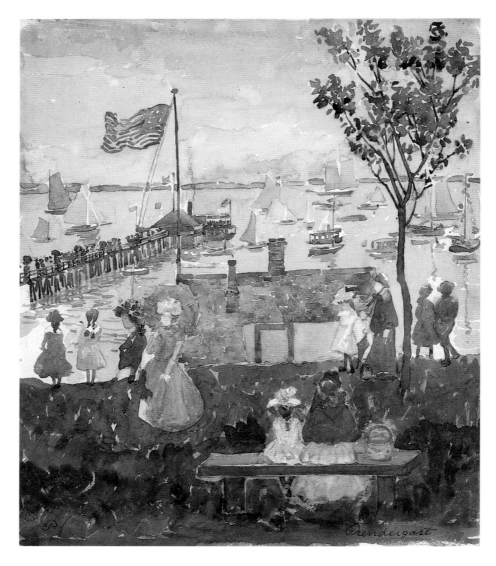

115. MAURICE PRENDERGAST
(1858–1924)
Excursionists, Nahant
Watercolor, gouache, and graphite underdrawing on
white wove paper, 19⅜ × 14³⁄₁₆ in.
Signed at lower right: Prendergast; at lower left: P.
Inscribed at bottom: Excursionists
The Lesley and Emma Sheafer Collection, Bequest of
Emma A. Sheafer, 1973
1974.356.2

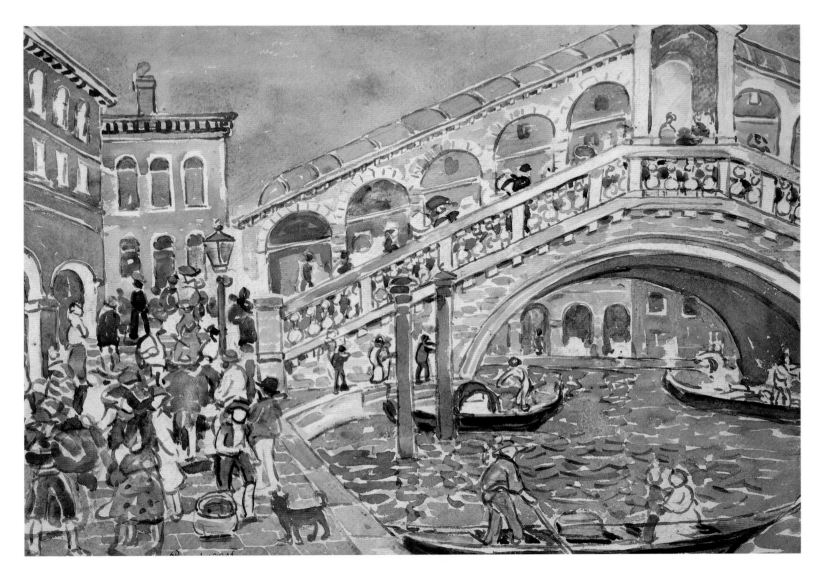

116. MAURICE PRENDERGAST
(1858–1924)
Rialto Bridge (Covered Bridge, Venice)
Watercolor and graphite on white wove paper
(reverse: *Park Scene*, watercolor and graphite),
15¼ × 22⅛ in.
Signed at lower left: Prendergast
The Lesley and Emma Sheafer Collection, Bequest of
Emma A. Sheafer, 1973
1974.356.1

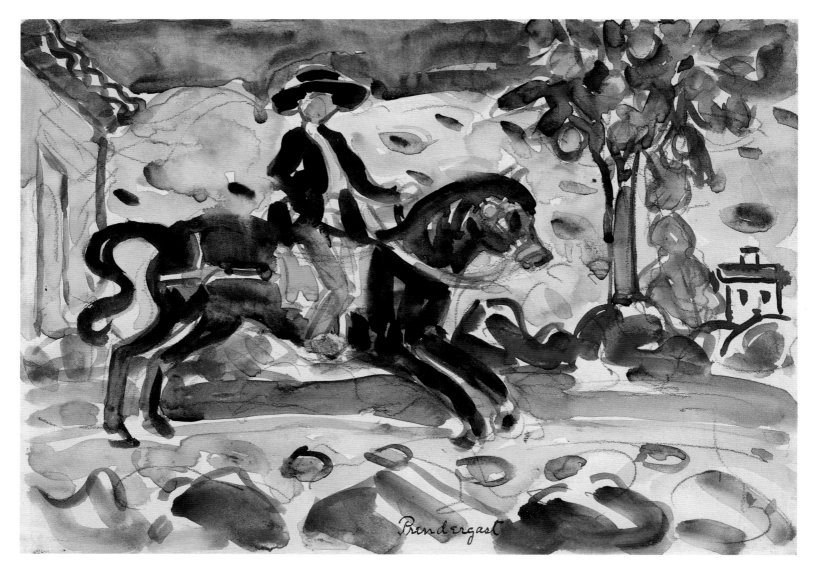

117. MAURICE PRENDERGAST
(1858–1924)
The Rider
Watercolor and graphite on off-white wove paper,
10 × 13⅞ in.
Signed at bottom: Prendergast
Bequest of Margaret S. Lewisohn, 1954
54.143.8

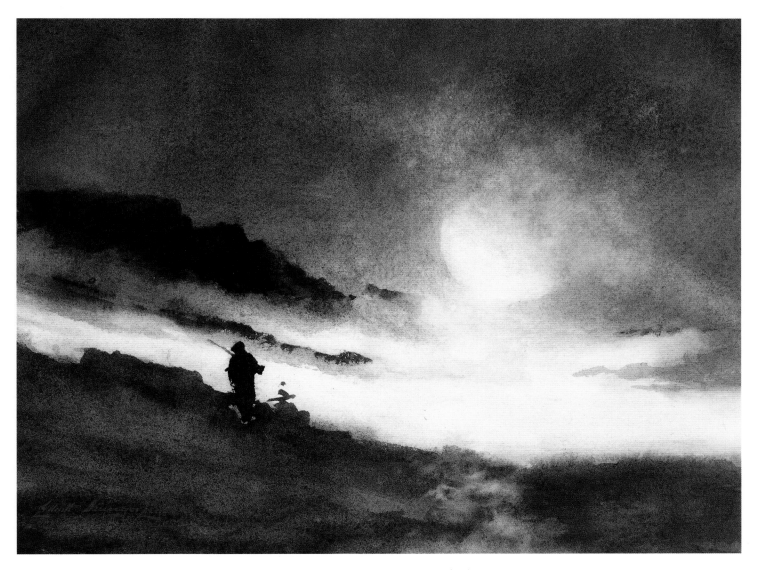

118. ELLIOTT DAINGERFIELD
(1859–1932)
Moon Rising over Fog Clouds
Watercolor on off-white wove paper, 7¹³⁄₁₆ × 10³⁄₁₆ in.
Signed at lower left: Elliott Daingerfield
Gift of A. W. Bahr, 1958
58.21.6

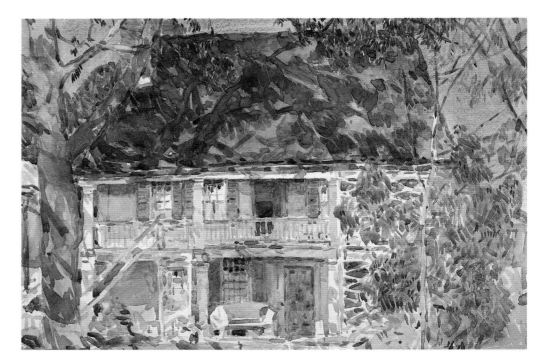

119. CHILDE HASSAM
(1859–1935)
The Brush House
Watercolor and charcoal underdrawing on off-white
wove paper, 15⁵⁄₁₆ × 22³⁄₈ in.
Rogers Fund, 1917
17.31.1

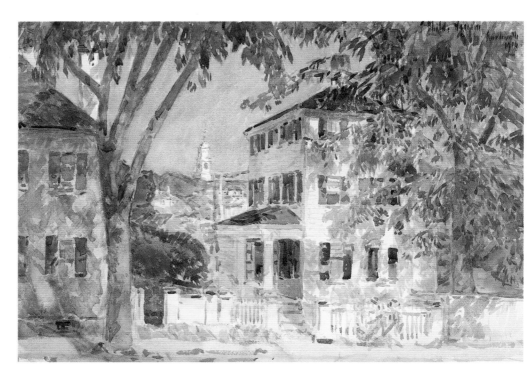

120. CHILDE HASSAM
(1859–1935)
Street in Portsmouth, 1916
Watercolor on off-white wove paper, 15¹⁄₈ × 22 in.
Signed, inscribed, and dated at upper right: Childe
Hassam/Portsmouth[?]/1916
Rogers Fund, 1917
17.31.2

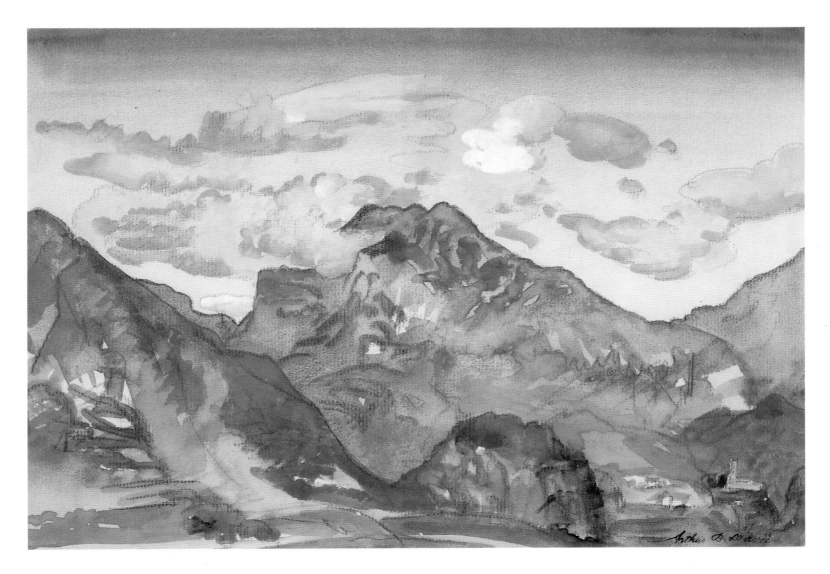

121. ARTHUR B. DAVIES
(1862–1928)
Mountains
Watercolor and black chalk on off-white laid paper,
10¼ × 14¹³⁄₁₆ in.
Stamped at lower right: Arthur B. Davies
Bequest of Lizzie P. Bliss, 1931
31.67.5

122. GEORGE LUKS
(1866–1933)
The Brook
Watercolor and graphite on white wove paper,
14 × 20 in.
Signed at lower right: George Luks
The Lesley and Emma Sheafer Collection, Bequest of
Emma A. Sheafer, 1973
1974.356.13

"There are only two great artists in the world—Frans Hals and little old George Luks."[1] This unequivocal conclusion was expressed by Luks himself, one of the most colorful figures among the early-twentieth-century realist painters who were sometimes contemptuously referred to as the Ashcan School. At times, Luks's cult of personality, gift for telling tall tales, and Rabelaisian behavior almost overwhelm his art. Essentially self-taught—for he lacked the discipline and patience to complete his formal training at the Pennsylvania Academy of the Fine Arts and the Düsseldorf Academy—Luks gained experience while working as an illustrator, cartoonist, and artist-reporter for the *Philadelphia Press*. In Philadelphia he met a group of like-minded newspaper artists who in 1908 banded together to form the nucleus of The Eight. This revolutionary group advocated a new, democratic art whose subject would be the everyday life of ordinary city dwellers.

Luks worked in the mediums of oil and watercolor with equal aptitude and authority. His watercolors are less well known and quite different in their subjects and tonality from his Ashcan-style oils. There are about 240 of them in all—a substantial body of work.[2] During his lifetime, Luks exhibited watercolors regularly at the New York Water Color Club, an organization he joined in 1914, and in one-man exhibitions at both the Kraushaar Gallery and the Rehn Gallery, his dealers in New York.

With its brilliant palette and expressionistic intensity, *The Brook* exemplifies Luks's powerful response to the beauties of landscape. Taking nature as a point of departure, the artist has created a schematized composition of rhythmic swirls and dashes executed in nonrealistic tones. The energy of the brushstrokes, the Fauve-like intensity of color, and the artful use of the paper reserve (those parts left unpainted to scintillating effect) combine to create a powerful yet supremely elegant work.

1. Quoted in *George Luks* (exhib. cat., Museum of Art, Munson-Williams-Proctor Institute, Utica, N.Y., 1973), p. 6.
2. For a catalogue of Luks's watercolors, see Ralph Clayes Talcott, "The Watercolors of George Luks" (master's thesis, Pennsylvania State University, 1970).

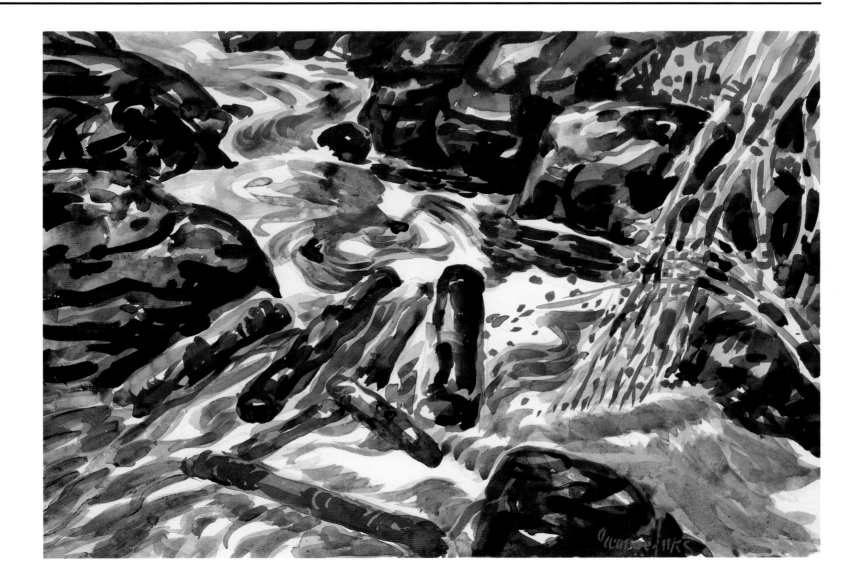

123. GEORGE LUKS
(1866–1933)
Railroad Crossing
Watercolor and graphite on white wove paper,
13¹⁵⁄₁₆ × 19¹⁵⁄₁₆ in.
Signed at lower right: George Luks. Inscribed on
reverse: Railroad Crossing/Berk. Hills
The Lesley and Emma Sheafer Collection, Bequest of
Emma A. Sheafer, 1973
1974.356.24

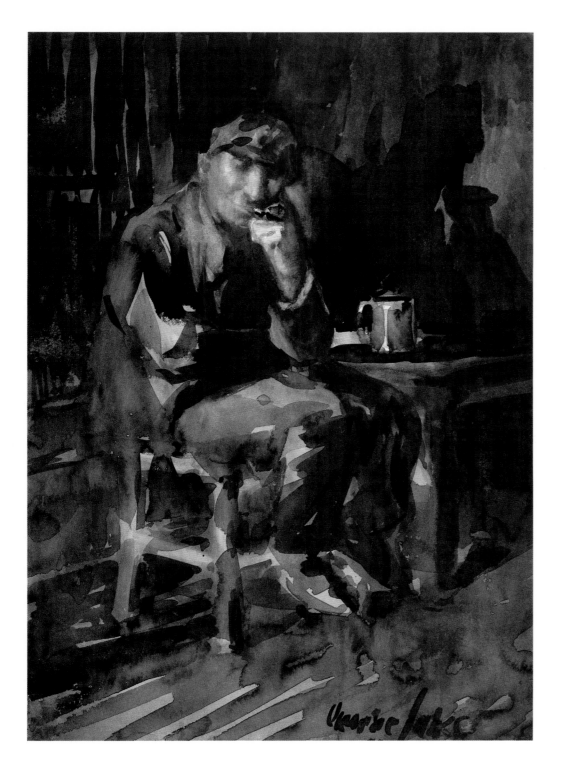

124. GEORGE LUKS
(1866–1933)
David Parrish: Interior of a Tavern
Watercolor and graphite underdrawing on off-white
wove paper, 19$^{15}/_{16}$ × 13$^{7}/_{8}$ in.
Signed at lower right: George Luks
Arthur Hoppock Hearn Fund, 1955
55.102

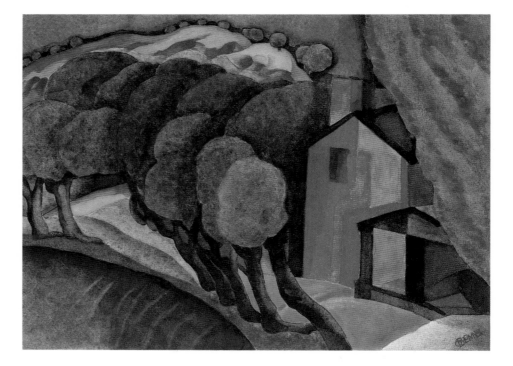

125. OSCAR BLUEMNER
(1867–1938)
Glowing Night
Watercolor and graphite on off-white wove paper,
9¼ × 12⅜ in.
Signed at lower right: BLUEMNER
Bequest of Charles F. Iklé, 1963
64.27.10

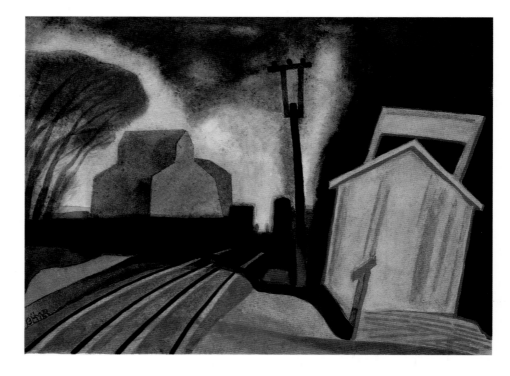

126. OSCAR BLUEMNER
(1867–1938)
Flag Station, Elizabeth, New Jersey
Watercolor on off-white wove paper, 10⅝ × 13⅛ in.
Signed at lower left: BLUEMNER
Bequest of Charles F. Iklé, 1963
64.27.9

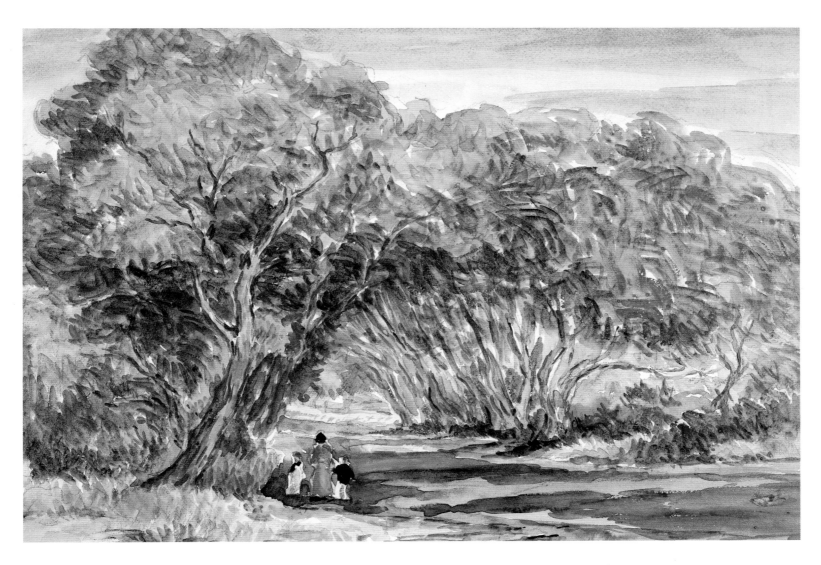

127. REYNOLDS BEAL
(1867–1951)
Annisquam, Massachusetts, 1923
Watercolor and graphite underdrawing on off-white
wove paper, 15¹¹⁄₁₆ × 22¾ in.
Inscribed and dated at lower right: Annisquam
Mass/Aug. 1923/Sketching with Mary Huntington
Gift of Mr. and Mrs. Sidney Bressler, 1973
1973.41

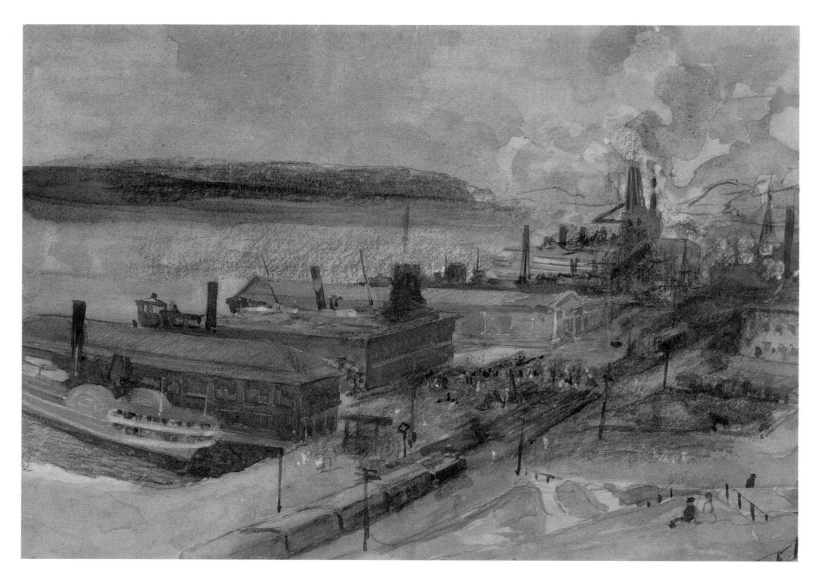

128. GEORGE OVERBURY "POP" HART
(1868–1933)
125 Street Ferry
Watercolor, black chalk, and graphite on manila-
colored cardboard, 14⅛ × 20 in.
Gift of Rita and Daniel Fraad, Jr., 1978
1978.509.2

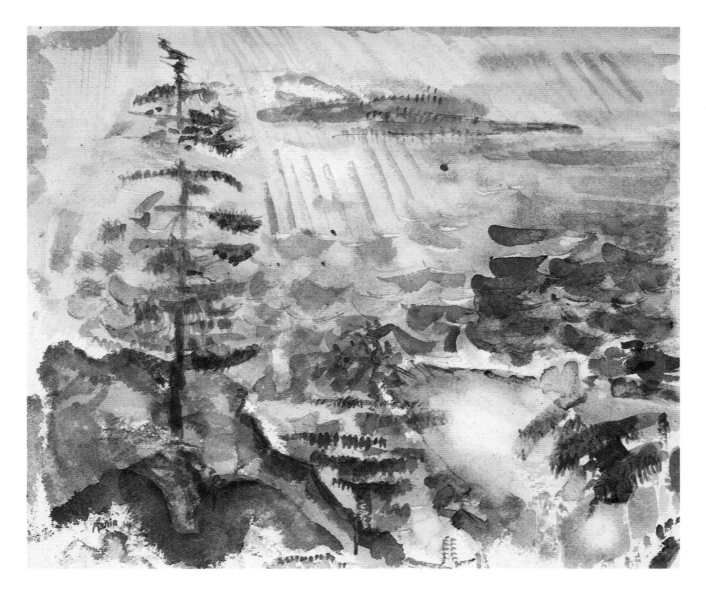

129. JOHN MARIN
(1870–1953)
West Point (Casco Bay), Maine, 1914
Watercolor on off-white wove paper, 14⅛ × 16⁷⁄₁₆ in.
Signed and dated at lower left: Marin 14. Inscribed on
reverse: West Point (Casco Bay) Maine
Bequest of Charles F. Iklé, 1963
64.27.3

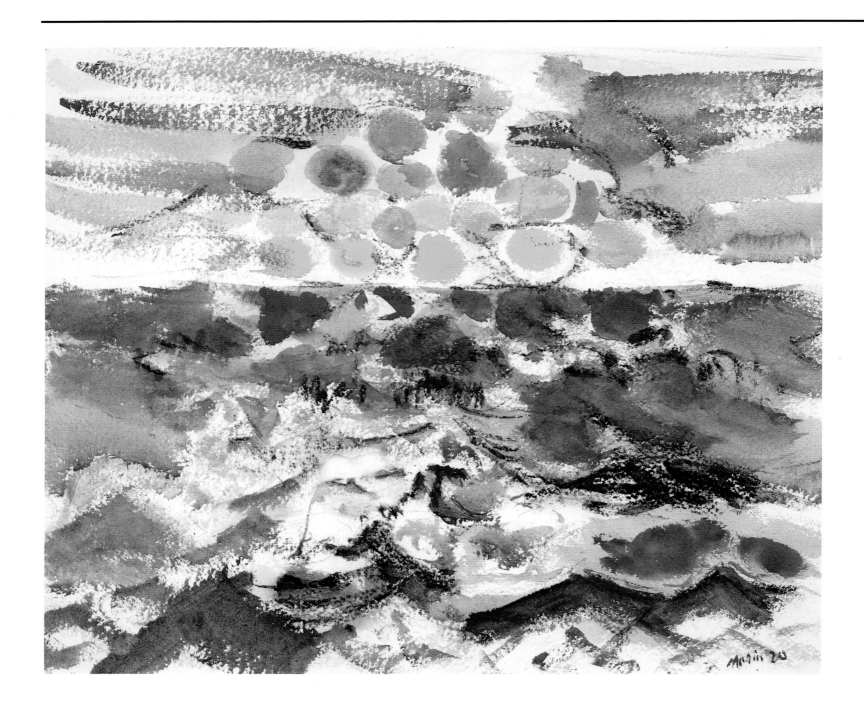

130. JOHN MARIN
(1870–1953)
Sun Spots, 1920
Watercolor and charcoal on off-white wove paper,
16½ × 19¾ in.
Signed and dated at lower right: Marin 20
Alfred Stieglitz Collection, 1949
49.70.121

The elemental power of the sea and its varied moods and movements provided John Marin, a consummate watercolorist and one of the most original of our early modernists, with a theme that he would explore in both oil and watercolor for a period of forty years. Perhaps more than any other subject, the sea challenged this artist's imagination. In response, he created an immense body of work expressing his intensely felt subjective reactions to the sea—as opposed to simply recording its external appearance. His approach was essentially expressionistic; his technique one of simplification and modified distortion, by which natural forms were reduced to an easily recognized, stylized shorthand.

Marin's seascapes are almost always based on the sensations and emotions he experienced during annual summer excursions to the Maine coast. In 1914 he spent his first summer there, in a rented cottage at West Point, across Casco Bay from Portland. The dramatic combination of rocks, islands, and water so inspired him that with rare exceptions, he chose to spend his summers in Maine for the rest of his life.

Sun Spots is one of the artist's more abstract compositions. Painted in 1920, probably during the summer months, at Stonington, on Deer Isle, the picture is a bold schematization of water and sky depicted with quick, broad brushstrokes in hues of blue, green, rose, and golden yellow.[1] Marin was fascinated by the sun, and here he has described the optical sensation that results from gazing too long at its burning image. The clarity and simplicity of the composition are remarkable. When *Sun Spots* was exhibited in 1921, Henry Tyrrell, a newspaperman, poet, and art critic, wrote an evocative description of the work: "He had a dozen golden sundisks flung into one picture—a mad attempt at registering the ecstatic suddenness of dayspring over dancing waves on the ocean's horizon verge."[2]

1. In 1922 Marin painted a variant of *Sun Spots* with similar dimensions and in the same medium. In 1982 the painting was exhibited at Kennedy Galleries, New York, and reproduced as number 13 in the exhibition catalogue, *John Marin and the Sea.*
2. Henry Tyrrell, "American Aquarellists—Homer to Marin," *The International Studio,* vol. 74, no. 294 (September 1921), p. xxxiii.

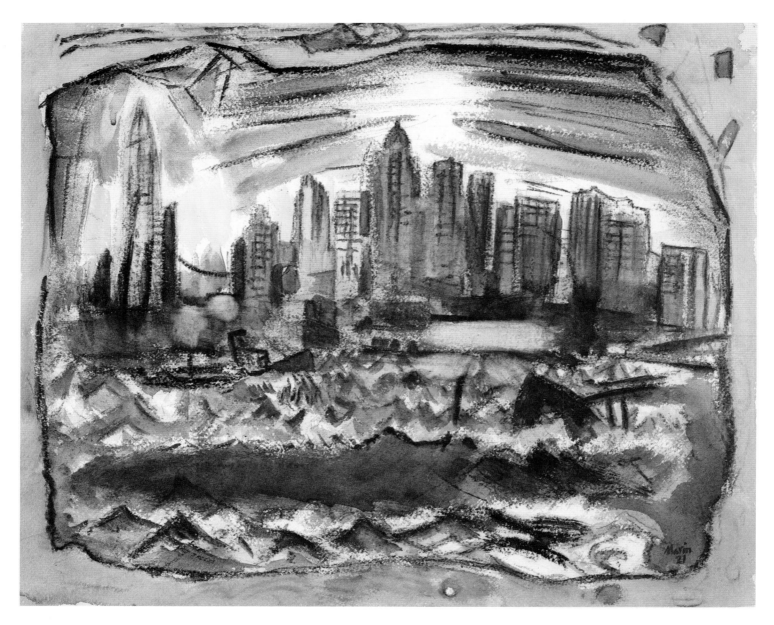

131. JOHN MARIN
(1870–1953)
Lower Manhattan from the River, No. 1, 1921
Watercolor and charcoal on off-white paper,
21¾ × 26½ in.
Signed and dated at lower right: Marin/21
Alfred Stieglitz Collection, 1949
49.70.122

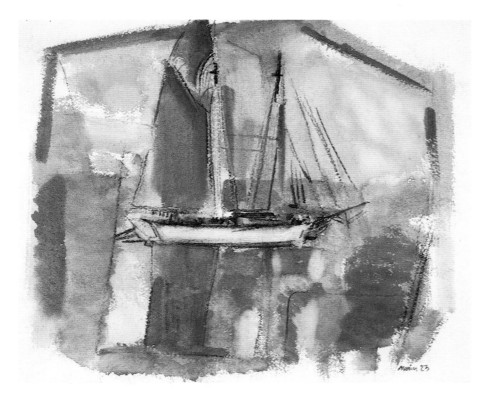

132. JOHN MARIN
(1870–1953)
Two-Master, Becalmed, 1923
Watercolor and charcoal on off-white wove paper,
16½ × 19⅞ in.
Signed and dated at lower right: Marin 23
Alfred Stieglitz Collection, 1949
49.70.128

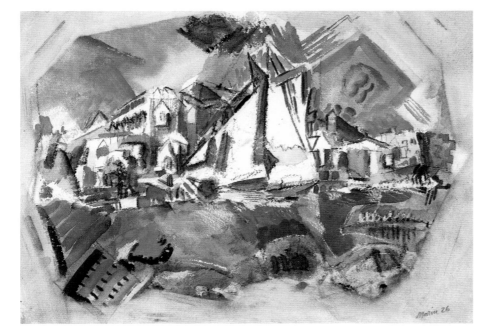

133. JOHN MARIN
(1870–1953)
Pertaining to Stonington Harbor, Maine,
No. 4, 1926
Watercolor and charcoal on off-white wove paper
mounted on paperboard, 18¼ × 23¼ in.
Signed and dated at lower right: Marin 26
Alfred Stieglitz Collection, 1949
49.70.134

134. JOHN MARIN
(1870–1953)
Related to Downtown New York, Movement
No. 2 (The Black Sun), 1926
Watercolor and charcoal on white wove paper,
21⅞ × 27¾ in.
Signed and dated at lower right: Marin 26
Alfred Stieglitz Collection, 1949
49.70.135

In the fall of 1910, when John Marin returned to New York City after five years of travel and study in Europe, the skyline and tempo of the city were undergoing a dramatic transformation. New technology had stimulated the building of skyscrapers whose towers soared forty to fifty stories high. An important series of the artist's watercolors record the construction of the Woolworth Building which, at its completion in 1913, became the tallest building in the world. Marin was both excited and intimidated by the phenomenon of the new architecture and by the markedly accelerated pace of urban life. In a letter of 1911 addressed to his new friend, dealer, and patron, Alfred Stieglitz, he revealed his ambivalent feelings about the stresses and stimuli generated by the rapidly changing city: "I have just started some Downtown stuff and to pile these great houses one upon another with paint as they do pile themselves up there so beautiful, so fantastic—at times one is afraid to look at them but feels like running away."[1]

In an attempt to master this intensely vital, at times threatening, urban environment, Marin developed New York City into a major theme—an especial metaphor that he was to examine in detail throughout the remainder of his long professional life. His views of Manhattan form a personal, idiosyncratic vision of a pulsating, modern metropolis where everything is in motion and in which even the skyscrapers have become animate. The artist expressed his feelings about the city in an introduction to his 1913 exhibition catalogue, "If these buildings move me they too must have life. Thus the whole city is alive; buildings, people, all are alive; and the more they move me the more I feel them to be alive. It is this 'moving of me' that I try to express."[2]

Executed in a semiabstract, schematized mode, *Related to Downtown New York, Movement No. 2 (The Black Sun)* is less straightforward and topographical than many of Marin's city views. None of the structures is identifiable, although the boxy forms of the white skyscraper dominating the center of the composition are reminiscent of the powerfully massed, set-back towers of the Telephone Building, whose impressive silhouette once overshadowed lower Manhattan and served as a focal point for several of Marin's 1926 New York views.

The scene pictured here is of downtown Manhattan as viewed from across the Hudson River—whose presence is suggested only by the tugboat in the right foreground. An expressionistically colored black sun with streaming black rays looms ominously over the skyline of the city, whose energy and staccato tempo are conveyed by slashing diagonal lines. In an effort to center and stabilize the fragmented forms and tilted composition of this watercolor, Marin introduced a wide inner frame painted in gray wash. This novel concept of a frame within a frame is an aesthetic device that assumed increasing importance in the artist's oeuvre.

1. Dorothy Norman, ed., *The Selected Writings of John Marin* (New York, 1949), pp. 3–4.
2. Ibid., p. 4.

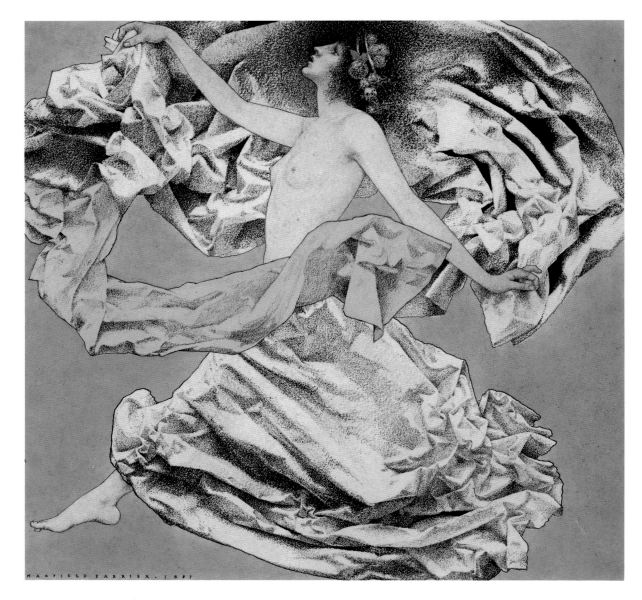

135. MAXFIELD PARRISH
(1870–1966)
Figure, 1897
Watercolor, black ink, shellac, and cut-out paper on
off-white wove paper, 11³/₁₆ × 11⁹/₁₆ in.
Signed and dated at lower left: MAXFIELD PARRISH.
1897. Signed and dated on reverse: Maxfield
Parrish/December 1897
Gift of A. E. Gallatin, 1923
23.230.3

136. F. Luis Mora
(1874–1940)
Portrait of the Artist's Father in the Studio,
1901
Watercolor and graphite underdrawing on light gray
wove paper, 18⅜ × 12⅛ in.
Signed and dated at lower left: F. Luis Mora/19-01
Gift of Mr. and Mrs. Walter C. Crawford, 1978
1978.513.3

137. F. Luis Mora
(1874–1940)
Mrs. F. Luis Mora and Her Sister, 1902
Watercolor and graphite on wove paper mounted on
board, 29¹³⁄₁₆ × 21¹⁵⁄₁₆ in.
Signed and dated at lower left: F. Luis Mora/1902
Gift of Mr. and Mrs. Raymond J. Horowitz, 1965
65.237

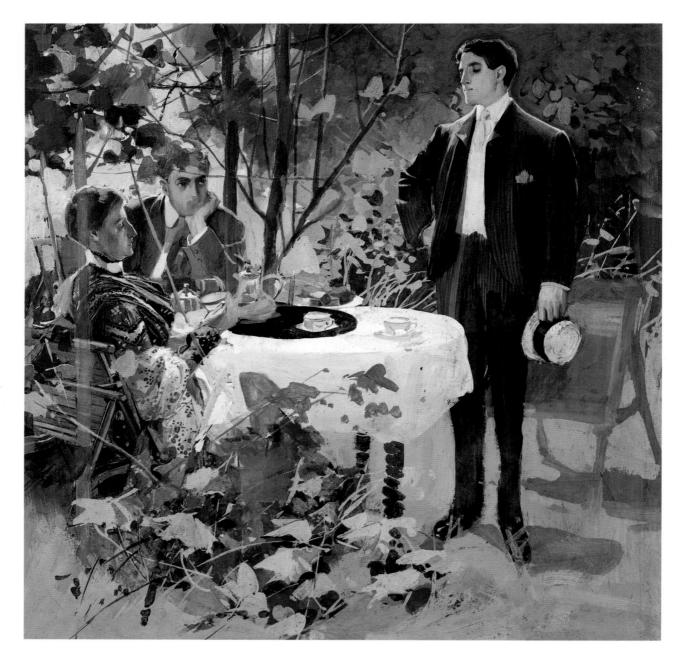

138. JOSEPH CHRISTIAN LEYENDECKER
(1874–1951)
At Tea
Gouache and graphite on cardboard, 13½ × 13¹⁵⁄₁₆ in.
Gift of Augusta M. Leyendecker, 1953. 53.109.3

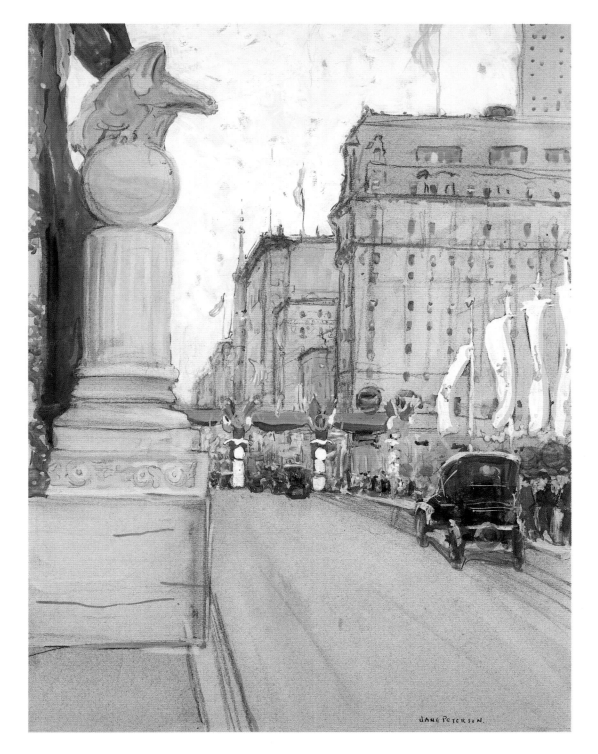

139. JANE PETERSON
(1876–1965)
Parade
Gouache, watercolor, and charcoal on gray wove
paper, 24 × 17¹⁵⁄₁₆ in.
Signed at lower right: JANE PETERSON
Gift of Martin Horowitz, 1976
1976.387

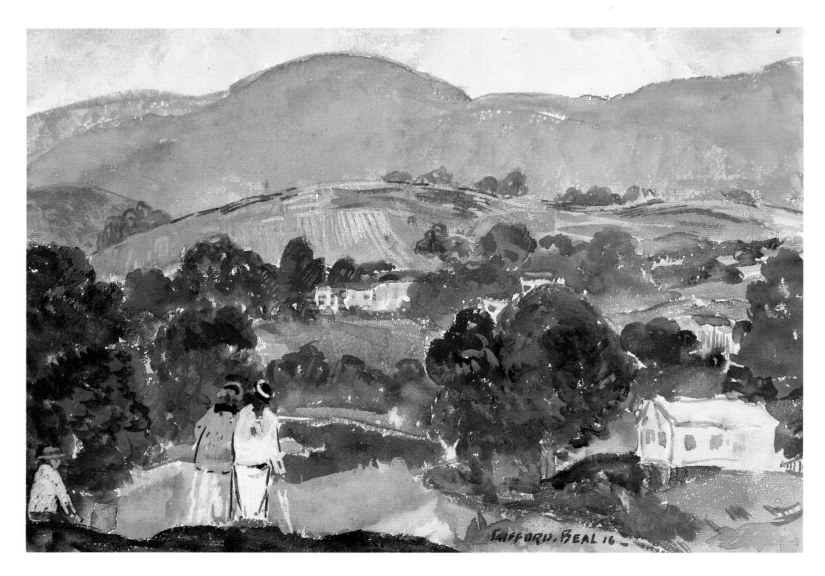

140. GIFFORD BEAL
(1879–1956)
Across the Valley, 1916
Watercolor and gouache on off-white wove paper,
14⅛ × 20 in.
Signed and dated at lower right: GIFFORD BEAL 16
Rogers Fund, 1924
24.49.2

141. ARTHUR G. DOVE
(1880–1946)
Goat
Watercolor, gouache, and graphite on paperboard,
4 × 6 in.
Signed at bottom: Dove
Alfred Stieglitz Collection, 1949
49.70.75

142. ARTHUR G. DOVE
(1880–1946)
Tree (41), 1935
Watercolor and gouache on off-white wove paper,
4¹⁵⁄₁₆ × 7 in.
Signed at bottom: Dove. Inscribed and dated on
reverse: Tree (41) 1935
Alfred Stieglitz Collection, 1949
49.70.96

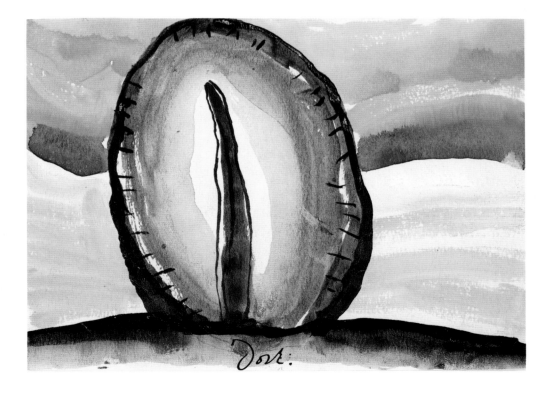

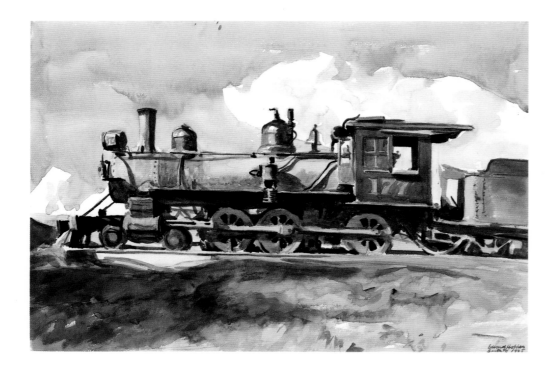

143. EDWARD HOPPER
(1882–1967)
D. & R. G. Locomotive, 1925
Watercolor and graphite on white wove paper,
13⅞ × 19¹⁵⁄₁₆ in.
Signed, inscribed, and dated at lower right:
Edward Hopper/Santa Fe 1925
Hugo Kastor Fund, 1957
57.76

144. EDWARD HOPPER
(1882–1967)
House of the Foghorn, I, Two Lights, Maine
Watercolor and graphite on white wove paper,
13⅞ × 20 in.
Signed and inscribed at lower right:
Edward Hopper/Two Lights
Bequest of Elizabeth Amis Cameron Blanchard (Mrs.
J. O. Blanchard), 1956
56.216

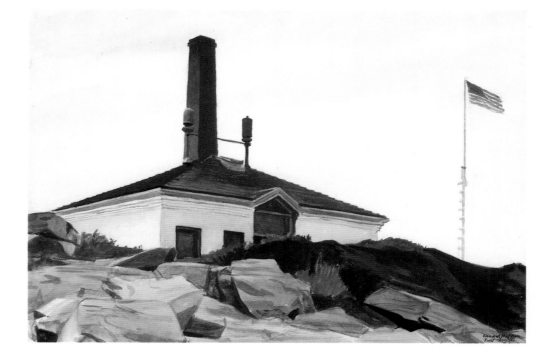

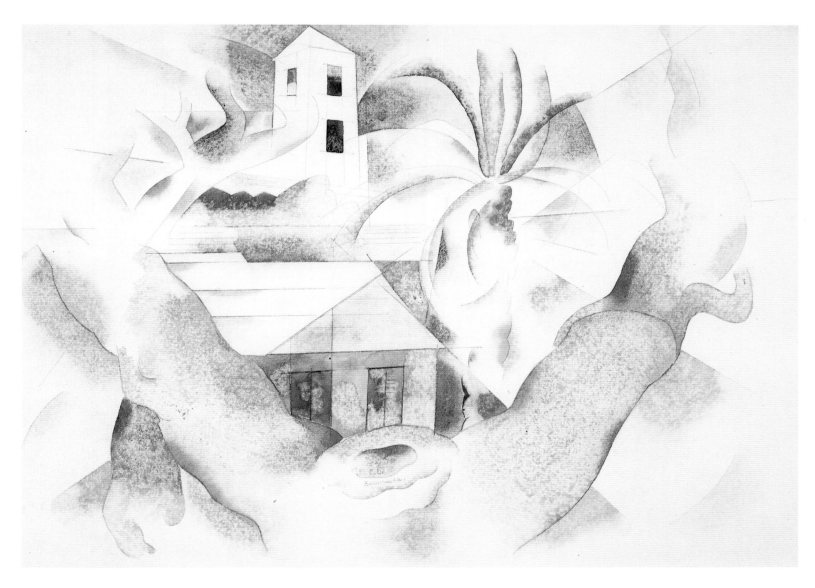

145. Charles Demuth
(1883–1935)
Bermuda No. 1, Tree and House
Watercolor and graphite on white wove paper
(reverse: graphite drawing), 10 × 13¹⁵⁄₁₆ in.
Signed and inscribed at lower center: C. D./Bermuda
Alfred Stieglitz Collection, 1949
49.70.55

146. CHARLES DEMUTH
(1883–1935)
Bermuda No. 2 (The Schooner), 1917
Watercolor and graphite on white wove paper,
9¹⁵⁄₁₆ × 13⅞ in.
Signed and dated at lower left: C. Demuth/1917
Alfred Stieglitz Collection, 1949
49.70.56

Charles Demuth played a central role in the dissemination of Cubism in America. A quintessential cosmopolitan, Demuth moved with ease in the most sophisticated artistic circles. In Paris he regularly visited the legendary salon of Gertrude Stein, frequented by Pablo Picasso, Juan Gris, Henri Matisse, and Marcel Duchamp. In New York, he joined the elite circle of early American modernists around Alfred Stieglitz, the influential dealer-collector-photographer. From time to time, in order to counter the ill effects of a hedonistic lifestyle on a constitution weakened by diabetes, Demuth would retire to the peace and security of his family home in Lancaster, Pennsylvania. In the studio overlooking the garden, he produced much of his best work, painting exquisite still lifes of flowers, fruits, and vegetables and composing elegant Precisionist views of the urban sprawl around Lancaster.

Bermuda No. 2 (The Schooner) belongs to a series of watercolors that Demuth called Interpretive Landscapes. It was executed in 1917 while the artist wintered on the island of Bermuda in the company of Marsden Hartley. The two friends had spent the preceding summer together in Provincetown, Massachusetts, where Demuth, influenced by Hartley's semiabstract Cubist compositions, had begun to paint in a new nonfigurative style, very different in form, color, and content from his previous work. Hartley was not the only influence on Demuth during this critical period when the artist was experimenting with Cubist theory and attempting to incorporate it into his own aesthetic. Albert Gleizes, a French Cubist painter, also visited Bermuda in the winter of 1917. We know there was contact between the two artists, who had met before, and it is likely that the example of Gleizes's decorative, modified Cubist style encouraged Demuth to work in a more abstract mode.[1]

It was, however, the watercolors of Paul Cézanne that served as the paramount influence on Demuth as he painted his brilliant Cubist-inspired Bermuda series. The work of Cézanne provided a profound stimulus for many of the early American modernists, and Demuth had frequent opportunities to study the French master's watercolors in private homes and public exhibitions in both Paris and New York.

With its delicately painted washes in muted tones and large areas of white paper reserve, *Bermuda No. 2 (The Schooner)* reveals its Cézannesque antecedents. The fragility of the paint surface is further emphasized by the mottled texture, which Demuth achieved by means of a blotting technique. Within Demuth's personal adaptation of Cubism, the subject matter retains a high degree of recognizability. In this watercolor, for example, Demuth constructed a semiabstract but still entirely comprehensible view of a sailboat by creating subtle distortions of the vessel's masts, sails, and rigging. His treatment is a departure from the wholesale alterations characteristic of the Cubist work of Picasso and Georges Braque, in which the image was dismembered piece by piece and reassembled. Demuth further demonstrated his refined modernist affinities by structuring the multifaceted image of the boat within a network of Cubist-Futurist radiating lines and planes.

1. A detailed discussion of Demuth's involvement with Cubism is provided in Barbara Haskell, *Charles Demuth* (New York, 1987), pp. 121–44.

147. CHARLES DEMUTH
(1883–1935)
Flowers, 1918
Watercolor and graphite on off-white wove paper,
18 × 11¹⁵⁄₁₆ in.
Signed and dated at lower left: C. Demuth/1918
Rogers Fund, 1923
23.104

148. CHARLES DEMUTH
(1883–1935)
Cyclamen, 1920
Watercolor and graphite on off-white wove paper,
13¾ x 11¾ in.
Signed and dated at lower left: C. Demuth – /1920
Gift of A. E. Gallatin, 1923
23.231

149. CHARLES BURCHFIELD
(1893–1967)
Abstract Composition
Watercolor and graphite on white wove
paper, 7 × 9⅛ in.
Monogram, watercolor on off-white
wove paper, 2⅞ × 4 in.
The Lesley and Emma Sheafer Collection,
Bequest of Emma A. Sheafer, 1973
1974.356.26a, b

191

150. CHARLES BURCHFIELD
(1893–1967)
Dandelion Seed Balls and Trees,
1917
Watercolor and graphite on off-white
wove paper, 22¼ × 18¼ in.
Signed and dated at lower right:
Chas Burchfield – 1917.
Inscribed and dated on reverse:
DANDELION SEED-BALLS AND TREES
May 25, 1917
Arthur Hoppock Hearn Fund, 1940
40.47.2

EXHIBITION CHECKLIST

The 150 watercolors illustrated in this publication were grouped into two selections of 75 for the national tour organized by the American Federation of Arts. The combined selections will be exhibited at the Metropolitan Museum of Art from October 15 to December 10, 1991.

Selection I

Seattle Art Museum
Seattle, Washington
February 7–March 31, 1991

Thomas Gilcrease Institute of American History
and Art
Tulsa, Oklahoma
April 20–June 15, 1991

1. Johann Henrich Otto. *Fraktur Motifs*
2. Attributed to Christian Mertel (formerly known as the C. M. Artist). *Birth and Baptismal Certificate for Samuel Beckle* (b. 1795)
5. Unidentified artist. *The Abraham Pixler Family*
6. Joseph H. Davis. *Mr. and Mrs. Daniel Otis and Child*
10. Unidentified artist. *The Orphans*
11. Sarah Fairchild. *Union Park, New York*
16. John Rubens Smith. *Allan Melville*
17. William James Bennett. *View of South Street, from Maiden Lane, New York City*
19. Pavel Petrovitch Svinin. *"Worldly Folk" Questioning Chimney Sweeps and Their Master before Christ Church, Philadelphia*
21. Pavel Petrovitch Svinin. *Night Life in Philadelphia—an Oyster Barrow in front of the Chestnut Street Theatre*
23. William Guy Wall. *The Bay of New York and Governor's Island Taken from Brooklyn Heights*
25. William Guy Wall. *View on the Hudson River*
27. Nicolino Calyo. *View of the Tunnel of the Harlem Railroad*
28. Charles Burton. *View of the Capitol*
30. John William Hill. *Interior of Trinity Chapel, New York City*
32. John William Hill. *Plums*

33. John William Hill. *Peach Blossoms*
35. David Johnson Kennedy. *Entrance to Harbor—Moonlight*
36. William Rickarby Miller. *Catskill Clove*
38. James Hamilton. *Beach Scene*
41. Christian Schuessele and James Sommerville. *Ocean Life*
43. George Inness. *Olive Trees at Tivoli*
44. Enoch Wood Perry. *A Month's Darning*
46. William Trost Richards. *Sunset on Mount Chocorua, New Hampshire*
48. William Trost Richards. *The Mount Washington Range, from Mount Kearsarge*
49. William Trost Richards. *Moonlight on Mount Lafayette, New Hampshire*
51. William Trost Richards. *Sundown at Centre Harbor, New Hampshire*
53. William Trost Richards. *A Rocky Coast*
57. James McNeill Whistler. *Scene on the Mersey*
58. William Stanley Haseltine. *Vahrn in Tyrol near Brixen*
60. William Stanley Haseltine. *Sette Sale (Villa Brancaccio), Rome*
62. John La Farge. *Paradise Rocks—Study at Paradise, Newport, R.I.*
65. John La Farge. *Portrait of Faase, the Taupo of Fagaloa Bay, Samoa*
67. John La Farge. *The Strange Thing Little Kiosai Saw in the River*
68. Winslow Homer. *Two Ladies*
70. Winslow Homer. *Nassau*
73. Winslow Homer. *Shore and Surf, Nassau*
74. Winslow Homer. *Natural Bridge, Bermuda*
75. Winslow Homer. *Fishing Boats, Key West*
78. Henry Fenn. *Everglades*
80. William John Hennessy. *An Old Song*
83. Henry Roderick Newman. *East Entrance, Room of Tiberius, Temple of Isis, Philae*
84. Thomas Eakins. *Young Girl Meditating*
87. Thomas Eakins. *Taking Up the Net*

88. Thomas Eakins. *Cowboy Singing*
89. J. Alden Weir. *Anna Dwight Weir Reading a Letter*
93. John Singer Sargent. *Tiepolo Ceiling—Milan*
94. John Singer Sargent. *Figure with Red Drapery*
95. John Singer Sargent. *Rushing Brook*
96. John Singer Sargent. *Spanish Fountain*
98. John Singer Sargent. *In the Generalife*
99. John Singer Sargent. *Sirmione*
100. John Singer Sargent. *Boats*
103. John Singer Sargent. *Giudecca*
107. John Singer Sargent. *Tommies Bathing*
110. John Singer Sargent. *Army Mules*
114. Maurice Prendergast. *Court Yard, West End Library, Boston*
116. Maurice Prendergast. *Rialto Bridge (Covered Bridge, Venice)*
119. Childe Hassam. *The Brush House*
121. Arthur B. Davies. *Mountains*
123. George Luks. *Railroad Crossing*
124. George Luks. *David Parrish: Interior of a Tavern*
125. Oscar Bluemner. *Glowing Night*
127. Reynolds Beal. *Annisquam, Massachusetts*
128. George Overbury "Pop" Hart. *125 Street Ferry*
130. John Marin. *Sun Spots*
131. John Marin. *Lower Manhattan from the River, No. 1*
132. John Marin. *Two-Master, Becalmed*
136. F. Luis Mora. *Portrait of the Artist's Father in the Studio*
139. Jane Peterson. *Parade*
141. Arthur G. Dove. *Goat*
143. Edward Hopper. *D. & R.G. Locomotive*
145. Charles Demuth. *Bermuda No. 1, Tree and House*
148. Charles Demuth. *Cyclamen*
149. Charles Burchfield. *Abstract Composition*

Selection II

Denver Art Museum
Denver, Colorado
February 2–March 31, 1991

The Chrysler Museum
Norfolk, Virginia
May 9–July 7, 1991

3. Attributed to the Cross-legged Angel Artist. *Birth and Baptismal Certificate for Anamaria Weidner* (b. 1802)
4. Unidentified artist. *The Crucifixion*
7. Henry Walton. *Frances and Charles Cowdrey*
8. Unidentified artist. *Stylized Bird*
9. Unidentified artist. *The Picnic*
12. Unidentified artist. *Hudson River Railroad Station, with a View of Manhattan College*
13. Archibald Robertson. *Collect Pond, New York City*
14. John Hill. *View from My Work Room Window in Hammond Street, New York City*
15. Charles Balthazar Julien Févret de Saint-Mémin. *Osage Warrior*
18. Pavel Petrovitch Svinin. *Merrymaking at a Wayside Inn*
20. Pavel Petrovitch Svinin. *Negroes in front of the Bank of Pennsylvania, Philadelphia*
22. William Guy Wall. *New York from Weehawk*
24. William Guy Wall. *The Bay of New York Taken from Brooklyn Heights*
26. David Claypoole Johnston. *At the Waterfall*
29. John William Hill. *Circular Mill, King Street, New York City*
31. John William Hill. *Landscape: View on Catskill Creek*
34. John William Hill. *Still Life with Fruit*
37. William Rickarby Miller. *Catskill Clove in Palingsville*

39. William Louis Sonntag. *Frontier Cabin*
40. Thomas Waterman Wood. *Reading the Scriptures*
42. George Inness. *Across the Campagna*
45. Wiliam Trost Richards. *Lake Squam and the Sandwich Mountains*
47. William Trost Richards. *The Franconia Mountains from Campton, New Hampshire*
50. William Trost Richards. *Lake Squam from Red Hill*
52. William Trost Richards. *Purgatory Cliff*
54. William Trost Richards. *From Paradise to Purgatory, Newport*
55. James David Smillie. *The Ausable, September, 1869*
56. James McNeill Whistler. *Lady in Gray*
59. William Stanley Haseltine. *Castel Fusano—near Rome*
61. William Stanley Haseltine. *Mill Dam in Traunstein*
63. John La Farge. *The Great Statue of Amida Buddha at Kamakura, Known as the Daibutsu, from the Priest's Garden*
64. John La Farge. *Wild Roses and Irises*
66. John La Farge. *Girls Carrying a Canoe, Vaiala, Samoa*
69. Winslow Homer. *Hurricane, Bahamas*
71. Winslow Homer. *Sloop, Nassau*
72. Winslow Homer. *The Bather*
76. Winslow Homer. *Taking On Wet Provisions*
77. Winslow Homer. *Channel Bass*
79. Henry Fenn. *Caesarea Philippi (Banias)*
81. George Henry Smillie. *Tremezzo, Lake Como*
82. Henry Farrer. *City and Sunset*
85. Thomas Eakins. *The Pathetic Song*
86. Thomas Eakins. *Home-spun*
90. Edmund H. Garrett. *Cottage Garden, Warwick, England*
91. John Singer Sargent. *Venetian Doorway*
92. John Singer Sargent. *Woman with Collie*

97. John Singer Sargent. *Escutcheon of Charles V of Spain*
101. John Singer Sargent. *Mountain Stream*
102. John Singer Sargent. *Tyrolese Crucifix*
104. John Singer Sargent. *Venetian Canal*
105. John Singer Sargent. *Camp at Lake O'Hara*
106. John Singer Sargent. *Figure and Pool*
108. John Singer Sargent. *Camouflaged Field in France*
109. John Singer Sargent. *Tommies Bathing, France 1918*
111. Robert Blum. *Street Scene in Ikao, Japan*
112. Bruce Crane. *Snow Scene*
113. Maurice Prendergast. *Piazza di San Marco*
115. Maurice Prendergast. *Excursionists, Nahant*
117. Maurice Prendergast. *The Rider*
118. Elliott Daingerfield. *Moon Rising over Fog Clouds*
120. Childe Hassam. *Street in Portsmouth*
122. George Luks. *The Brook*
126. Oscar Bluemner. *Flag Station, Elizabeth, New Jersey*
129. John Marin. *West Point (Casco Bay), Maine*
133. John Marin. *Pertaining to Stonington Harbor, Maine, No. 4*
134. John Marin. *Related to Downtown New York, Movement No. 2 (The Black Sun)*
135. Maxfield Parrish. *Figure*
137. F. Luis Mora. *Mrs. F. Luis Mora and Her Sister*
138. Joseph Christian Leyendecker. *At Tea*
140. Gifford Beal. *Across the Valley*
142. Arthur G. Dove. *Tree (41)*
144. Edward Hopper. *House of the Foghorn, I, Two Lights, Maine*
146. Charles Demuth. *Bermuda No. 2 (The Schooner)*
147. Charles Demuth. *Flowers*
150. Charles Burchfield. *Dandelion Seed Balls and Trees*

THE AMERICAN
FEDERATION OF ARTS

Staff

Myrna Smoot, *Director*
Barbara Poska, *Executive Assistant to the Director*
Sheila Look, *Office Assistant*

EXHIBITIONS

J. David Farmer, *Director of Exhibitions*
Robert Workman, *Administrator for Exhibitions*
Marie-Thérèse Brincard, *Senior Exhibition Coordinator*
P. Andrew Spahr, *Senior Exhibition Coordinator*
Donna Gustafson, *Exhibition Coordinator*
Michaelyn Mitchell, *Head of Publications*
Carol S. Farra, *Registrar*
Andrea Farnick, *Associate Registrar*
Kathleen Flynn, *Assistant Registrar*
Deborah Notkin, *Exhibition Assistant*
Julie Min, *Exhibition Assistant*
Annie E. Raulerson, *Exhibition Assistant*

MEDIA ARTS

Sam McElfresh, *Director of Media Arts*
Tom Smith, *Assistant Director of Media Arts*
Thomas Smith, *Media Arts Assistant*
Kari Olson, *Media Arts Assistant*

DEVELOPMENT, MEMBERSHIP, AND PUBLIC INFORMATION

Susan J. Brady, *Director of Development and Public Affairs*
Gretchen MacKenzie, *Director of Membership and Events*
Phillip Ambrosino, *Membership Assistant*
Jillian W. Slonim, *Director of Public Information*
Penne Smith, *Public Information Assistant*
Jim Gaffey, *Grants Writer*

MUSEUM SERVICES

Susan Anthony Loria, *Director of Museum Services*
Ricki Lederman, *Professional Training Director and MMI Administrative Coordinator*
Mary Dalton, *MMI Administrative Assistant*

FINANCE AND ADMINISTRATION

Mark Gotlob, *Director of Finance and Administration*
Jim Finch, *Controller*
Patricia Holquist, *Senior Bookkeeper*
Jane Marvin, *Office Manager / Personnel Coordinator*
Sabina Moss, *Receptionist*

BUILDING

Marcos Laspina, *Superintendent*
Alfredo Caliba, *Custodian*

Government Support

Institute of Museum Services
National Endowment for the Arts
New York State Council on the Arts

Corporate and Foundation Patrons

BENEFACTORS

Cassa di Risparmio
Eastman Kodak Company
Exxon Corporation
J. Paul Getty Trust
The Horace W. Goldsmith Foundation
INCISA
The Knight Foundation
Mercedes-Benz of North America, Inc.
Metropolitan Life Foundation
PepsiCo, Inc.
Philip Morris Companies, Inc.
The Rockefeller Foundation
Sotheby's
US West
Lila Wallace–Reader's Digest Fund
The Andy Warhol Foundation for the Visual Arts, Inc.

PATRONS

Dayton Hudson Foundation
Gorham, Inc.

The James Irvine Foundation
Samuel H. Kress Foundation
Samuel & May Rudin Foundation

SPONSORS

Barker Welfare Foundation
The Graham Foundation
IBM Corporation
The New York Times Company Foundation, Inc.
RJR Nabisco, Inc.
Warner Communications

ASSOCIATES

The American Austrian Foundation
Arco Foundation
Atlantic Van Lines
Bell South Corporation
Chevron USA, Inc.
Ciba-Geigy Corporation
Ford Motor Company
Gemini G.E.L.

DONORS

Alcoa Foundation
Consolidated Edison Company of New York
Lannan Foundation
The J. C. Penney Company, Inc.
Pfizer, Inc.
Phillips Petroleum Foundation, Inc.
Reynolds Metals Company
Syntex Corporation
Tandy Corporation
Times Mirror

FRIENDS

Abbeville Press, Inc.
The Berghoff-Huber Brewing Company, Ltd.
Greyhound Exhibitgroup Inc.
Estee Lauder
LEP–Profit

INDEX

203